Tamil Nadu

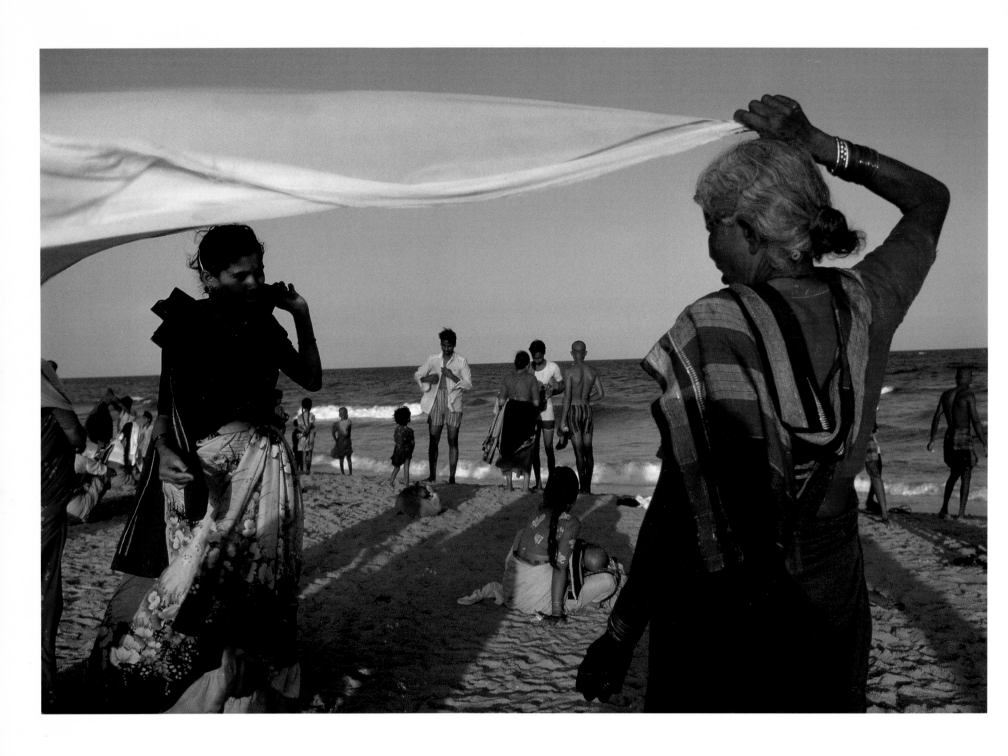

Bathers, Mamallapuram.

Tamil Nadu

Photographs and Text by Raghubir Singh

Preface by R.K. Narayan

D.A.P./Distributed Art Publishers

New York, New York

To all my friends in Tamil Nadu,
without them this book could not have been done

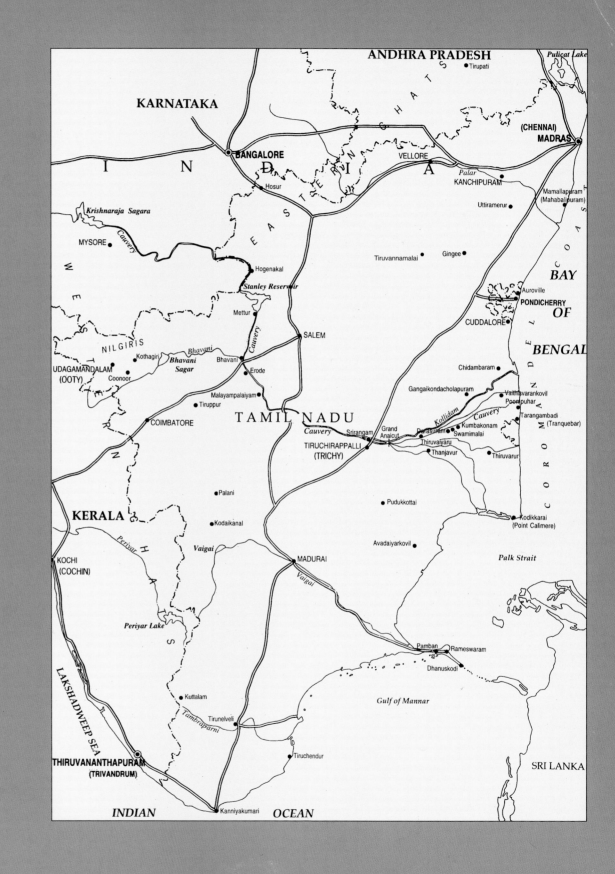

PREFACE BY R. K. NARAYAN

Childhood is the only time when one can enjoy a sense of being alive, letting the day pass without counting the hours. One hardly understands a clock on the wall. Occasionally my grandmother would call from the kitchen to ask, "See the clock and say what the small hand is showing." I had to hoist myself on a stool and after a long scrutiny answer, "The small hand is nowhere."

"It must be under the large one…wait till it moves"—the hand would, of course, move eventually, and I would shout, "No number—some lines, that is all," referring to the Roman numerals. I was taught only Arabic numbers up to twelve by my grandmother.

A day coming and going without any reckoning was heavenly, one existed in eternity. It was morning when you opened your eyes, night when you shut them—like the leaves of the enormous raintree in front of our home; its leaves automatically folded up at dusk and opened at dawn.

I got up from bed, was fed, washed and dressed in a shirt and a dhoti and lived the day mostly sitting on our doorstep and watching horse-drawn jutkas, rickshaws, and men and women.

The state of innocence and spontaneous joy in existence are lost when one is sent to school. On the first day I wept bitterly—the masters looked like tormentors and my class fellows fearsome bullies. My life at No.1 Vellala Street under the care of my grandmother was heavenly. My parents were in Bangalore and I was taken to Madras by my grandmother when I was two years old, to afford relief to my mother who bore the next child closely following my birth.

I had a peacock and monkey for company. The monkey was chained to a post, on top of which a little cabin was available for his shelter, but he preferred to sit on the roof of his home, hanging down his tail. He responded to the name Rama by baring his teeth, and kept a wary eye on the peacock, which was perpetually engaged in scratching the mud and looking for edible insects. I cannot say exactly when they came into my life, but they seemed to have been always there with me. In an early photo of myself, when I was four years old, I am set on a miniature bamboo chair flanked by the peacock and the monkey.

My uncle (Mother's brother), who brought me up, must have been one of the earliest amateur photographers in India. He kept his head, on most bright afternoons, under a black hood enveloping an enormous camera on a tripod. He posed me constantly against the flowers in the garden, in the company of my pets.

I had to remain rigid, unblinking, and immobile whenever he photographed us, and it was a feat to keep the monkey and the peacock together. I enjoyed these sessions, although my grandmother declared from time to time that a photograph was likely to shorten the subject's life.

I was proud of the group in the picture and hoped that others would see a resemblance between me and Rama. When I sought confirmation on this point, my grandmother was horrified and said, "What a fool to want to look like a monkey!"

Raghubir Singh has photographed splendidly the Purasawalkam neighbourhood where I lived till the age of sixteen. In a section on animals, there is a picture of a monkey and another of a peacock.

Some years ago I revisited Purasawalkam and spent a couple of hours viewing the old landmarks, and I found, though multi-storey buildings and new shop fronts and modern villas and the traffic stream have altered the general outlook, that the four or five temples of my childhood are still solid and unchanged, oil lamps still burning, and the congregations the same as they were more than seventy years ago.

Raghubir Singh's unique photographs of Tamil Nadu express the tradition of temples, the richness and variety of life, change as well as continuity in the environment and life in general.

Tamil Nadu

It Has Held My Camera-Eye Captive

By Raghubir Singh

Aｆｔｅｒ I ɢʀᴇᴡ ᴜᴘ ɪɴ Jaipur, my hometown, in Rajasthan state, I began a series of journeys to discover North India, particularly the Ganges, from its Himalayan source to the Bay of Bengal. I followed the river from place to place, from people to people, from mountain to plain to delta. This was a discovery, not only of geography, but of people, place and culture, the culture culled from geography. Through these discoveries, I came to understand that the true protagonists of North India are the mountain, the river and the plain.

As the years went by, I slowly turned my attention to South India. In time, I focused on Tamil Nadu. After my first visit to Madras, the capital city, and then on a drive to Madurai, the temple city, I became acutely aware of the densely different setting of Tamil Nadu. Yet, as in the north, the true protagonists of Tamil Nadu emerge out of its elemental ecology: the Coromandel Coast, the Cauvery river and the Western Ghats—the mountainous spine of south-western India. This geography shapes the people. The people and the setting together make this southern state dramatically different than any other part of India.

Between North India and Tamil Nadu lies the hot and harsh Deccan plateau. Even this severe setting was not a deterrent to the Islamic invasions of the 14th century that led to pillage and plunder, and ultimately to a short-lived sultanate in Madurai. But by the 15th century the invaders had been pushed back to the north. On the whole, Tamil Nadu was spared the massive destruction of temples that took place in North India. No temple was pulled down to be replaced by a mosque.

If the numerous temples of Tamil Nadu, rising tall, over miles and miles of paddy and palm, give it a particular distinction, so do the rites and rituals

around possibly India's oldest tradition, a tradition that is truer than that of the north. Tamil, its very language, is as old as Sanskrit. Simultaneously, this state's sense of science, mathematics, music, art, literature and philosophy reaches into India's earliest antiquity. And yet, such an ancient tradition has modernized! The modernization began early in the twentieth century. Tamil Nadu, along with the state of Kerala, took the demon of caste and demolished it in good measure. This early democratic spirit of the south has yet to be matched by the north. Individual rights, for man, woman and child are better upheld in the south than in the benighted cowbelt of the north. The difference between them is dramatic.

As I dug into Tamil Nadu's traditions, I understood, that the one entity that binds the web of Tamil life together is the Cauvery, the dakshin Ganga—the southern Ganges. Along with the Ganges, the Cauvery is one of the seven sacred rivers of India. Its name, with that of the six other streams, is on the lips of every devout Hindu who performs the morning prayers to the rising sun.

The Cauvery is born from a spring, at 1220-metre-high Talakaveri, in the Coorg Hills of Karnataka, Tamil Nadu's neighbouring state, where the river runs just over half of its 860-kilometre-length. Then, as the 65-kilometre-long boundary between the two states, it twists and turns, tumbles and thunders through hill and highland, until it falls at Hogenakal. This turbulent stretch of the Cauvery, as the state boundary, is an apt metaphor for the bitter water war between Karnataka and Tamil Nadu. The Cauvery's waters are stopped and stored in the Stanley Reservoir, just below the falls. Below the reservoir, the river's flow slowly slackens, until at Srirangam, it becomes sluggish. Yet, slack or sluggish, there is a storied spirit in the second-half of the river's reach for the sea. Poompuhar, the river's mouth, on the Coromandel Coast, was once a fabled port of call for Arab dhows and Greek and Roman galleons. The oldest literature of India, the Tamil poetry of the Sangam period, dating from the 3rd century BC to the 1st century AD, sings of the big ships of the Yavanas—the Ionian Greeks and Romans—that came calling. Today, Poopuhar is not even a port but a fishing village; and even as the sacred mouth of the southern Ganges, it is a small pilgrimage.

The popular pilgrimages are the storied temples, at Bhawani, below the Stanley Reservoir; at Srirangam the island in the Cauvery; at Kumbhakonam, the temple-town noted for craft and culture; at Chidambaram, the singular temple to Siva, the deity of dance; and at the countless temples that have sprung up along the innumerable arteries of the Cauvery, since the 2nd century AD, when the Grand Anicut Canal was constructed. The big temples, like those at Thanjavur and Gangaikondacholapuram, and the countless small ones, were raised from the deltaic wealth of the Cauvery; the same riverine wealth that powered the unmatched conquests of the Chola kings. In Tamil Nadu empire-building and temple-building went hand-in-hand.

From Chola monarch to modern man, Tamil Nadu's very spirit, through song and story and sculpture, music and poetry and pilgrimage, is resplendent in the life-giving and dynasty-raising river, that waters the sprawling rice-bowl of the south. The Tamil child's first cry, for food, is a cry for the Cauvery's bounty. Through all Tamil life, ancient to modern, the Cauvery is the very song of the soul.

The Cauvery is to Tamil Nadu what the Nile is to Egypt. What the waters of the Nile are to Egypt, the waters of the Cauvery are to Tamil Nadu. What the pyramids—built from the wealth of the Nile—are to Egypt, the temples are to Tamil Nadu. But, while the Nile is the Goliath among rivers, the Cau-

very is the David of them all, because, while the ancient civilization of the Nile is as dead as a mummy, the ancient civilization of the Cauvery continues to be a solid and living entity.

As I followed the Cauvery trail of temple and river and of a thousand-year-old canal system, I understood, after looking at a sea of sculpture—in the little-seen vault at Thiruvarur, in the much-seen museum in Madras, in the well visited Thanjavur Art Gallery, and at the well-known rock, cave and temple sites—that centuries before Donatello and Michaelangelo had touched stone and marble, and centuries before Massacio and Pierro della Francesca had put paint and pigment on wall and paper, Tamil sculptors had arrived at a high sense of humanism in their art. As a result, Tamil humanism is much older than the humanism of the Italian Renaissance. Witness, at Mamallapuram, the mimicking cat, the elephants coming down to water, the bathers by the Ganges, the Gods and animals by the sacred river; and in the nearby caves, the cow being milked and the Goddess Durga triumphant on her tigress. Likewise, in the finest Chola bronzes, for instance in the Thanjavur Art Gallery, witness the humanism in the Siva and Parvati sculptures. While Siva's legs are crossed, he stands, with ease, as Vrishabhavahana, or the Rider of the Bull—the bull against which he was leaning is lost. And look at Parvati! Look at her graceful stance! Behind the calm and composure, behind the finesse of line and form, burns the fire of a fine art. Such a spirit—of calm without and fire within—is also realised through the practised coolness of a contemporary art: Bharata Natyam, the national dance of India, that is totally the art of Tamil Nadu.

On mud or wood floor, through thump and throbbing passion, it flows like the river Cauvery, running through hill and valley, but in human form. A river of story is told through the dancer's sense of mime and musicality, through the movement of her eyes, through the sunlight and shade of her facial expression, as well as through the quest and curve of her fluid figure—that has the rhythm of flowing water. This stream of swift, subtle and sublime movements was crafted for the gods. It is the fruit of century upon century of civilization.

Until this century, Bharata Natyam was performed exclusively by devdasi women, chosen from select castes. The devadasi dancers were bonded to the temples. In a very early twentieth century spirit of democratization, Rukmini Devi Arundale, a young and determined Brahmin woman, cut the cords of caste: against absolute opposition from her high caste family and community, she learned to dance, she learned from the lower caste temple dancers. Then she made the art available to every caste and creed, through Kalakshetra, her dance and music academy, in Madras. Today, in a spirit of democratic humanism, Bharata Natyam is the dance of high and low.

Tamil Nadu's very geography evokes humanism. Witness the curve of the Coromandel Coast. It is sculpted by the sea, as an exquisite human profile. While the coastline from Madras to Mamallapuram forms the forehead, Auroville is the eye and Point Calimere, the tip of the nose, above the protruding tongue—pointed at Sri Lanka—that is Rameswaram and Dhanushkodi. Below the tongue, the land curves into a chin. There, the sculpted lines run out at Kanniyakumari, the land's end of India. It is as if the sea was Tamil Nadu's finest sculptor.

You cannot have such powerful sculpture, such powerful temples and such a powerful tradition of dance and music without the patronage of powerful kings and dynasties. There again, Tamil Nadu is different than any other part

of India. Raja Raja (985-1014 AD) and his son Rajendra I (1022-1044 AD), the greatest of the Chola monarchs, were the only rulers in the entire history of India, to conquer foreign lands—the Maldives and Sri Lanka—and to send expeditions to Java and the Malay Peninsula. To the Aryan north the sea was black and taboo (kala pani), while, to the Tamil south, it awakened the call for conquest.

And within the subcontinent itself, the Chola Empire encompassed all of South India, while expeditions were made as far north as Bengal. After Rajendra had defeated Mahipala, the ruler of Bengal, his army carried vessels full of water on their heads, from the Ganges to Gangai-konda-chola-puram ("City of the Chola Who Captured the Ganges," meaning: Rajendra had conquered land along the river). There, after carrying the sacred water for a distance of over 1,600 kilometres, they emptied the vessels into the "Liquid Pillar of Victory," a lake, sixteen miles long and three miles wide, that is still India's largest manmade lake. Through their feats Rajendra I and his father Raja Raja were visionary monarchs.

But vision and power extol a price. In the case of Raja Raja and Rajendra I, the price was the human scale in architecture. In the powerful and refined temples that father and son built, at Thanjavur and Gangaikondacholapuram, respectively, they abandoned the intimate humanism that an early Chola had arrived at in the Nagesvara temple at Kumbakonam and the Pallava dynasty at Mamallapuram and Kanchipuram. They turned to the architecture of visionary empire-builders. Their grand architectural strategy, itself, was new. Their passion was real. Their architecture is astonishing. Their two noted temples are parallels to the glory that Bernini and the Popes gave to Rome and the Moghuls gave to Agra, Delhi and Lahore. As a result, there is a sacrifice,

the stone sculptures done under the grand patronage of Raja Raja and Rajendra do not match the finesse of those done for their forefather at the Nagesvara temple. However, a later Chola, Rajendra II, briefly restored the sense of humanism to Tamil architecture, when he built the delicate Darasuram temple. But, alas, this return to humanism, in architecture, was a swan song. Its time was over. The Pandyas, at Madurai, emulated Raja Raja and Rajendra Chola and not the early Cholas or the Pallavas. The Madurai monarchs went for the towering temple. Their temple is a grand city by itself.

But, if Madurai does not suggest the human scale, it does suggest a journey through tunnels of time: through the long corridors—busy as beehives—that lead to the innermost sanctum. Until I made my journey to the sanctums of Tamil Nadu, I was oblivious of the achievements of the Cholas, the Pallavas and the Pandyas; in the north, we traditionally looked down on the south.

Having come down from the north, the north that normally snubs the south, I must make a frank comparison: What were the rajas of my native Rajasthan, before Raja Raja and Rajendra I? While the Rajput clans of Rajasthan created a mere culture, the Tamil rulers shaped a solid civilization. While our Rajput rulers, even the greatest of them—Prithviraj Chauhan, Rana Pratap and Jai Singh—ruled over small kingdoms, fighting largely defensive wars or buying peace by bowing to the Moghuls, the Cholas were supreme sovereigns of sweeping empires. Raja Raja's 900,000 soldiers have been called an "ocean-like" army.

So prejudiced is the historical sense of North India, I had never heard of the prowess of the Cholas, in high school and college, in Jaipur and Delhi, respectively. And yet, these southern sovereigns were as mighty as the Grand Moghul. They exchanged emissaries with China, Burma and Malaysia.

For the ancient and medieval rulers of Tamil Nadu, the Western Ghats—the mountainous spine—were not for conquest. The gods and animistic tribes lived there, the rivers rose there and the monsoon broke there. Therefore, with respect for sacred ecology, the mountains were left standing splendidly alone. Then the British arrived. They cut and felled the highland forests, and changed the continuum of the centuries by developing hill stations like Kodaikanal, Kothagiri and Ooty. They could not possess the lowlands completely, but in the virgin terrain of South India's highlands, they took full possession. In their fantasy of home—made nearly perfect by rain, mist, cold, scotch, sherry, cream and scones—they built Christ Church and Lovedale grammar school, the Wellington military college, and homes reminiscent of the domestic architecture from Scotland to Surrey. They built clubs—smoking rooms for men only, and women not permitted in the bar—from where, wearing red coats, mounted on horses, blowing bugles, and accompanied by yelping hounds, they chased the fox and the stag. Their trophies of shikar and sport pack the walls of the clubs, the clubs which are now run by Indian members.

Indians could never inherit the fantasy of the British. Instead, in the Indian way, we adapted rather than rejected the British hill station legacy. Upper and middle class Indians regularly escape from the heat of the plains for the cool and restful green of the Ghats. The horse and the hound and the red coat have, only recently, been done away with. But a tie and jacket continue to be compulsory every evening at the Ooty Club. There, snooker is still played in the very club room and on the very table where the game was invented. Away from the privileged sanctum of the club, in nearby Conoor, Lady Canning's seat, with its breathtaking view, is now for everyone. Exuberant busloads often pack the place. In contrast, the colonial came in ones and twos, and in

small numbers, to seek the solitude of the hills. Today, parts of the hill stations are as busy and as noisy as the bazaars of the plains. India now possesses the hill stations completely.

But the idea of the hill station, that can be retained from the solitude-seeking Briton, is to get away from it all. In the Nilgiris, the Blue Mountains, and other parts of the Western Ghats, I have walked and trekked and motored. On one memorable drive, between clumps of coffee and a patterned landscape of tea—the bushes dipping into valleys and rising on hillsides—I entered the high-range game sanctuary, noted for Tahr, the mountain goat. From there, one can trek down into Kerala. On another delicious drive, to a height of 8,000 feet, I stood on the border of Tamil Nadu and Kerala—in another part of the Western Ghats. Above me, on the crest of a hill, rose a giant white cross. There Tamil Christians working in plantations gather on feast days to offer prayers. Towards the Tamil Nadu plain, jagged cliffs cut through the morning mist that tinted the mountains blue. A stream streaked down a valley, sparkling in the sunlight, like a silver thread.

But Tamil Nadu is more than mountain, river and sea. It is more than temple and sculpture and antiquity. Today, through the machine, it is modern too! Driving north from Tirunelveli, along the Western Ghats—cloud canopied because they were cutting off the south-west monsoon from the Tamil Nadu plain—I saw a windmill power-farm running for miles. It was as if Brancusi and Calder had joined hands to cast hundreds of mobile and mythical white birds. The rotating blades—instead of flapping wings—were fanned by winds that volleyed against the mountain wall of the Ghats, that catch the north-east monsoon. At Hosur, Tamil Nadu's tiny industrial town, instead of windmills, I saw lines of trucks and tractors, computer components

and precision instruments being manufactured. Yet, in the streets, bullock carts jousted for space, with cars, scooters, trucks and buses. In the street, in the home or in the work place, India does not entirely blow away the baggage of the centuries; something of each century is becalmed to become a layer, in the layer upon layer of the palimpsest of life.

But, when an old tradition ropes in the mindless modern, it can shock and stun. One year, in Madurai, I could not photograph the Meenakshi temple because the new coat of paint—in a multiplicity of colour—drove me away. It reflected the painful plasticity of our times. Similarly, the cinema and political hoardings, through their size and colour, violate the senses, until you realise that, the vulgar—uncomfortably so—is an indelible part of life. But, something equally painful has become part of life on the road to Mamallapuram. On that road, amusement parks with names like "Dizzie World" and "Little Folks" have been raised as shoddy imitations of Disneyland. But, at the end of the road, standing before Arjuna's Penance, and taking in the sculpture of the cat mimicking Arjuna in penance, to fool the mice—the mice naively crawling at the cat's feet—I realised that the original Tom and Jerry story was immortalised at Mamallapuram, in the 8th century AD. There, the sculptor has suggested the essential narrative of the story and left us to imagine the end where the cat jumps on the mice at her feet. These animal fables of ancient India, travelled the trade routes, through the Arabs, and influenced Aesop. In coming back to Mamallapuram, through imitations of Walt Disney, they describe a full but sorry circle. A special relationship between the human and animal world distinguishes the classic life of India, as it does nowhere else in the world.

The special relationship between the human and the animal world is one of the distinguishing features of the fiction of R.K. Narayan. R.K. Narayan was born in Madras. When I first visited Madras, I suffered, not a sense of shock, but a deep sense of displacement, because, in the matter and manner of life, and in its geography of mountain, river and sea, Tamil Nadu is dramatically different than the North India that was a part of my blood and bones. It took time for me to attain an ease of mind, and it took time to achieve a familiarity of feeling with what were, at first, startling sights and sounds—Tamil itself is so different than Hindi. While Hinduism provides the broad bonding of north and south, the religious iconography of the south is very different, and I had to work to get to it. Finally, to get into Tamil Nadu life, I found on rereading some of the Narayan novels, and his autobiography, a gentle guide in prose. In time, I realised that the humanism of the Narayan novels is a modern mould for the classical humanism of Tamil Nadu. It is as if the monkey, the peacock and the tiger had been transported to a new terrain: from stories in sculpture to stories in prose.

In *My Days*, his autobiography, R.K. Narayan takes a poignant look at Purasawalkam, the Madras neighbourhood, where he was born and lived his childhood years. In Narayan's sixteenth year, his uncle took him to live in Mysore, in neighbouring Karnataka state, because Narayan's father had died early on. According to Susan Ram and N.Ram, Narayan's biographers, the noted novelist's fictional world of Malgudi is a melange of Mysore, Purasawalkam and Coimbatore—Tamil Nadu's big industrial city, where Narayan, a widower, spent much time with his daughter and her husband. Susan Ram pointed me towards Purasawalkam. I went there again and again, until I could feel the pulse of the place, until I had entered ordinary lives. But, I could not have done this without a thorough reading of

Narayan's novels. Some of the people I met there were the very flesh of his fiction.

I met a man, Srinivas Rao, the son of a diamond cutter. He is a printer of books. Rao and R.K. Narayan were both born in Vellala street, Purasawalkam. While Narayan moved away, Rao stayed on, in the house where he was born. When Rao worked at the Jupiter Press, in Madras, he had proudly supervised the printing of two Narayan novels: *Swami and Friends* and *Malgudi Days*. Now, Rao prints at home, on the ground floor, while he lives on the first floor.

Rao is small and frail. He is soft-spoken and self-effacing. He parts his grey hair in the middle. He is brown-skinned and square-faced. On his big nose rest a pair of spectacles. Their thick lenses obscure his eyes. But his face is expressive. These days sadness lines his face. Wearing his ubiquitous white vest and dhoti, he sat on a wood chair, next to the Amritsar-made, prewar model, handfed letterpress printing machine. There, he told me about his later life.

As he neared retirement, Rao was anticipating the pleasure of living out the evening of his life at the quiet ashram retreat of Sri Bhagwan Ramana Maharishi, at Tiruvannamalai. He had trained his son to take over the printing press. But fate willed otherwise. His only son died in a motorcycle accident. Rao—in spite of his age—had to stay on in Purasawalkam, working the printing press, caring for his infant grandson and daughter-in-law. Rao has turned 80 now, and his health is failing. Until that happened he sometimes broke away from the press, to make the short pilgrimage to the Ramana Maharishi ashram, below sacred Arunachala. "Now," Rao exclaims, with a sigh, "the doctor has forbidden me to travel! This year, I will not be able to attend the birth-centenary celebrations of Bhagwan!"

Over the revered Arunachala hill, the French master of the miniature camera, Henri Cartier-Bresson saw this sight: "One night, at exactly 8.47 p.m., we saw a huge ball of fire slowly cross the sky... At that precise moment the Bhagwan breathed his last." Cartier-Bresson had visited the ashram in 1950, on assignment for *LIFE* magazine, to photograph the last days of the man who was universally regarded as a saint. One of the memorable photographs he took, in Tiruvannamalai, shows a retired Public Works Department official, by a tree and before a water tank, with a small gathering of men, women and children—and goats by the water. The retired official is bearded, bare bodied and sports a loincloth. For ten years, he had lived in a cave on Arunachala hill. If fate had allowed Rao to retire to Tiruvannamali, he would not have reduced himself to similar abstinence. He would have relished the regular life of the ashram. He would have meditated in the silence of the sacred hill. Now the ashram and the hill are a memory to Rao. He is unlikely to visit there again. He will live out his last days, where he was born, in Purasawalkam, Madras.

Arunachala hill, the Western Ghats, the Coromandel Coast, the Cauvery, Poompuhar port, Gingee fort, Fort St.George, Madras town, the temple towns, the industrial towns, the neighbourhoods like Purasawalkam, the windmills and the villages by palm and paddy, and an infinite number of other items make up the multilayered and human world of Tamil Nadu. When I first went there, I was uncomfortable. Then, after much hard work, the sights, the sounds and the silences became comfortably captivating. What, at first had seemed remote and distant transformed itself into the intimacy of ordinary human lives. For four years Tamil Nadu has held my camera-eye captive.

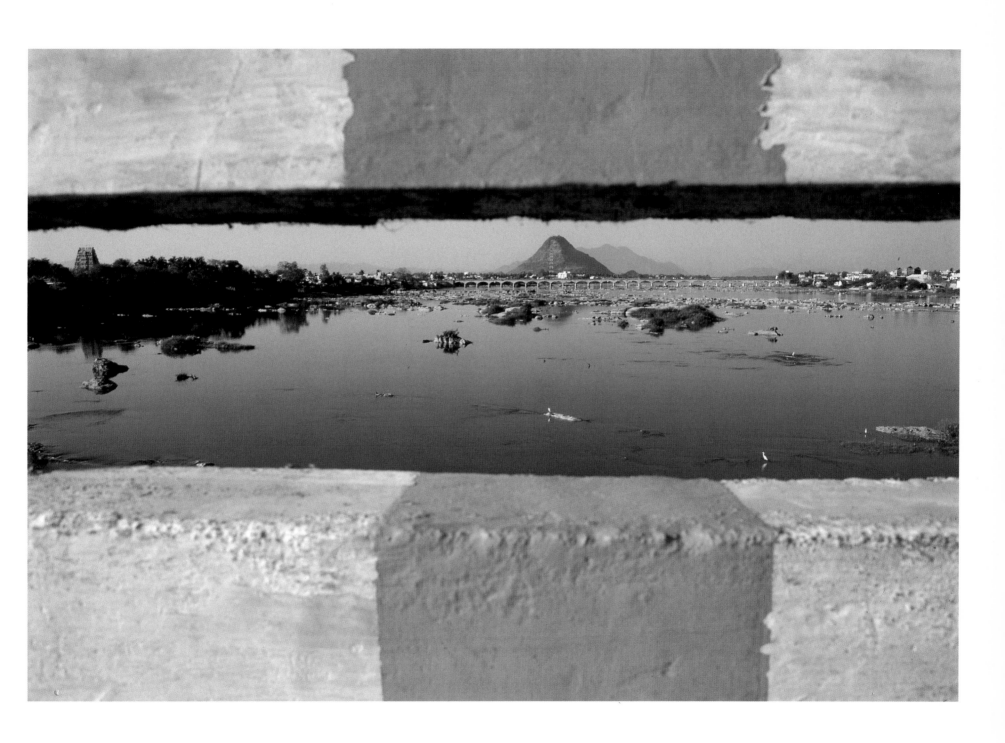

Cauvery river from a bridge, Bhawani.

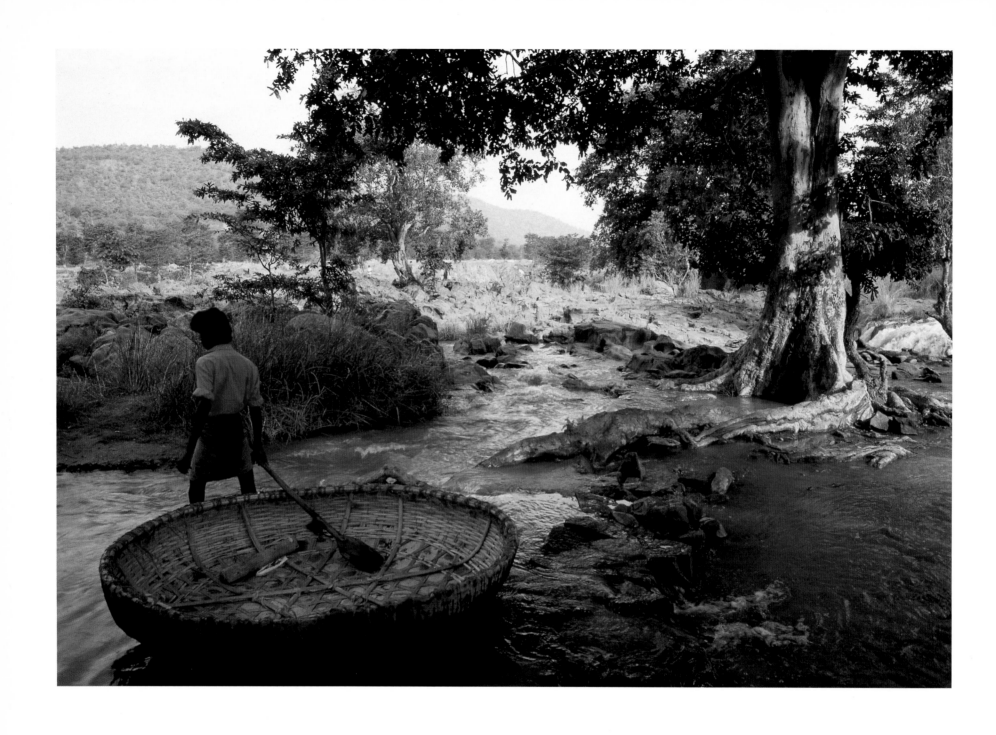

A man and his coracle-taxi, Cauvery river, Hogenakal.

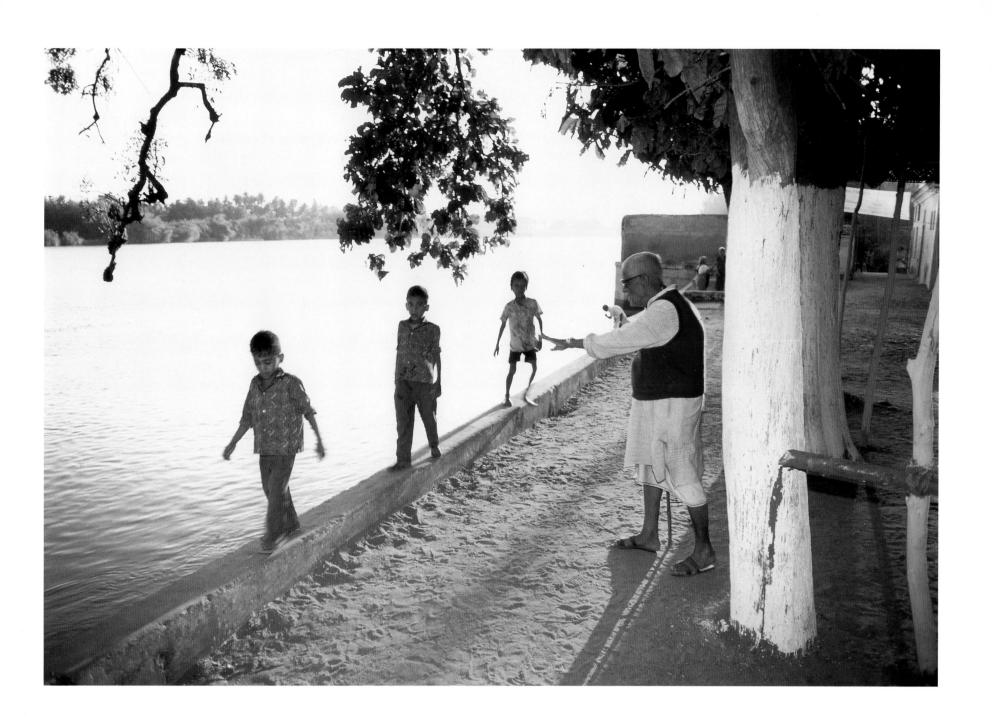

Boys and pilgrim by the Cauvery river, Thiruvaiyaru.

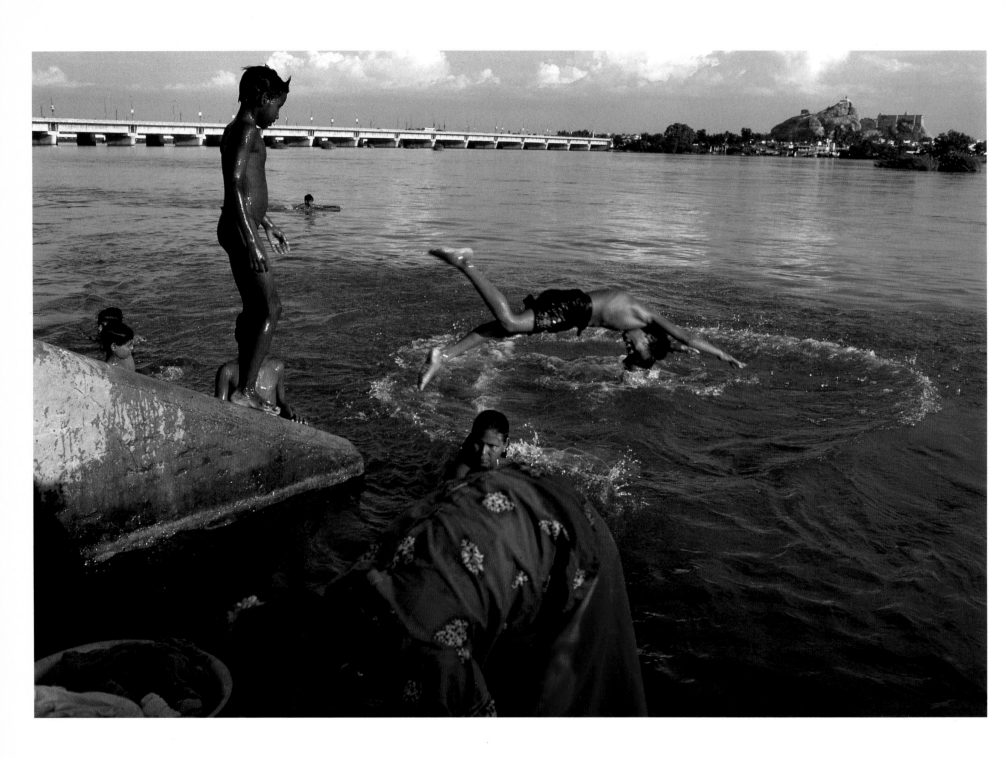

Swimmers, Cauvery river, Srirangam.

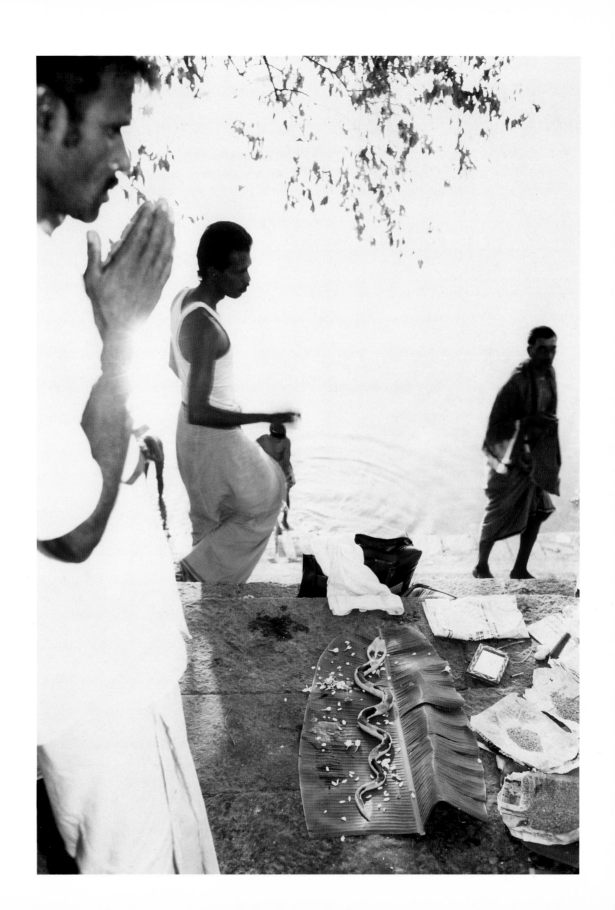

Worshippers and clay-cobra, Cauvery river, Bhawani.

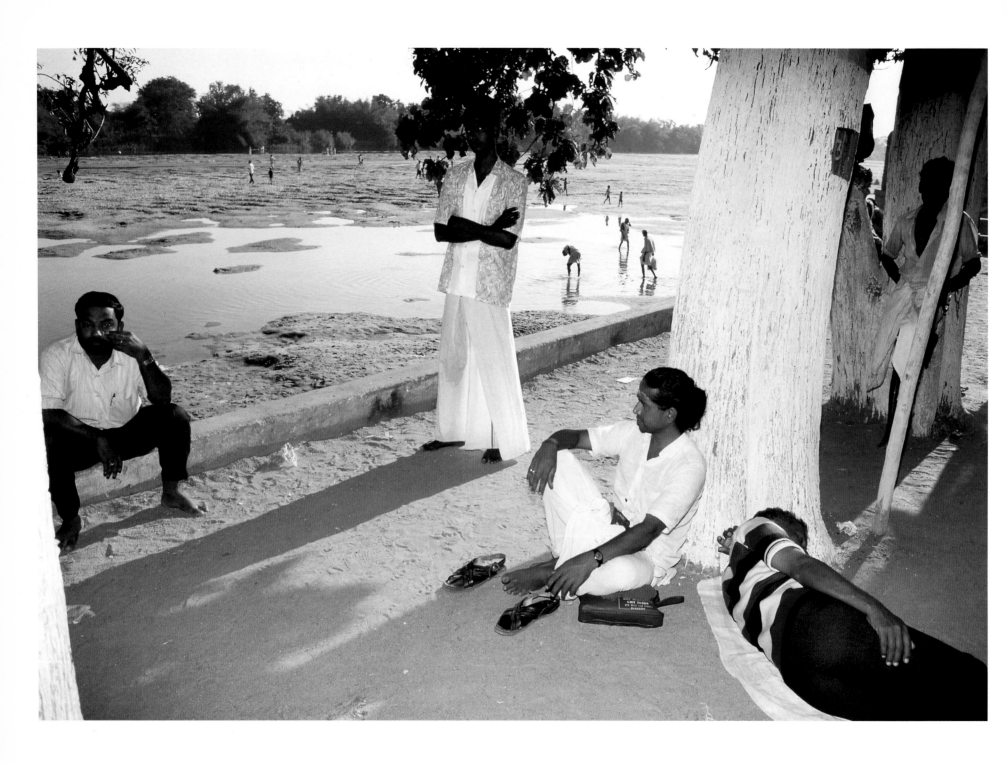

Music festival audience by the Cauvery river, Thiruvaiyaru.

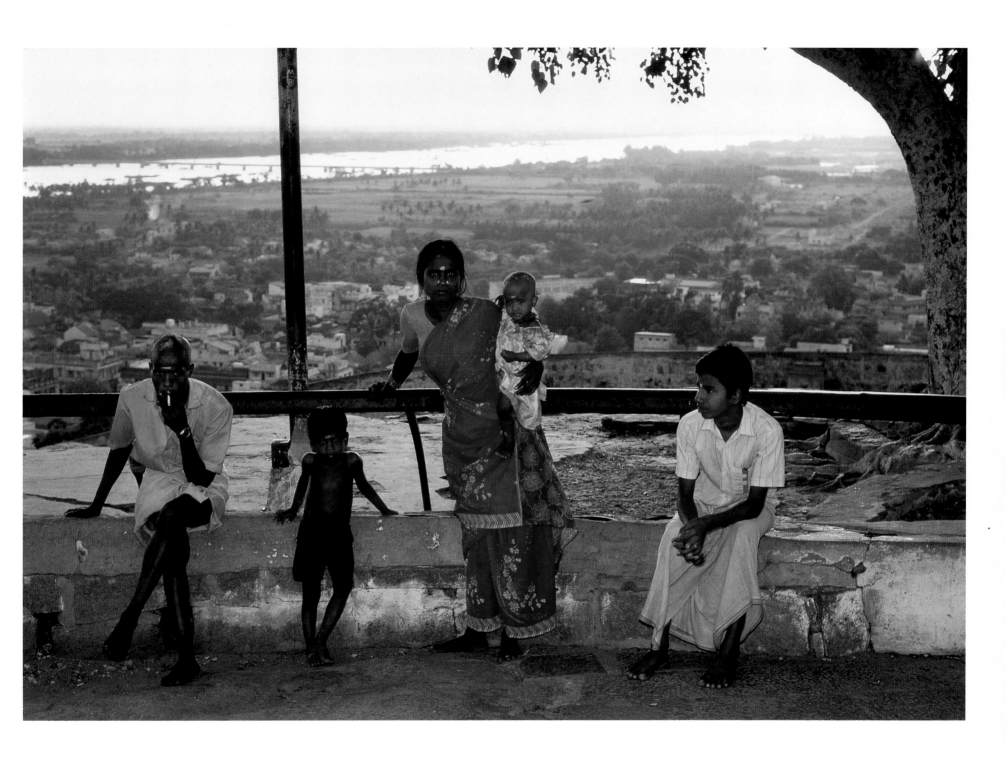

Pilgrims on Trichy Hill, overlooking the Cauvery river.

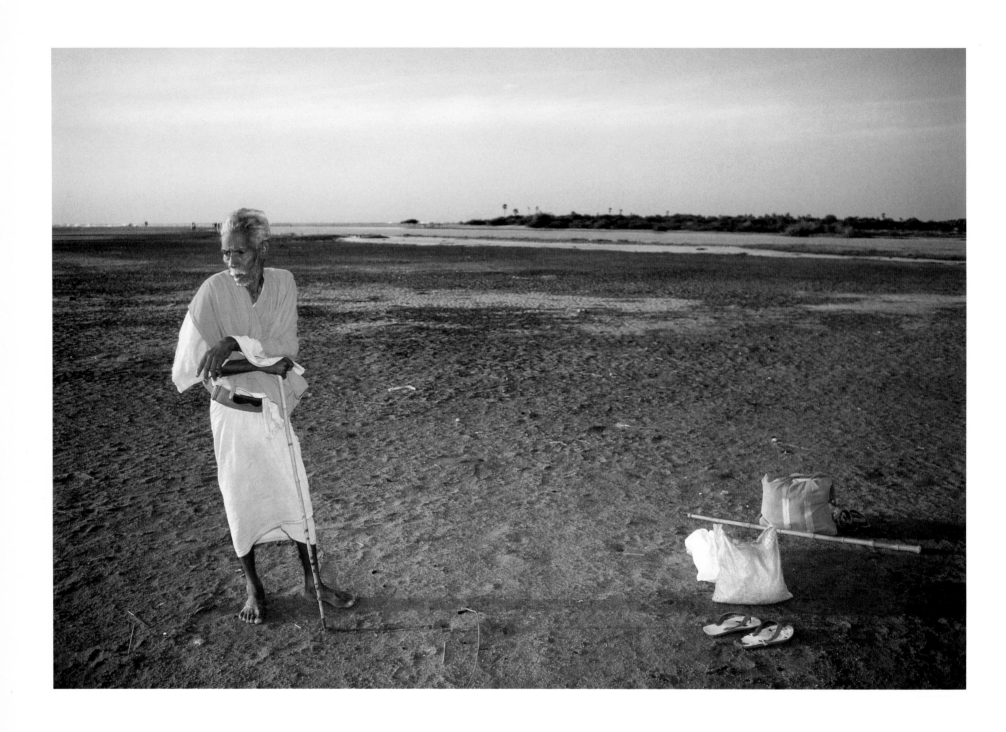

Pilgrim at Poompuhar, mouth of the Cauvery river.

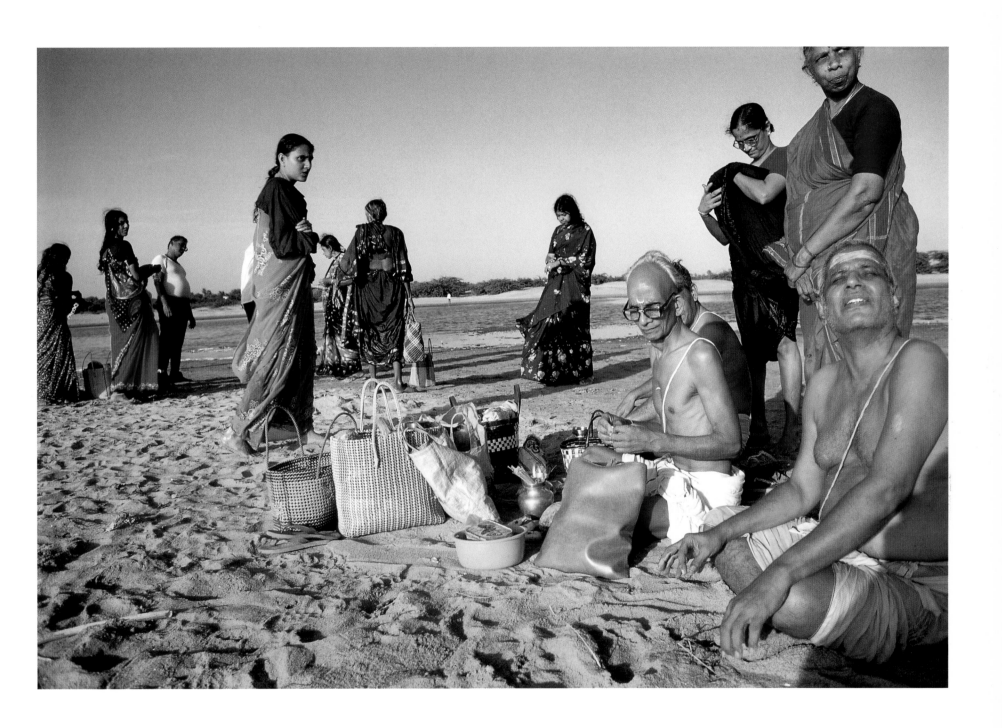

Brahmins doing rituals, Poompuhar.

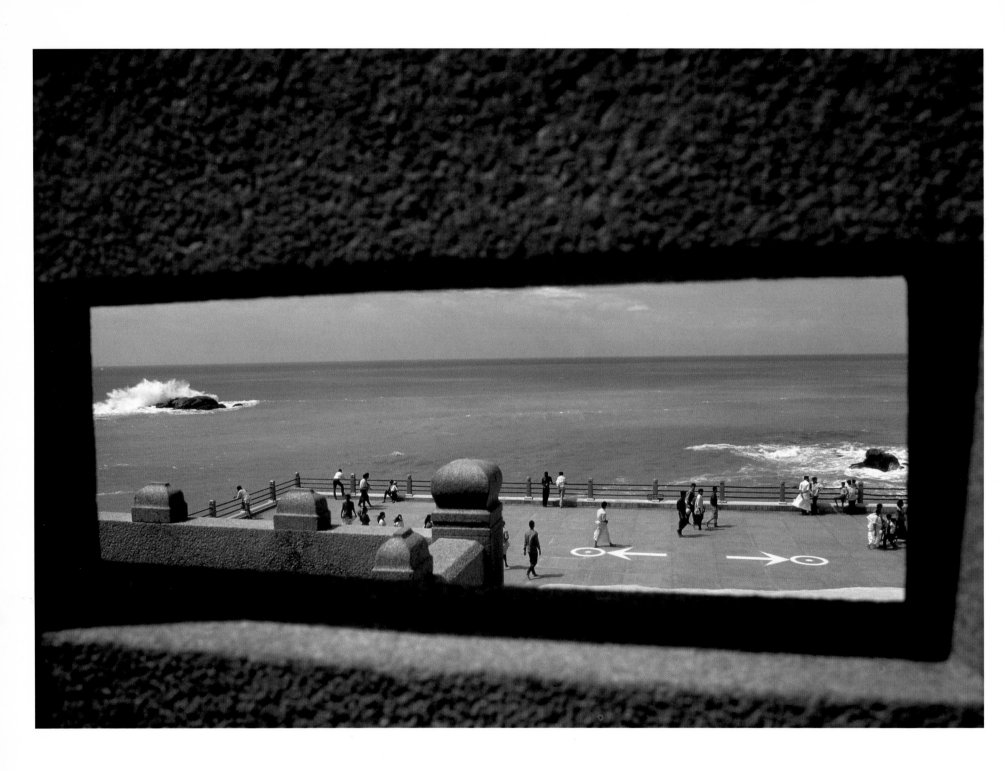

Visitors on Vivekananda Rock, Kanniyakumari.

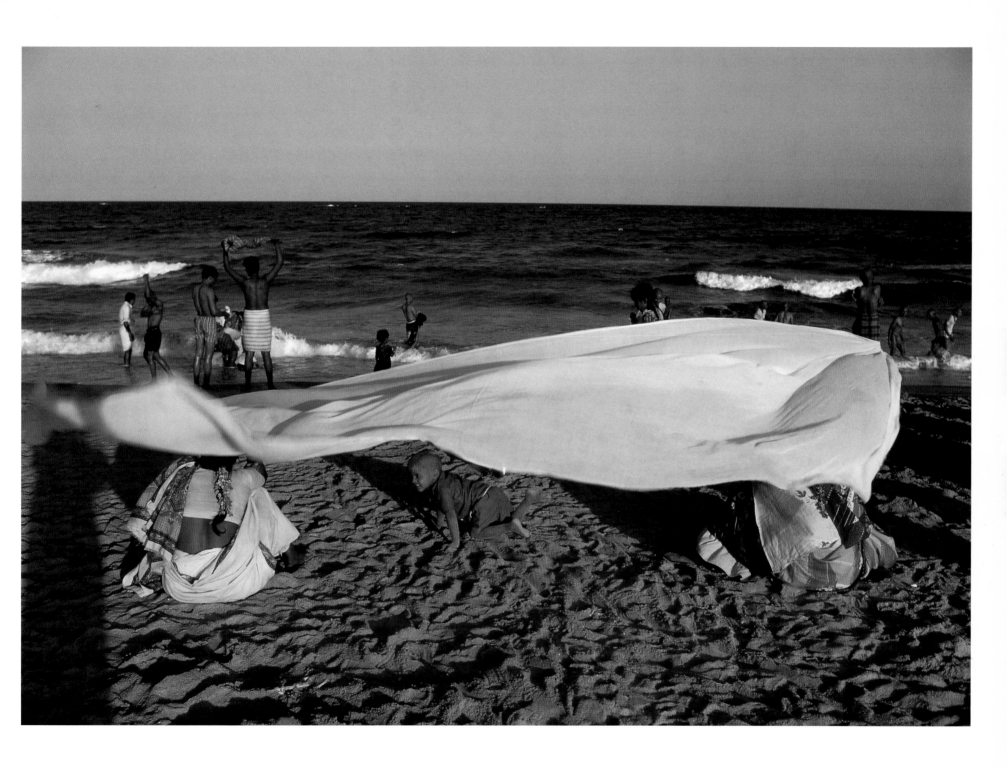

Bathers, Mamallapuram.

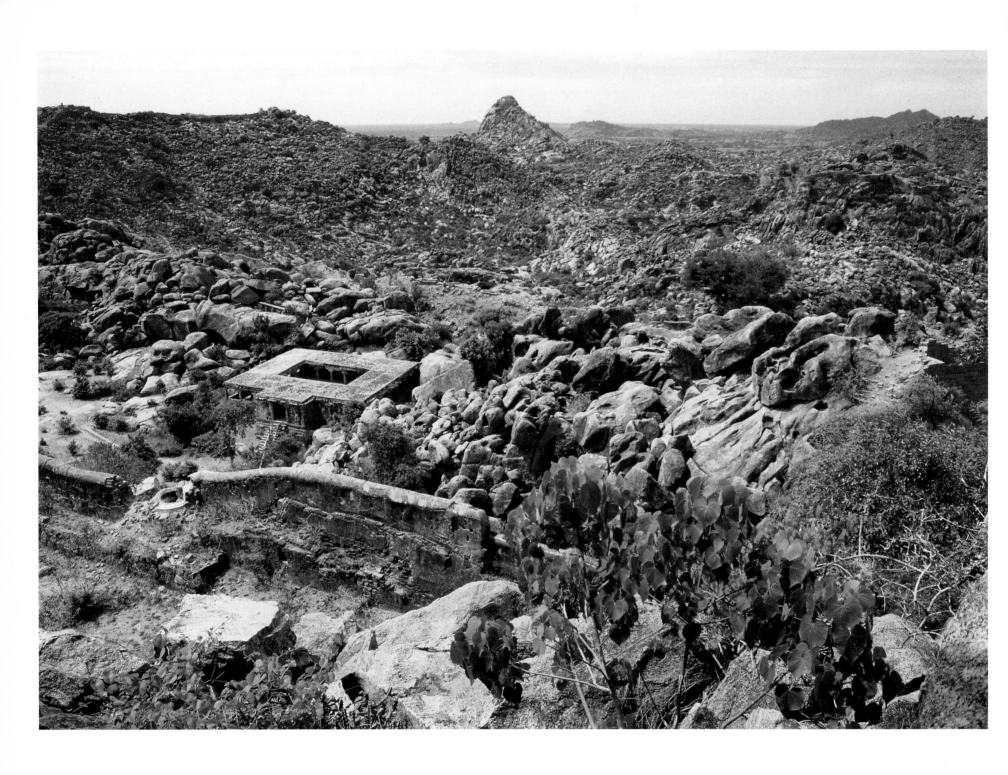

Rajagiri side of Gingee or Senji Fort.

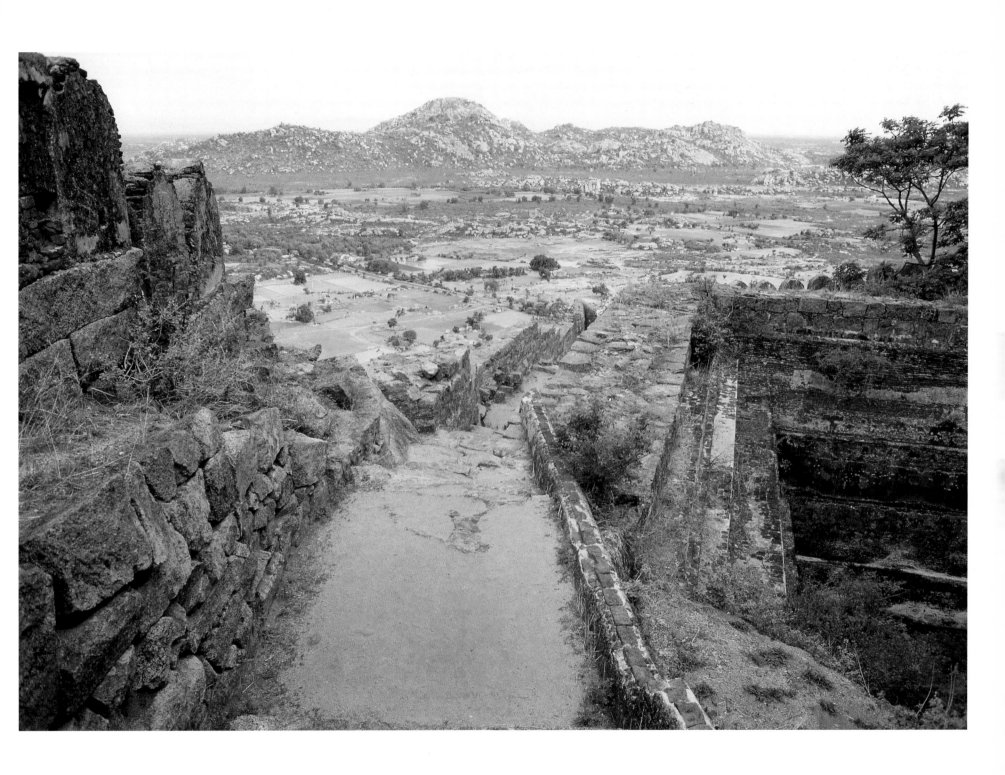

View from Rajagiri, Gingee or Senji Fort.

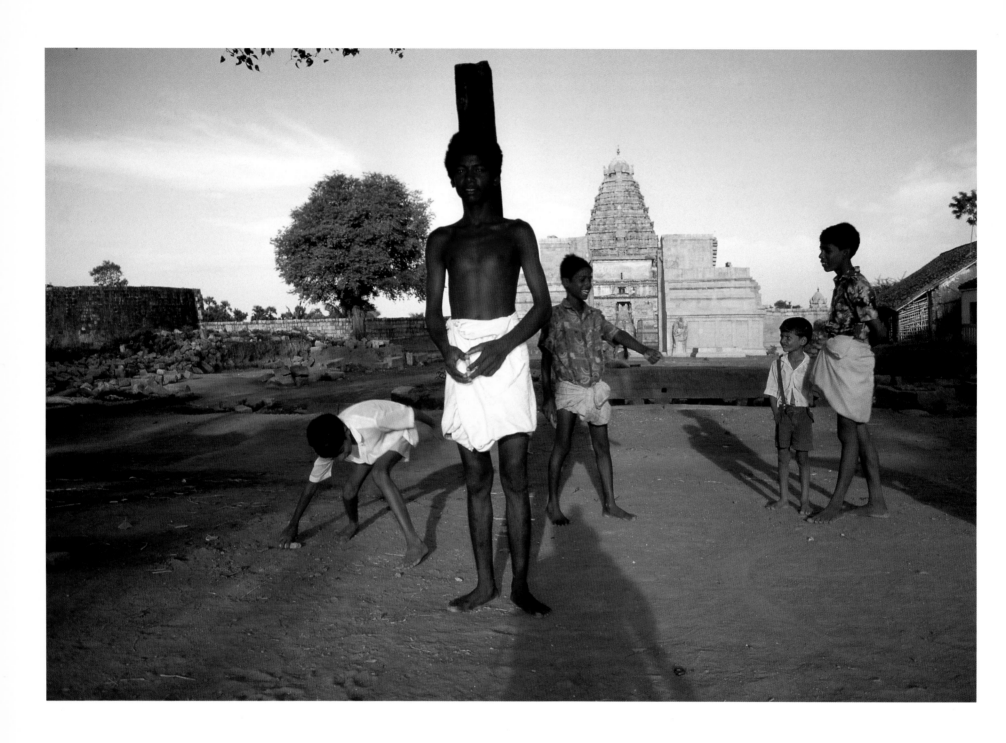

Schoolboys at play, Gangaikondacholapuram.

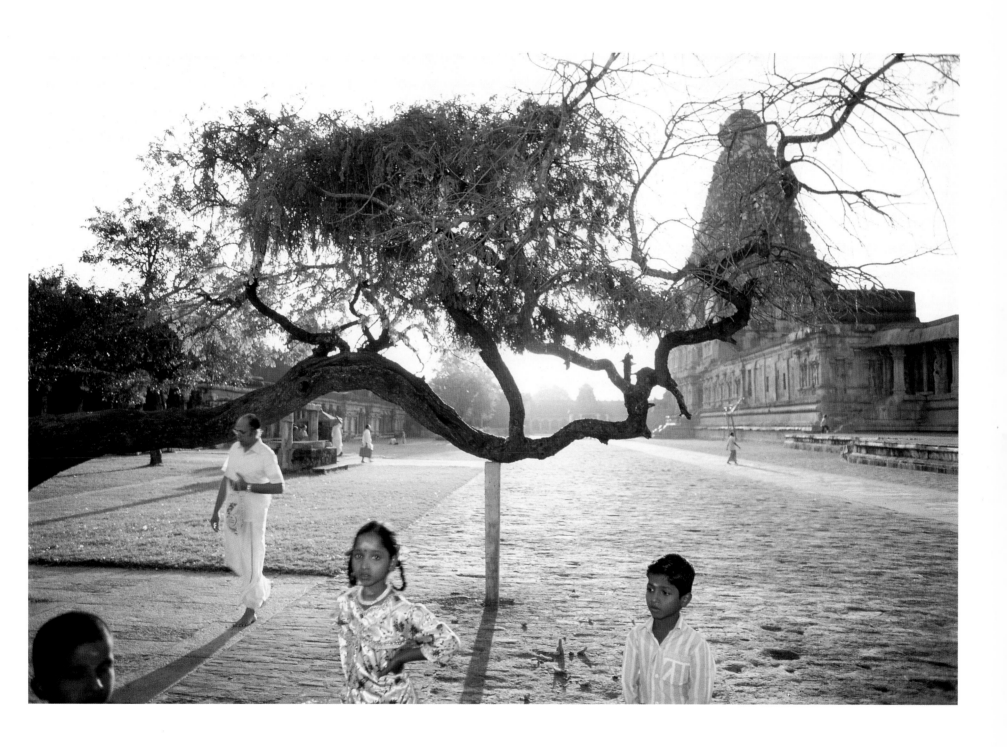

Brihadisvara Temple, Thanjavur.

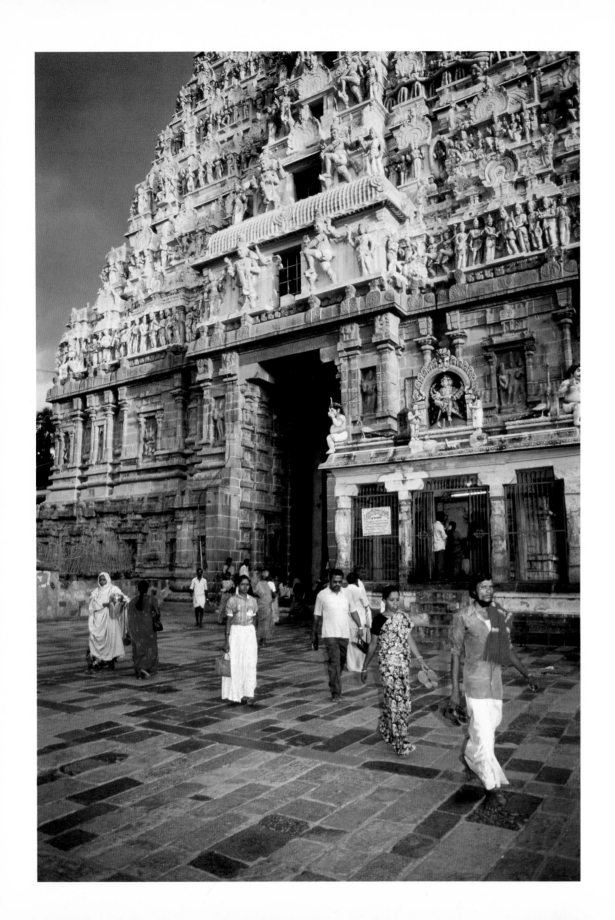

Worshippers and visitors, Chidambaram Temple.

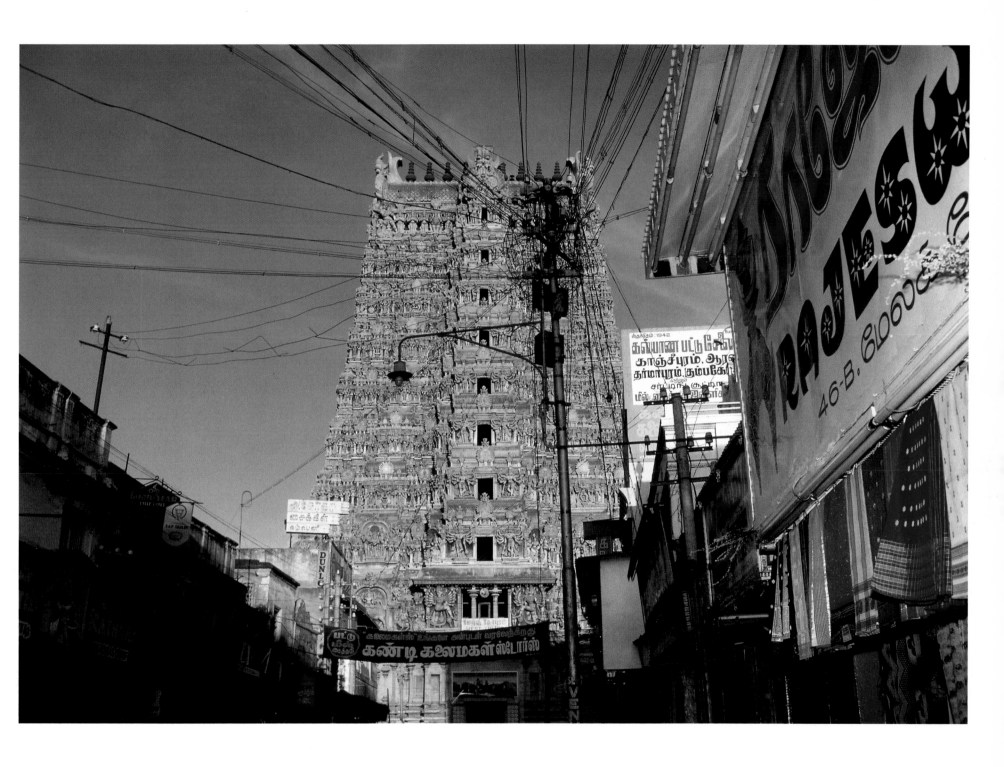

Western gopuram or tower, Minakshi Temple, Madurai.

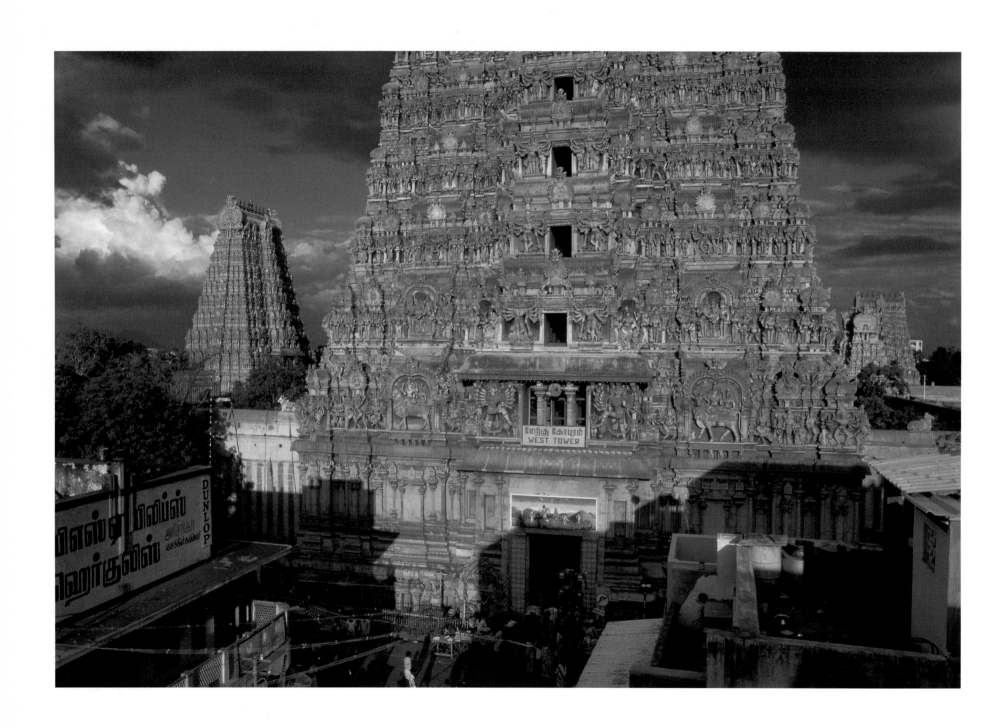

Minakshi Temple, Madurai.

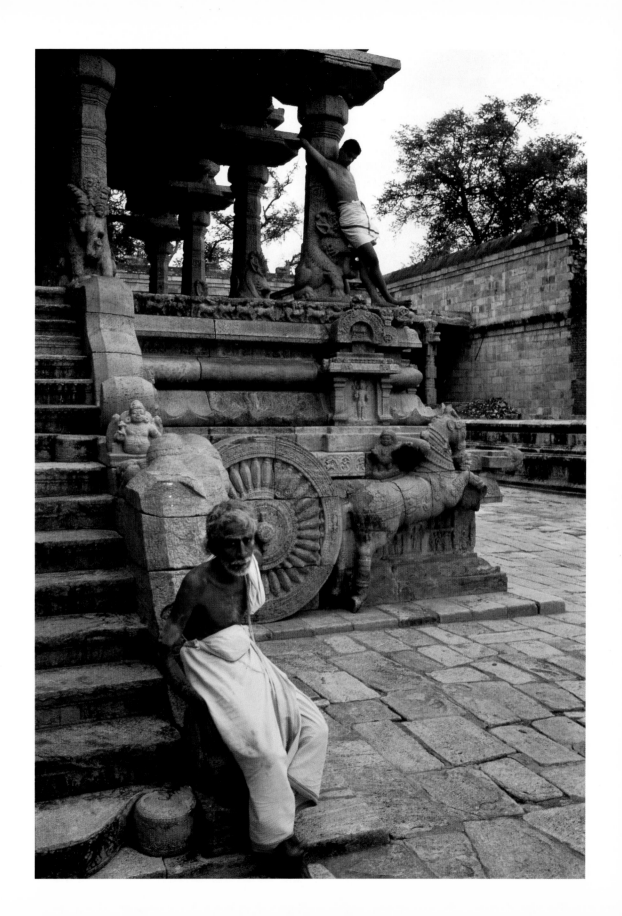

Retired civil servant, now a guide, Darasuram Temple.

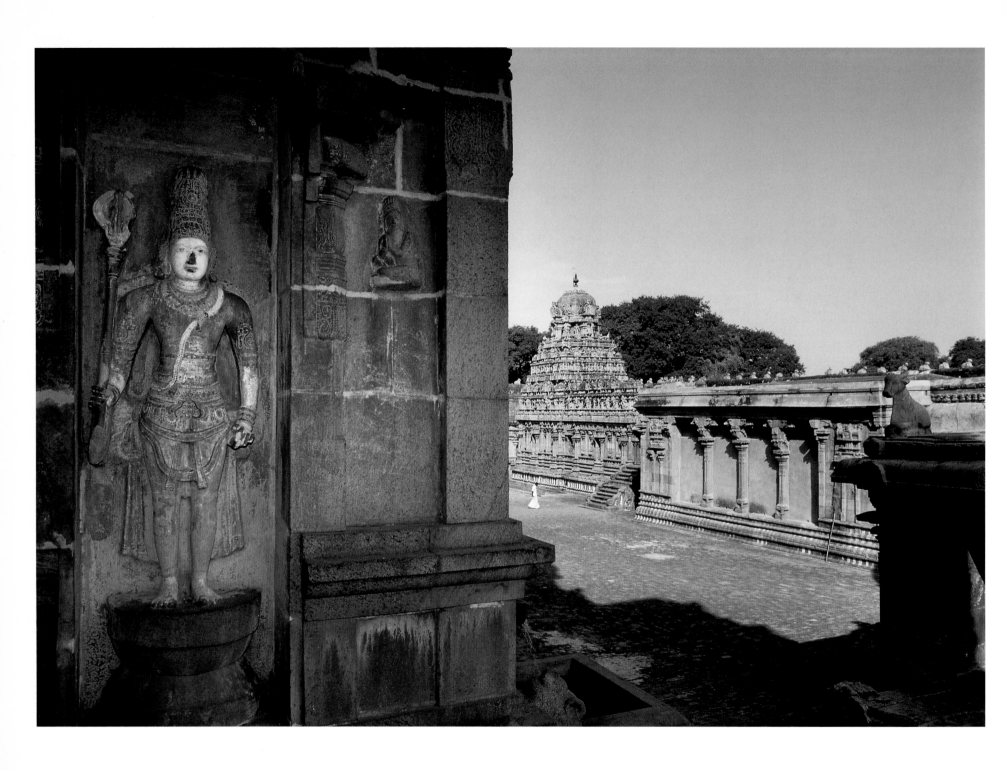

Guardian figure, Brihadisvara Temple, Thanjavur.

36

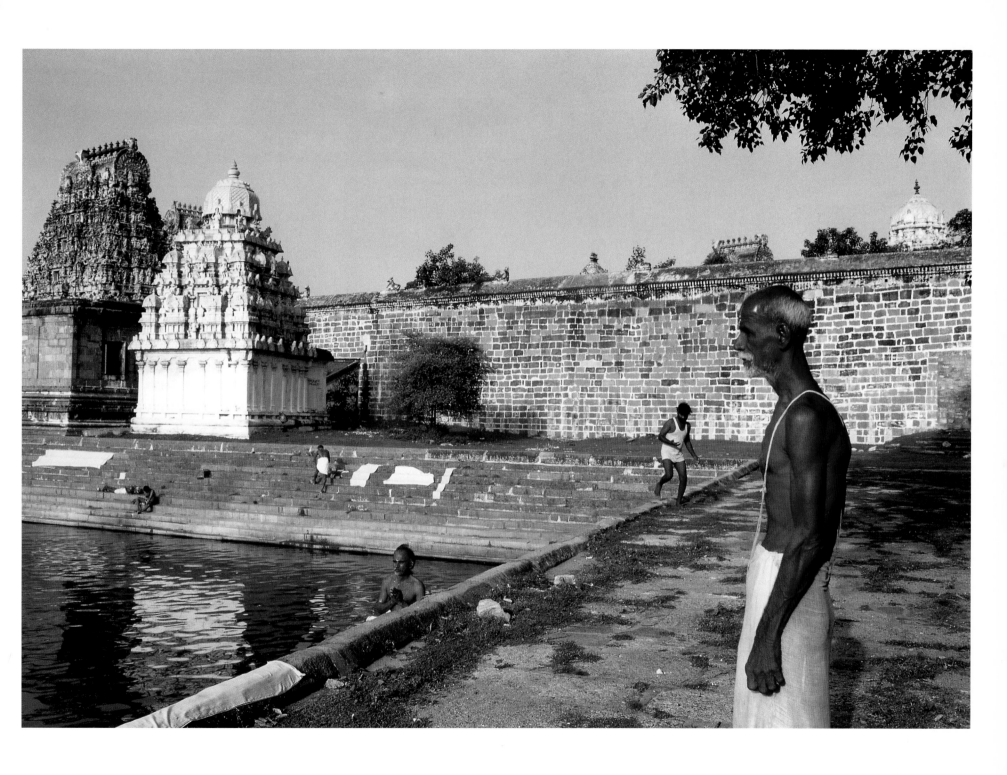

Bathers, Ekambaresvara Temple tank, Kanchipuram.

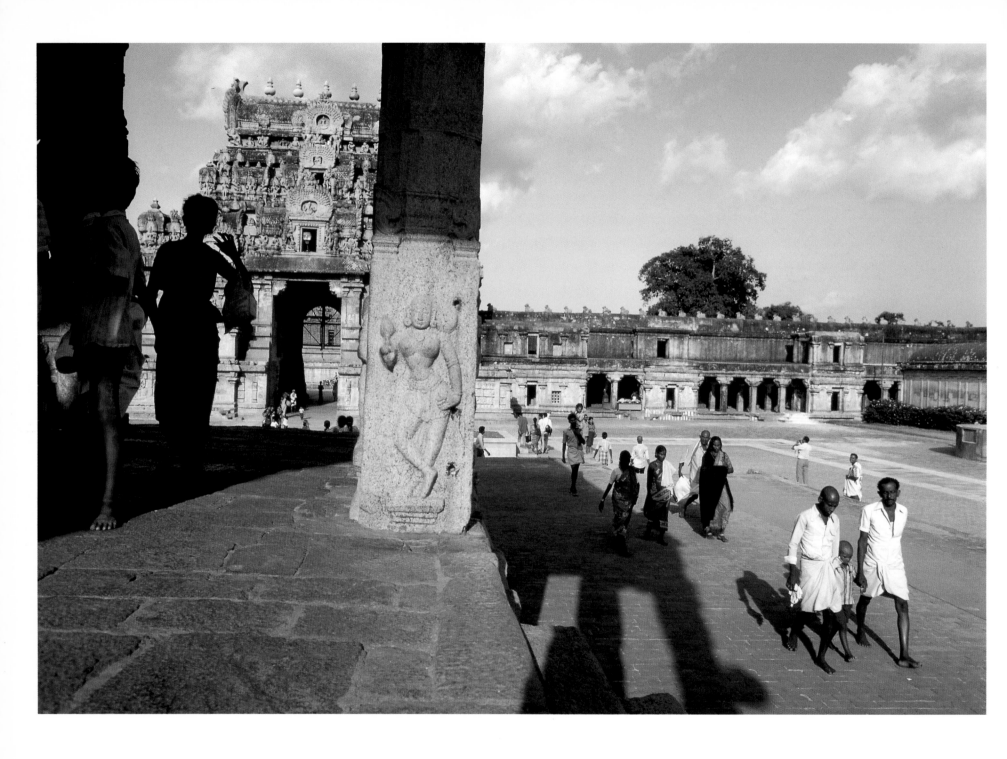

Courtyard and gateway, Brihadisvara Temple, Thanjavur.

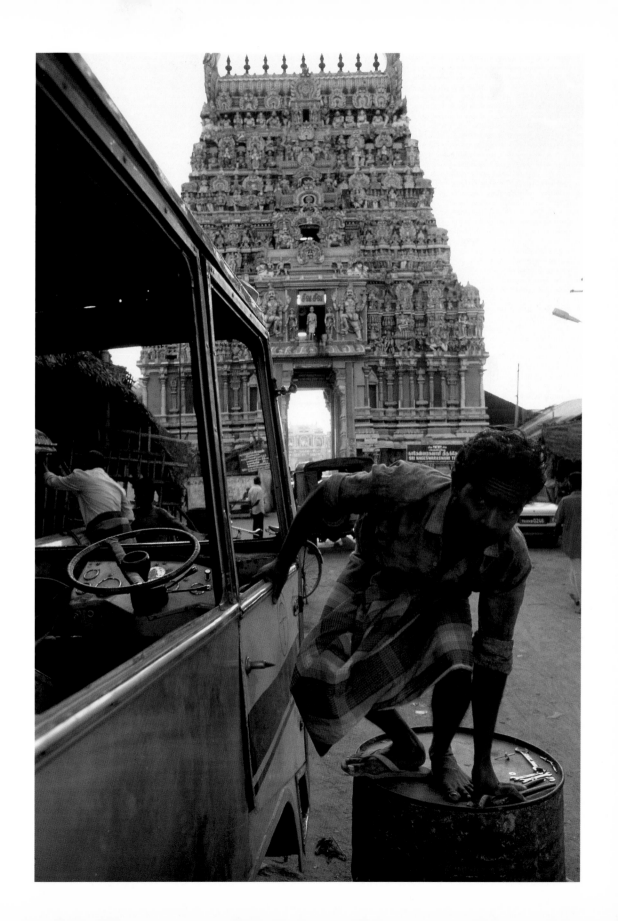

A mechanic, Ramaswami Temple, Kumbakonam.

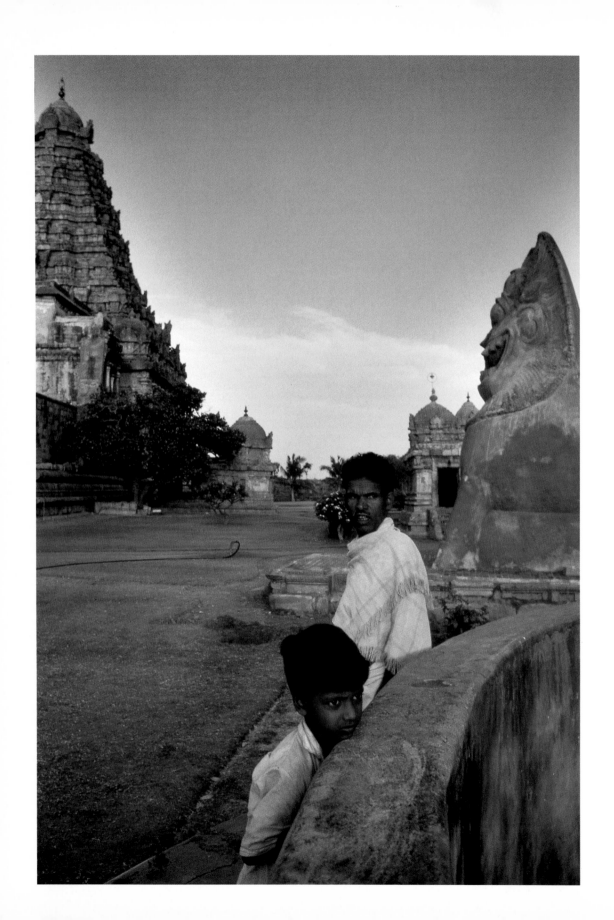

Pilgrims, the Lions's Well (right), Gangaikondacholapuram.

40

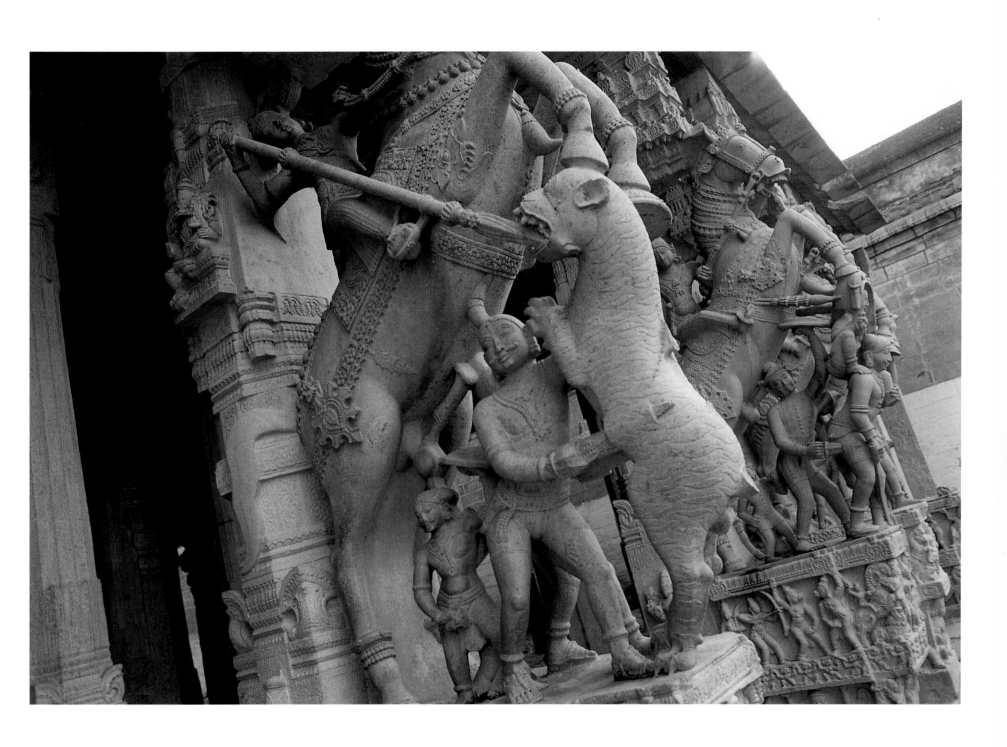

Columns, Hall of Thousand Pillars, Srirangam.

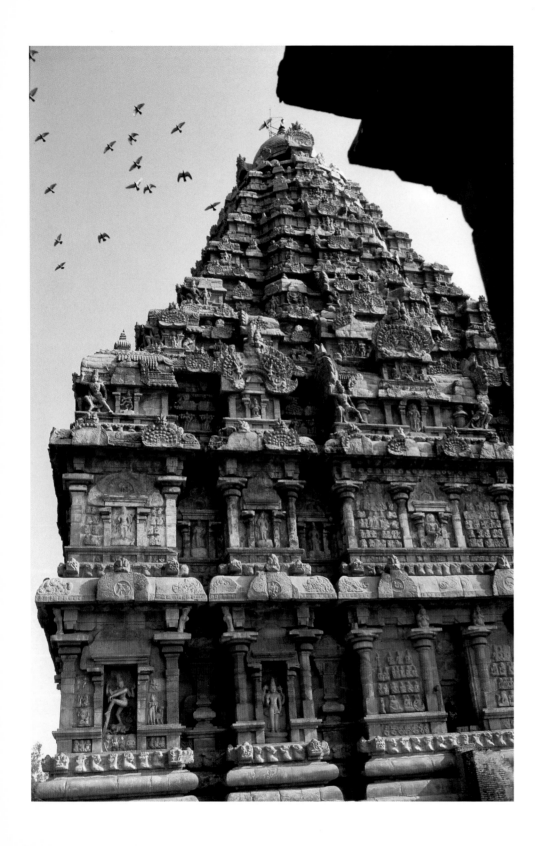

The Gangaikondacholapuram Temple.

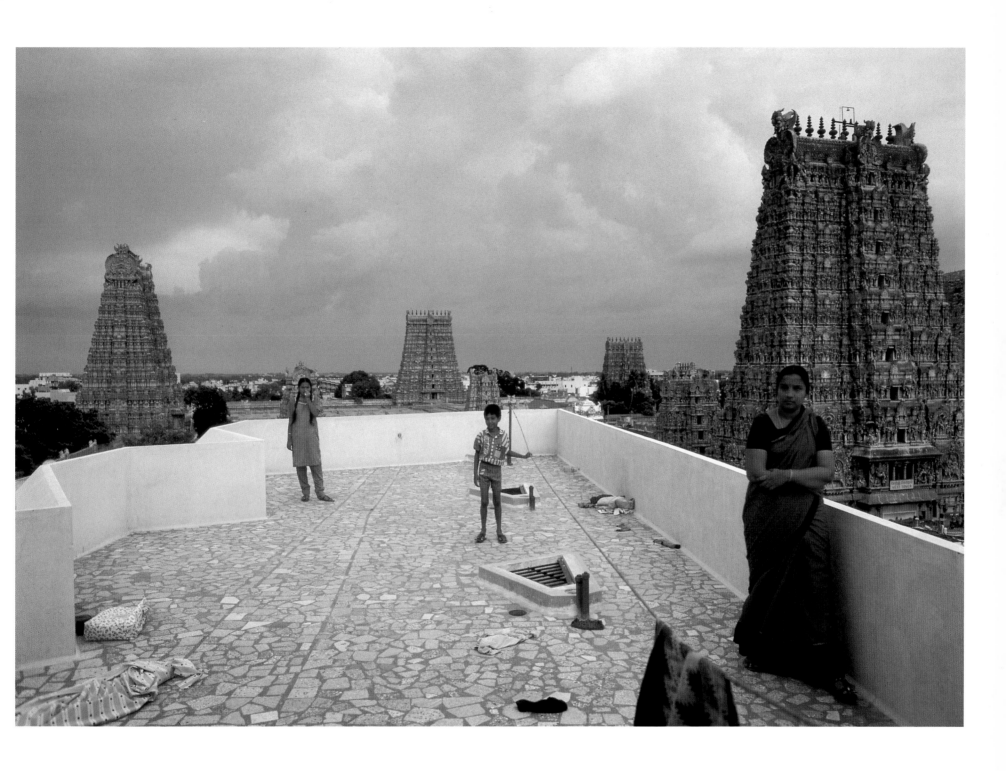

Visitors on rooftop. Background: Madurai Temple.

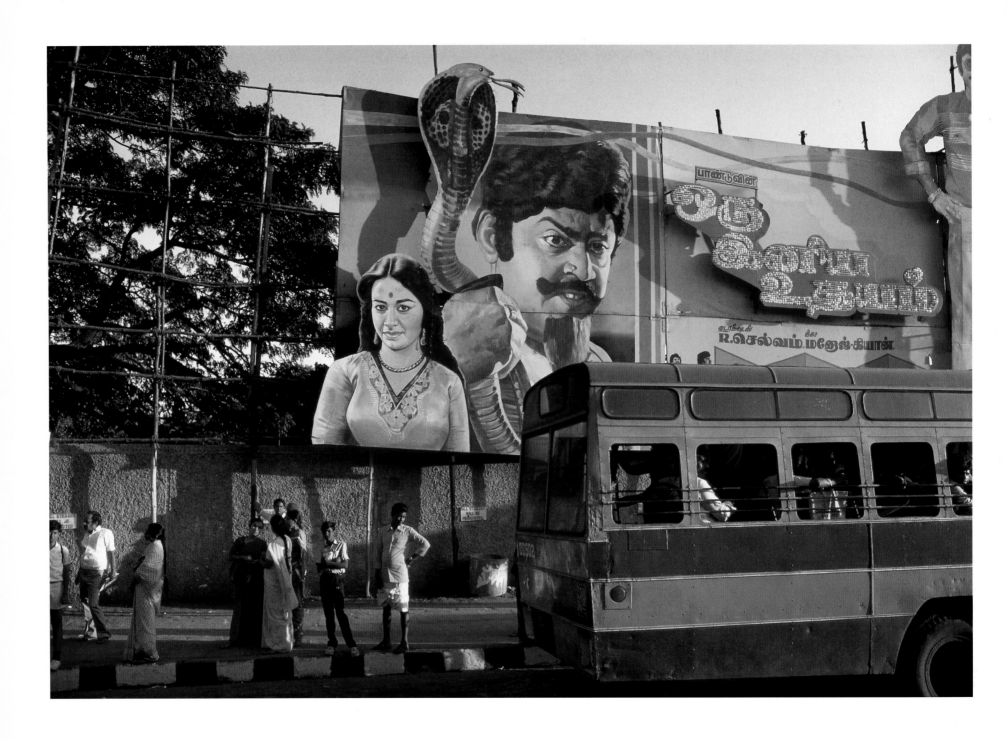

Bus commuters and cinema hoarding, Madras.

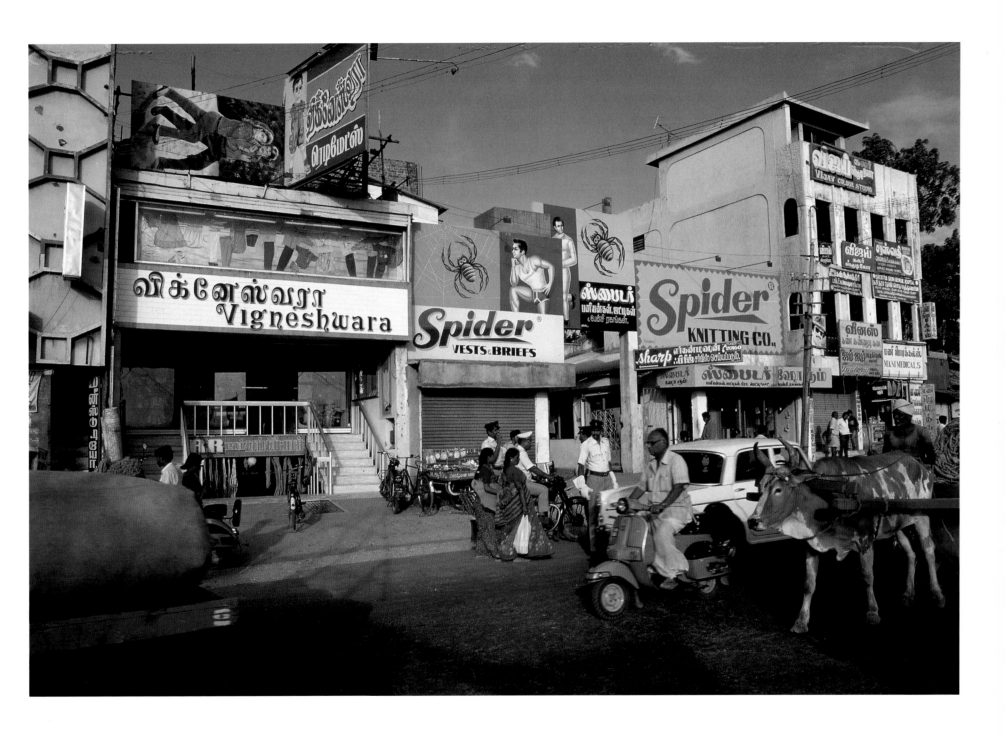

Hoseiry shops, Tiruppur.

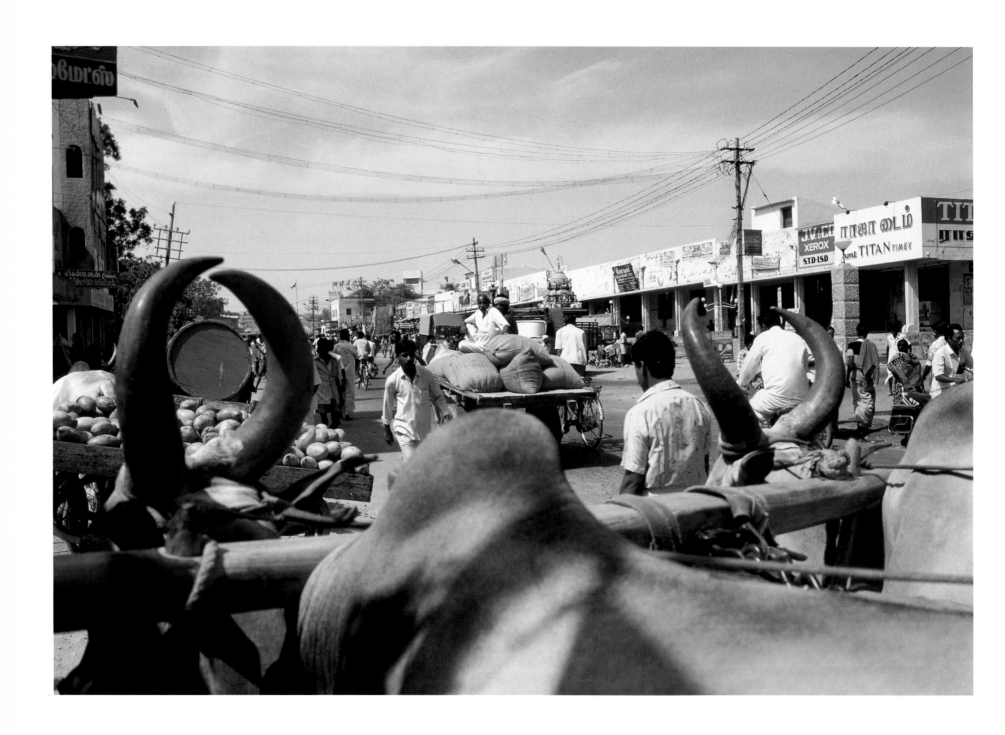

Bullock carts, Tiruppur.

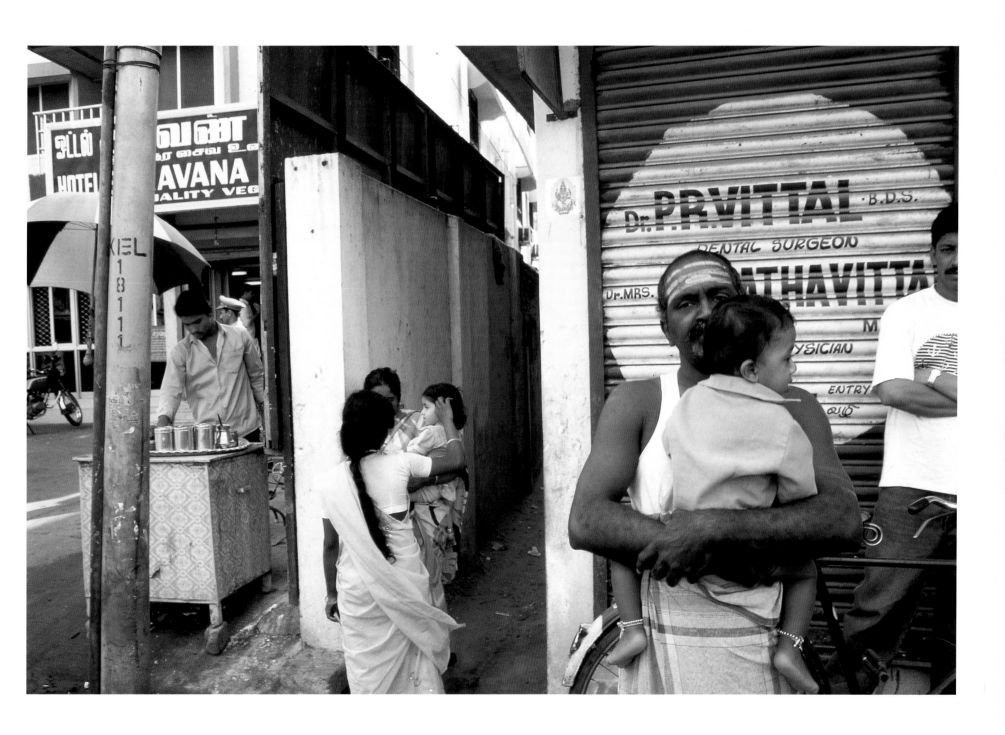

Purasawalkam neighbourhood people, Vellala street, Madras.

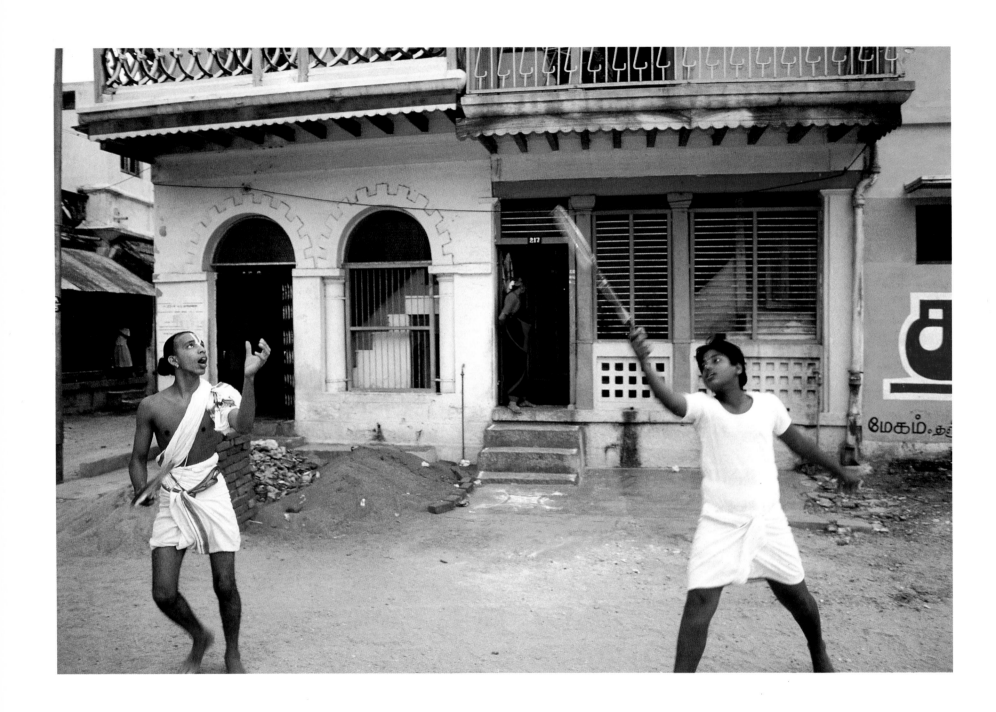

Badminton players, Srirangam.

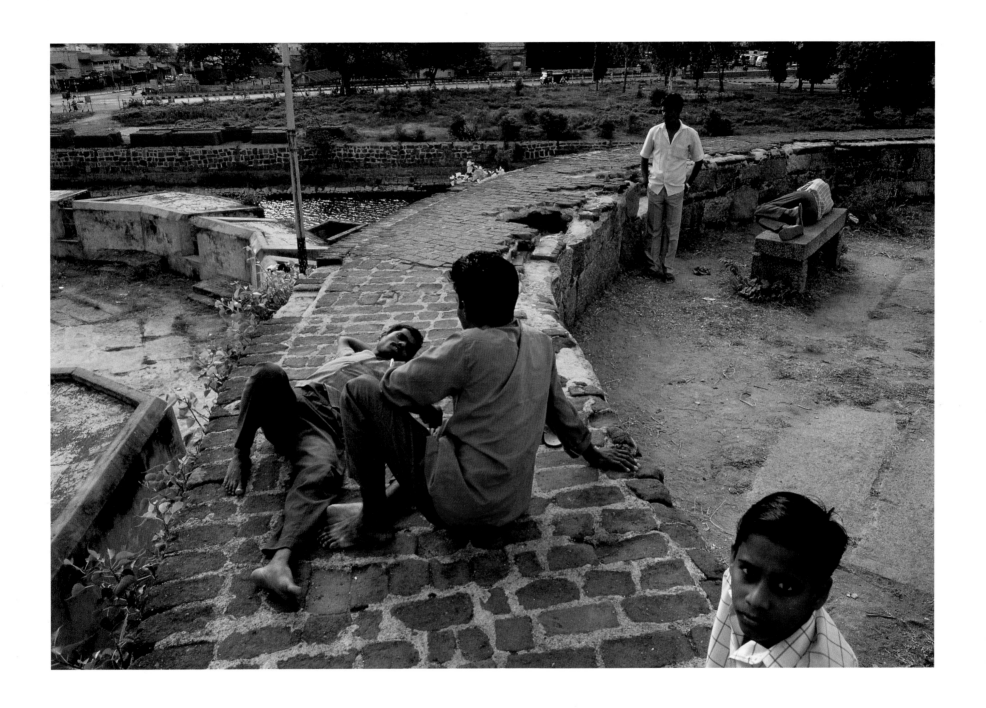

On Vellore Fort

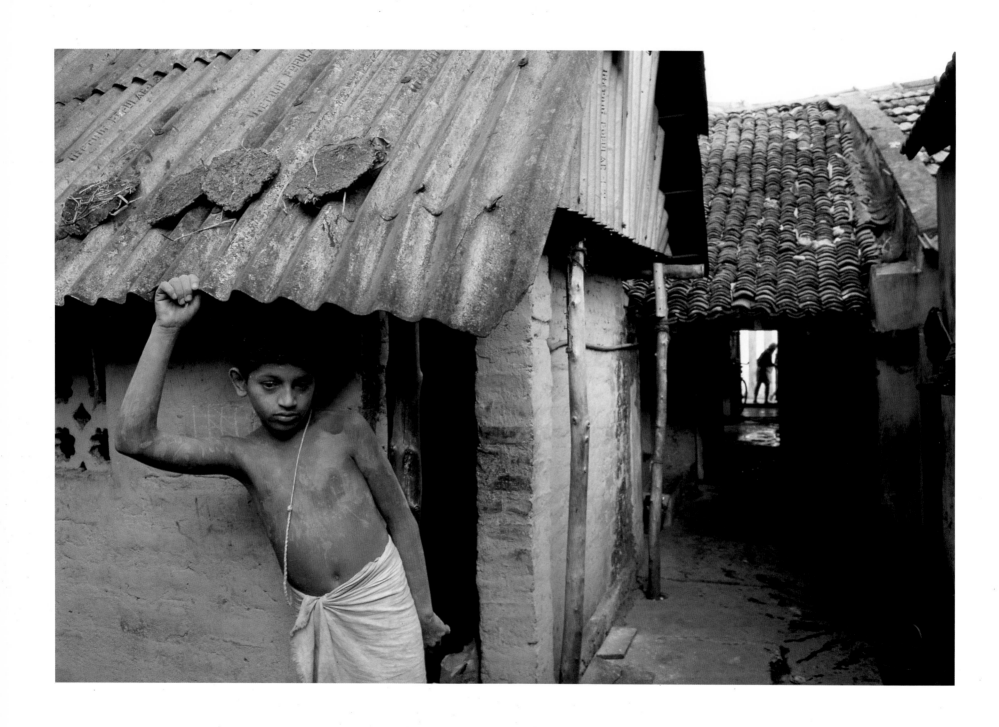

A boy coated in sacred ash, Purasawalkam, Madras

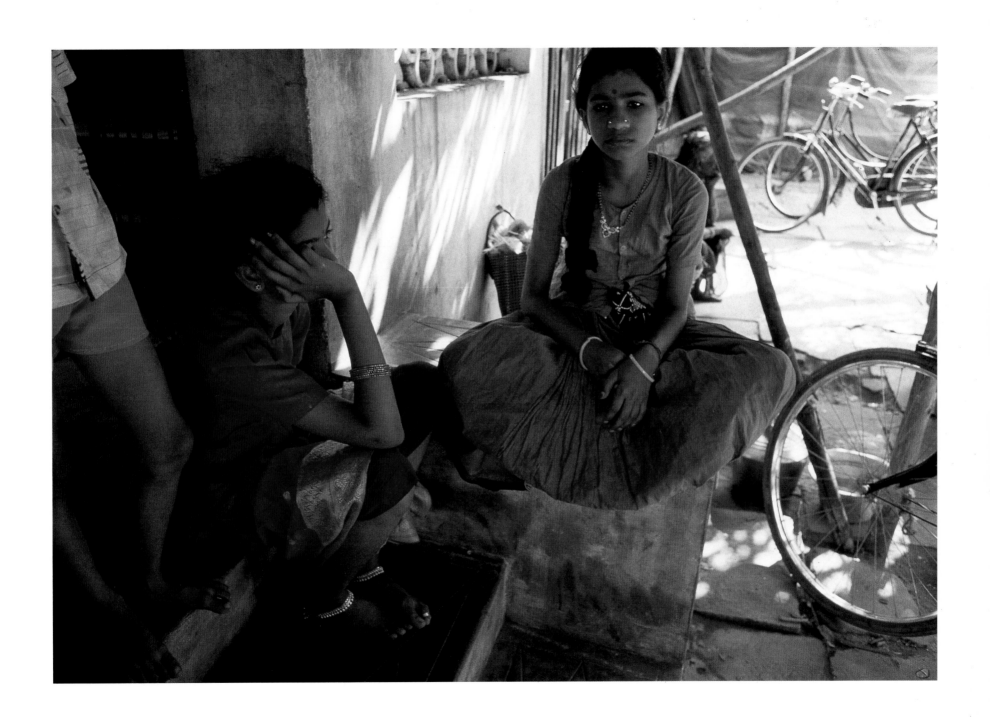

Dikshitar Brahmin children, Chidambaram

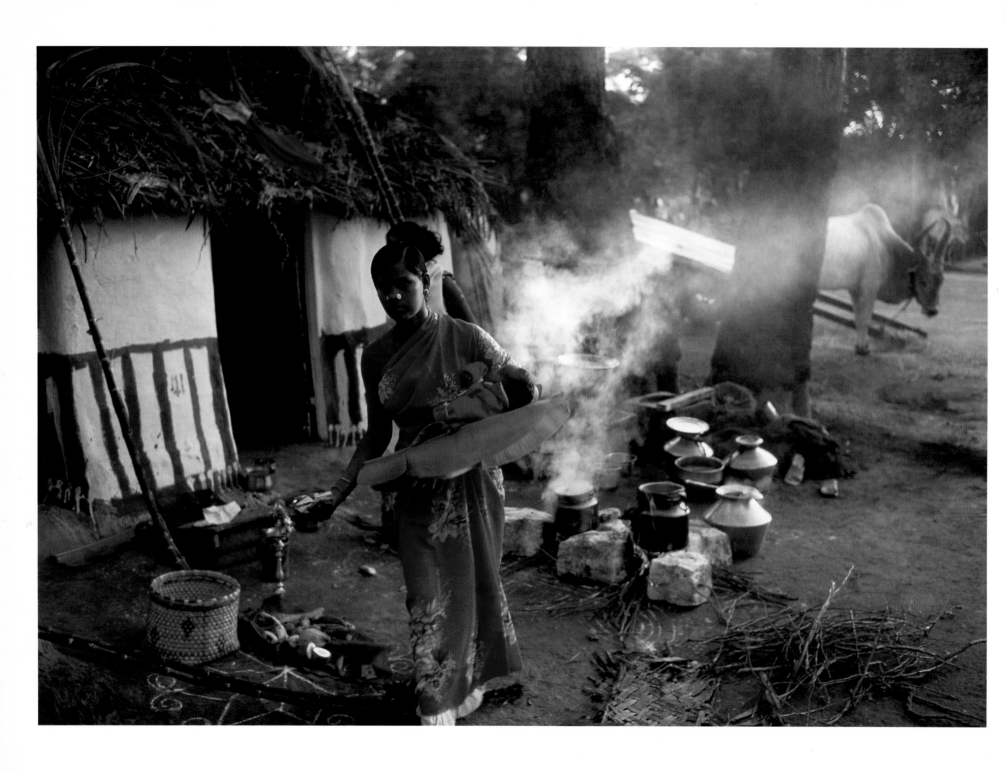

Cooking Pongal Festival rice, Madurai district

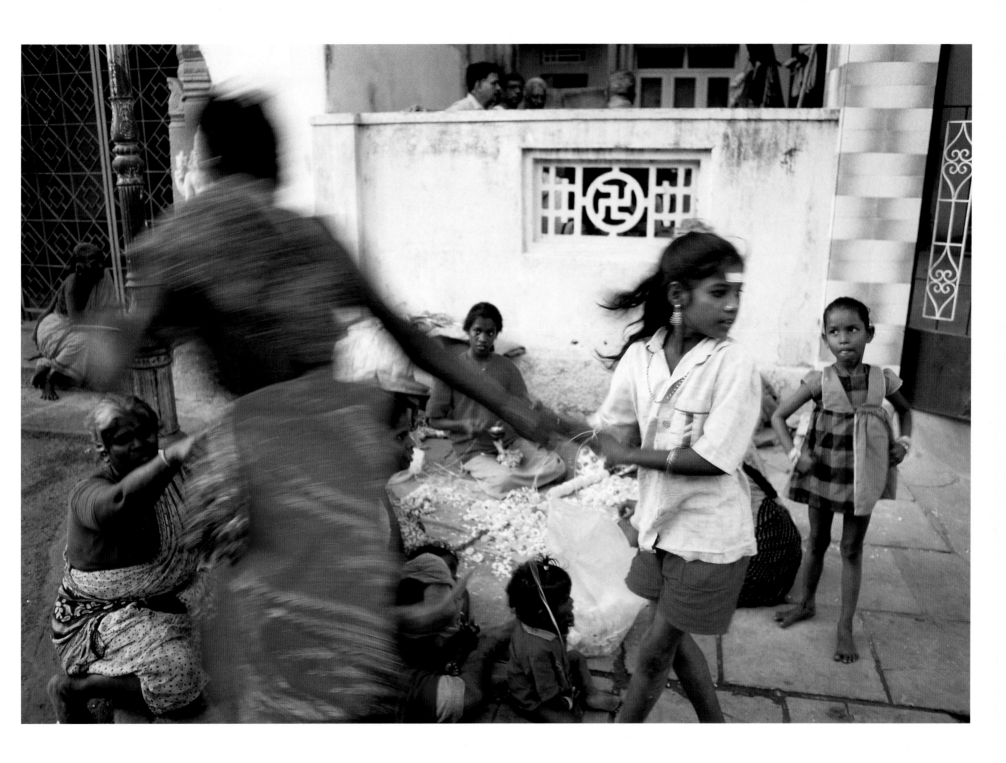

Flower sellers, Triplicane, Madras

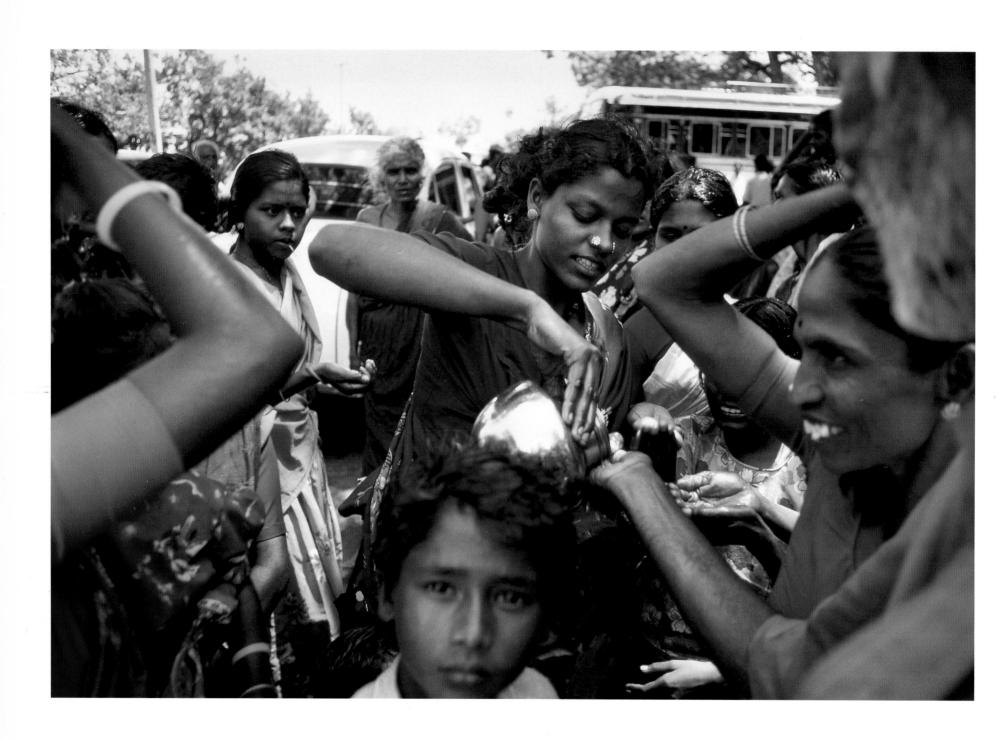

Distributing holy water, Kuttalam

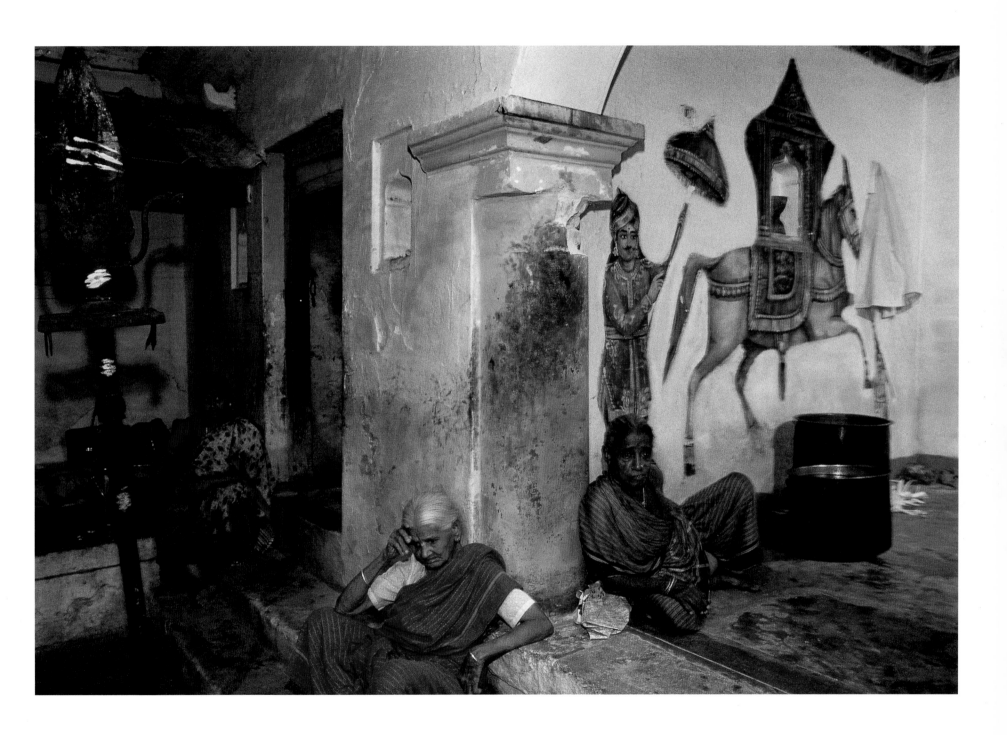

Women in a Srirangam house

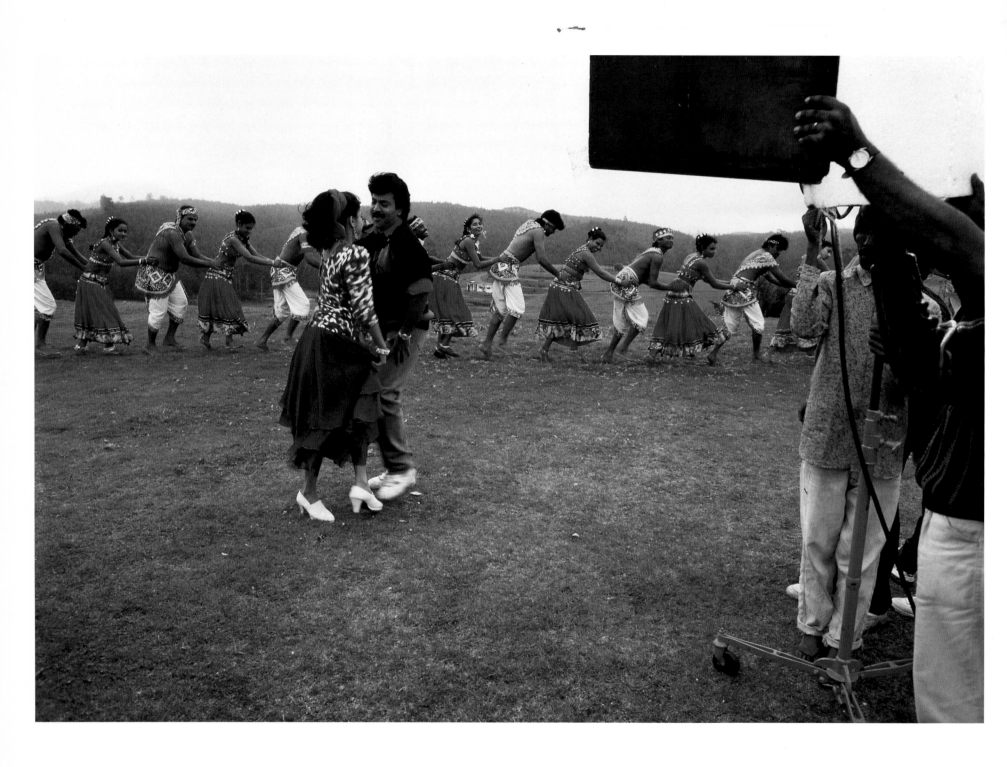

Filming a dance sequence, Ooty

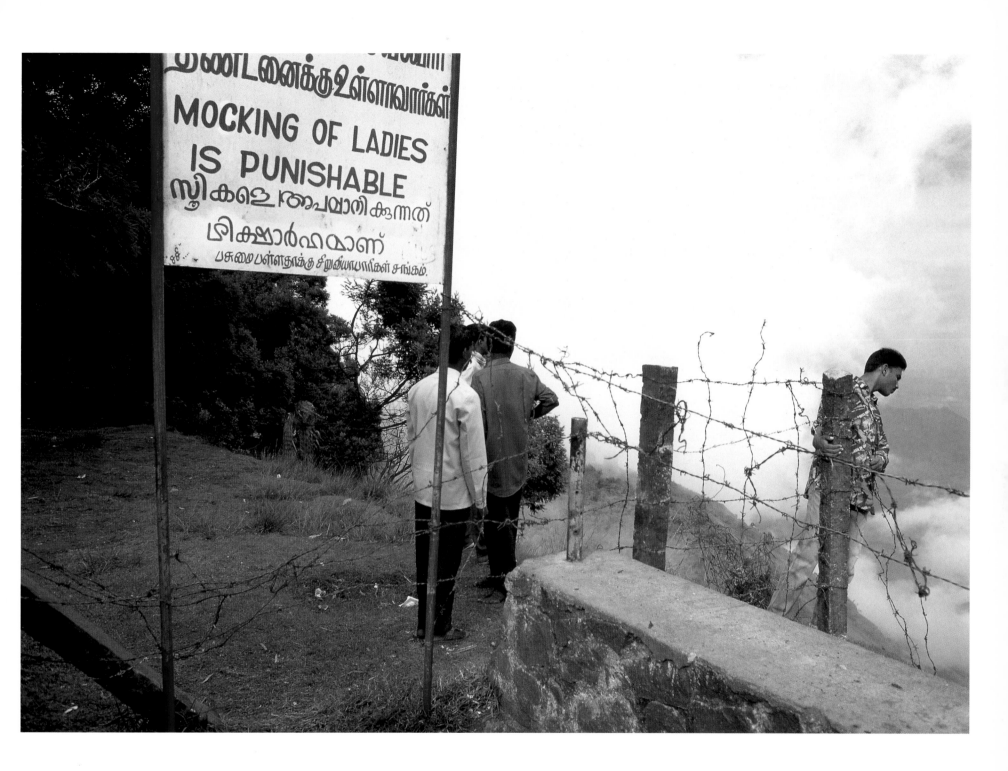

Signpost for men, Kodaikanal

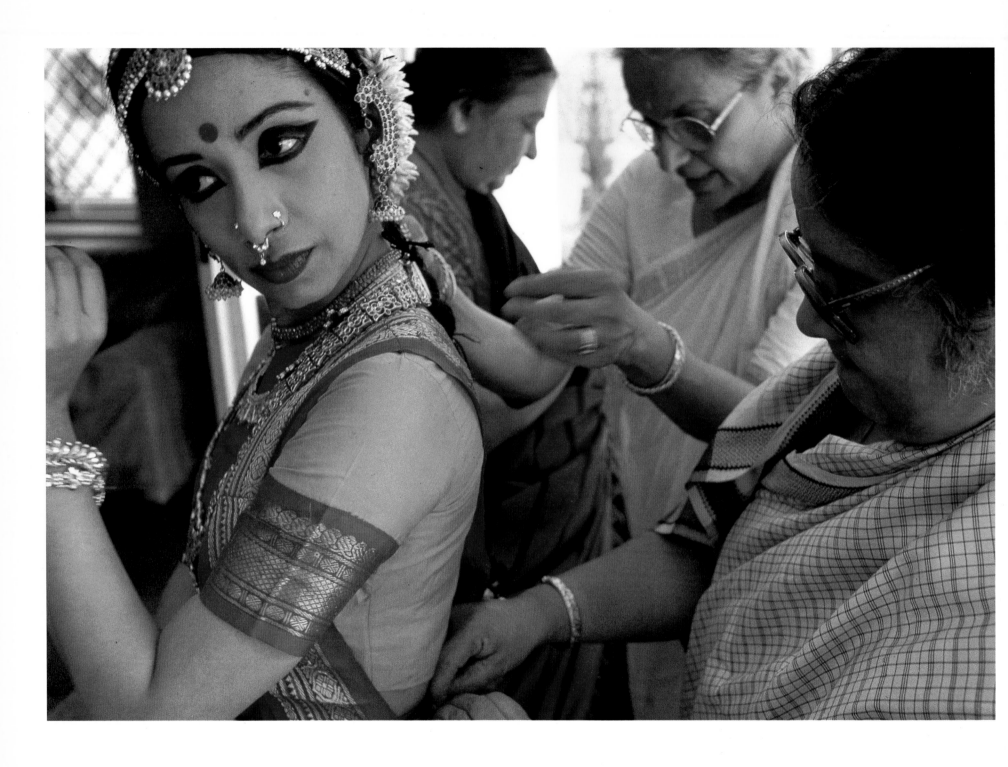

Alarmel Valli, Bharata Natyam dancer, Madras

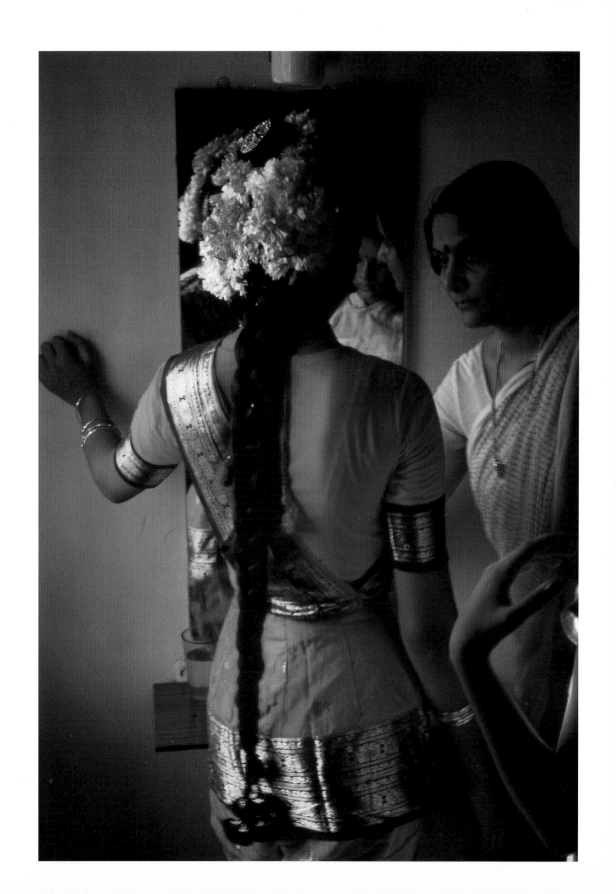

A Bharata Natyam student and mother, Chidambaram

59

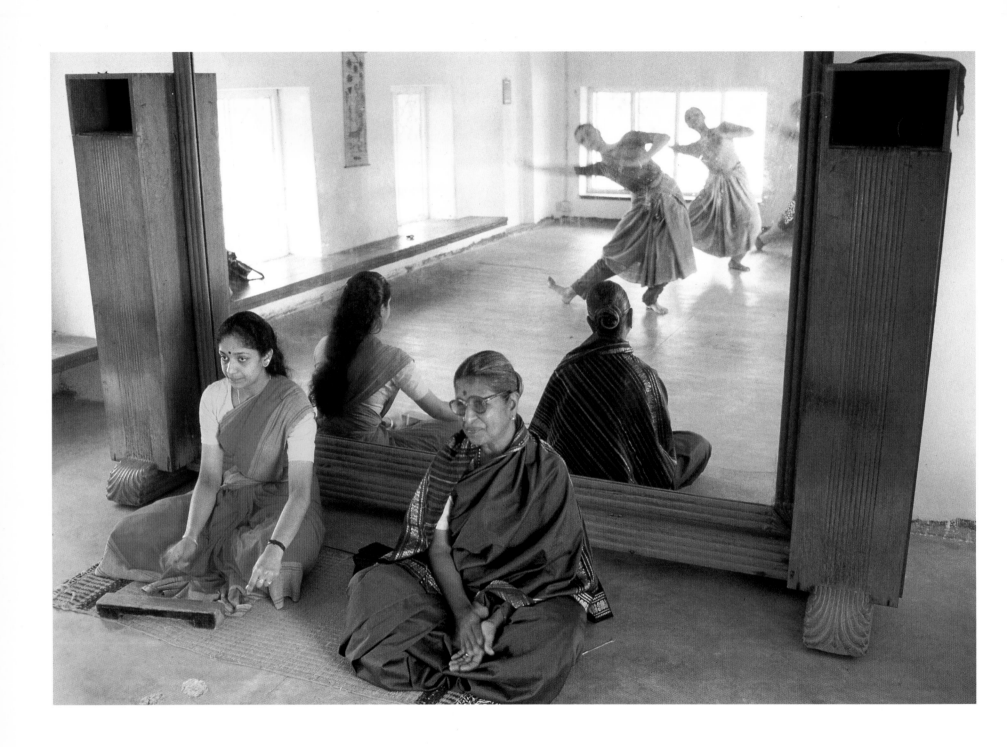

Bharata Natyam class, Kalakshetra, Madras

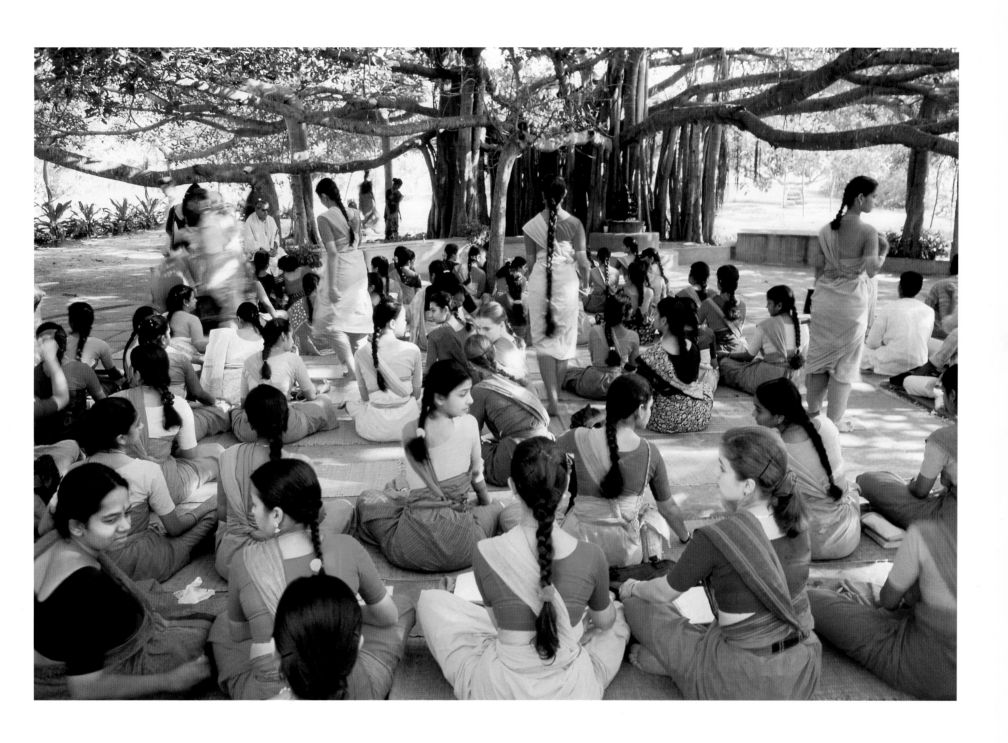

Students gather for prayers, Kalakshetra

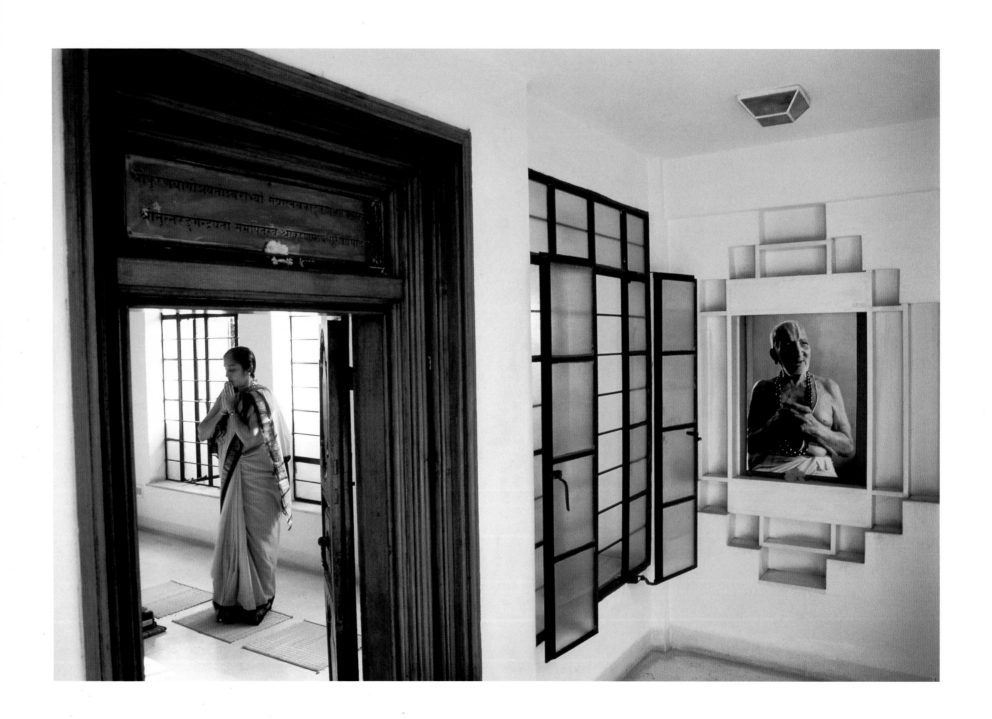

Late Yoga Guru Krishnamachari's ashram, Madras

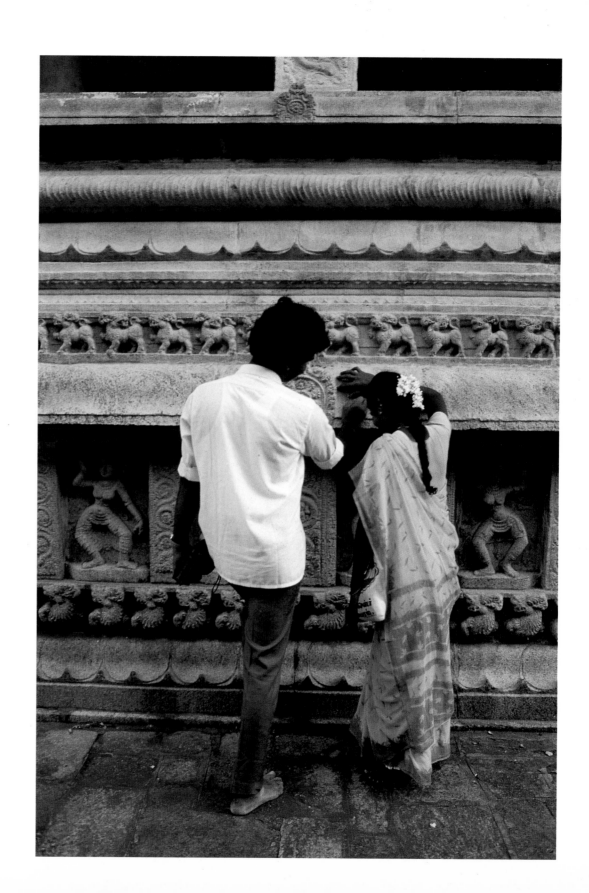

Student couple by a dance frieze, Chidambaram

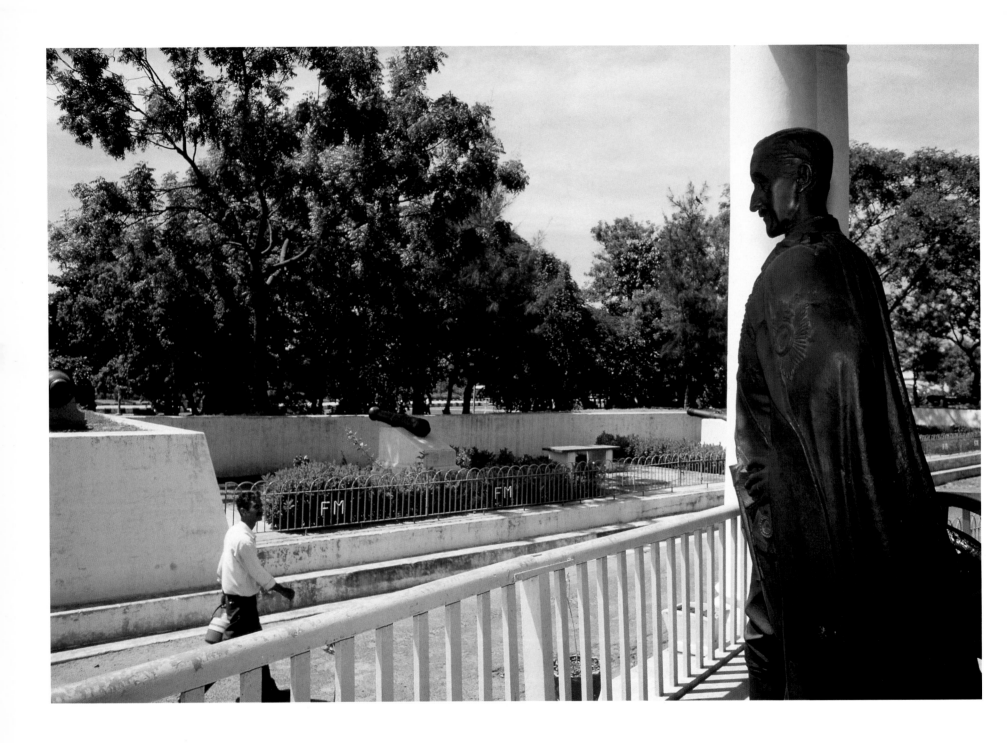

Lord Irwin's statue, Fort St.George, Madras

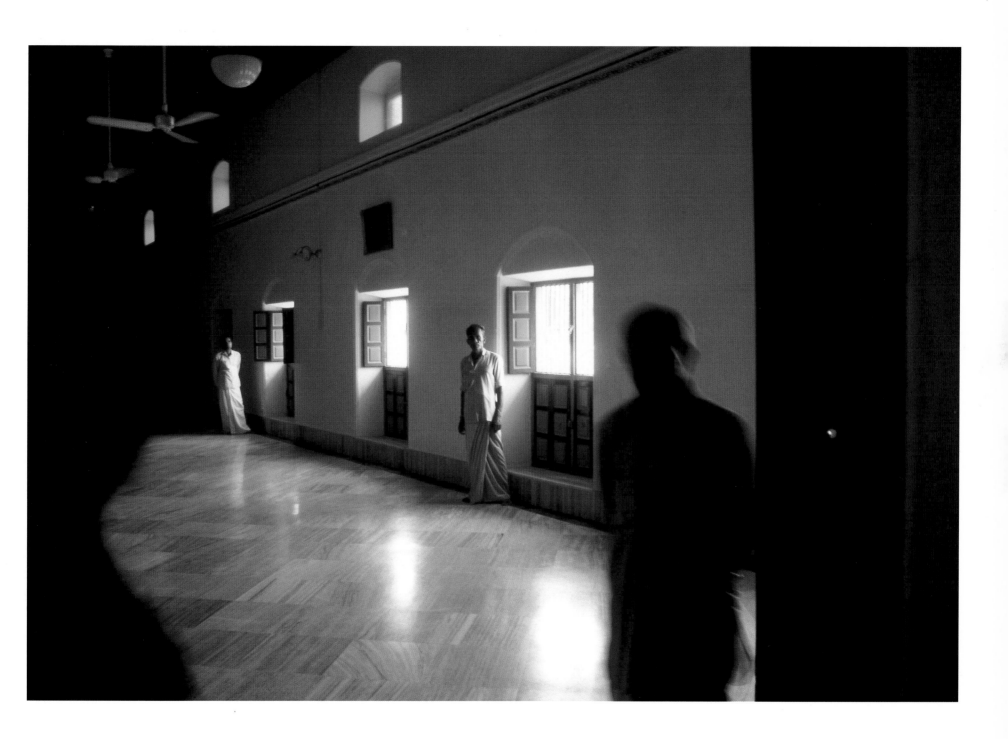

Domestic help, Raja of Chettinad's Palace, Pudukkotai

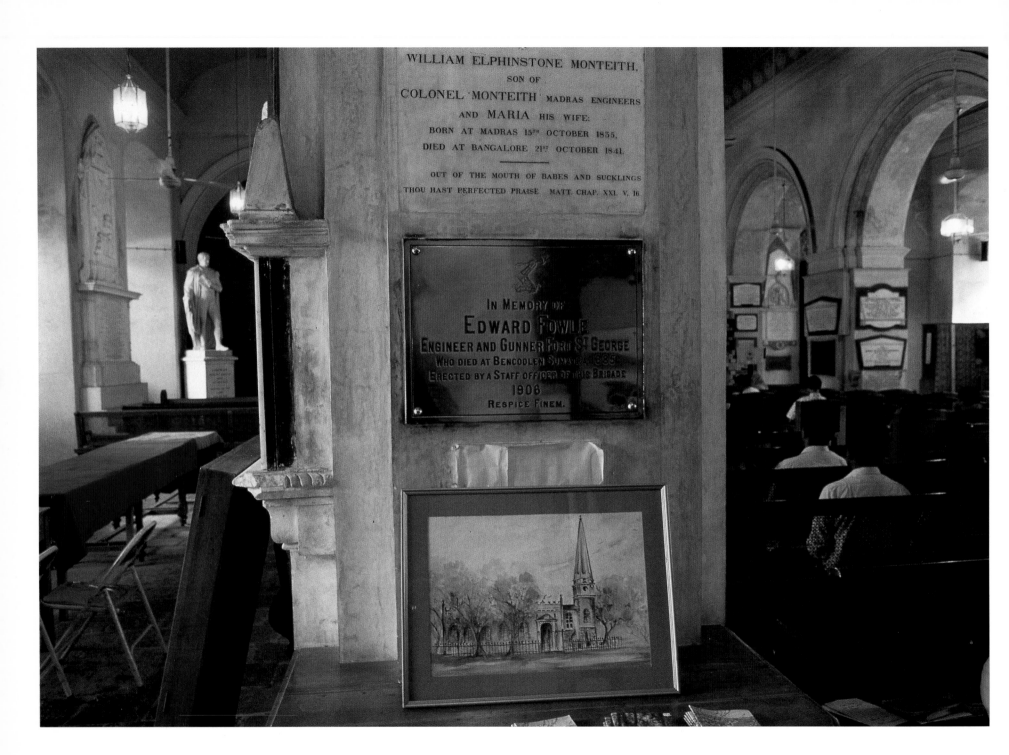

St.Mary's Church, Fort St.George, Madras

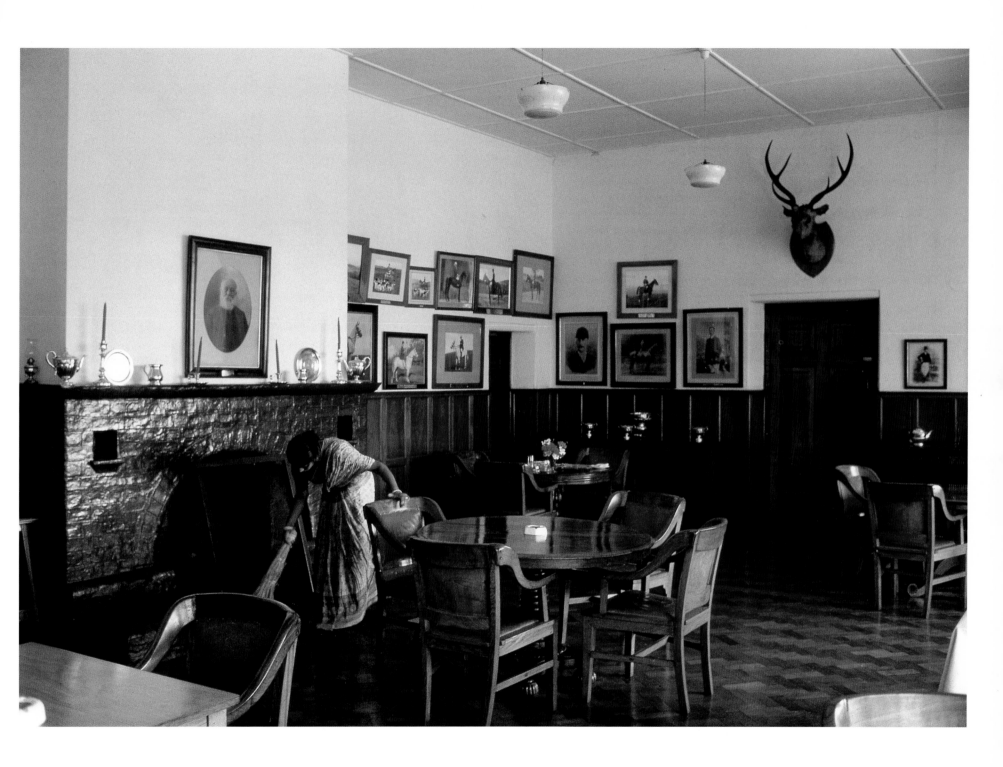

Cleaning woman, Ooty Club dining room

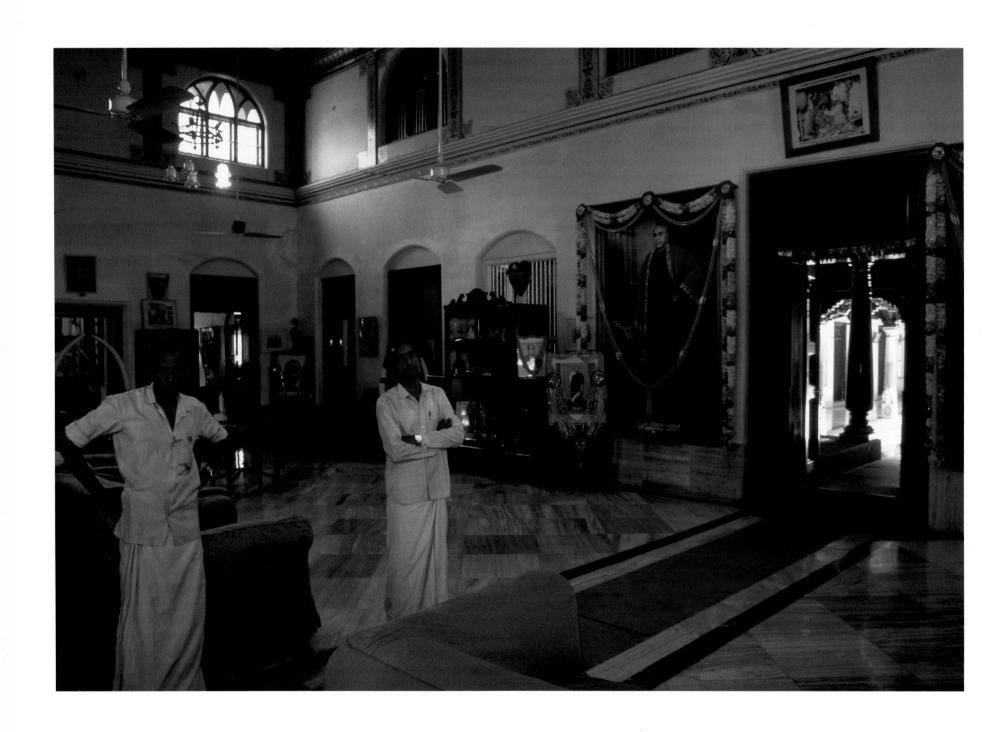

Raja of Chettinad's living room, Pudukkotai

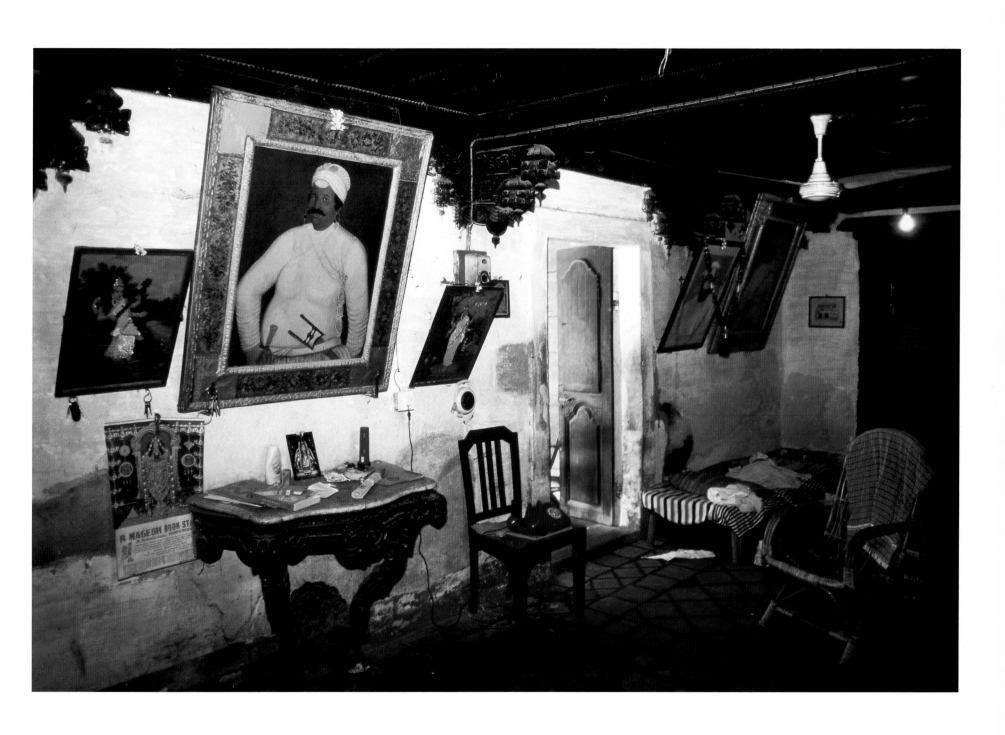

Ananda Ranga Pillai portrait and home, Pondicherry

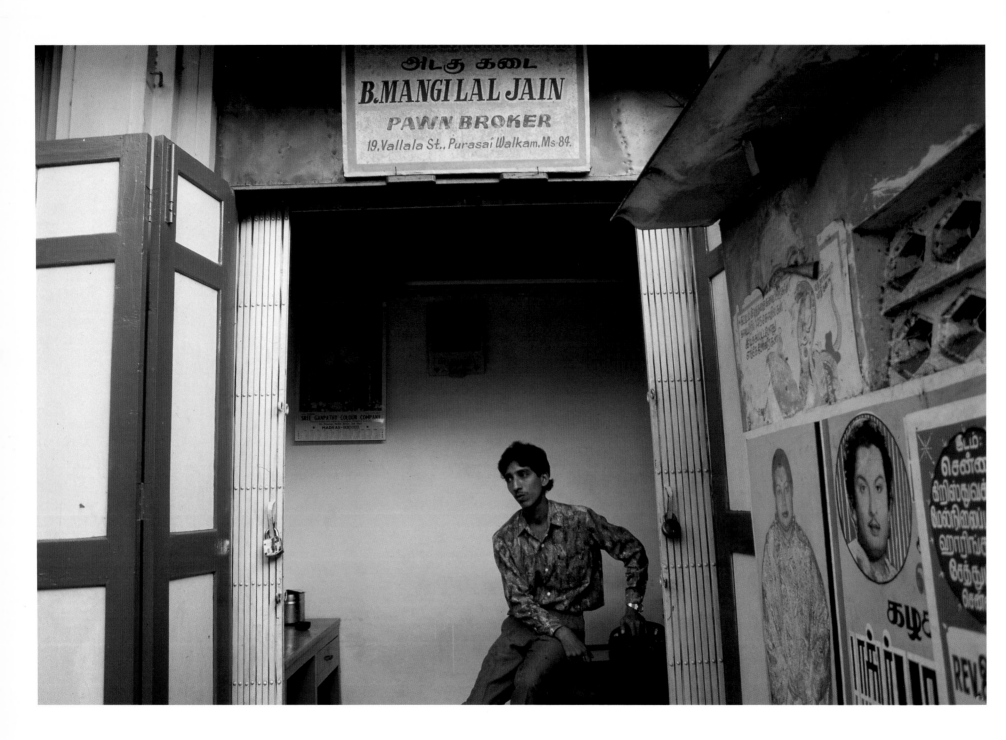

Pawn broker, Vellala Street, Purasawalkam

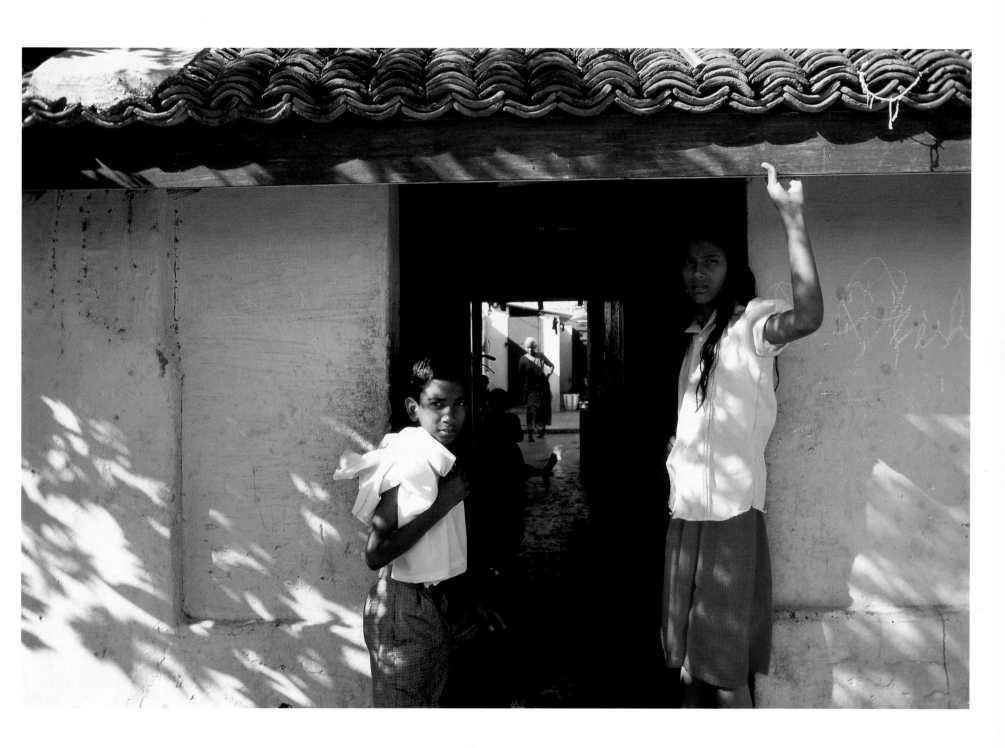

Teenagers at their door, Kanchipuram

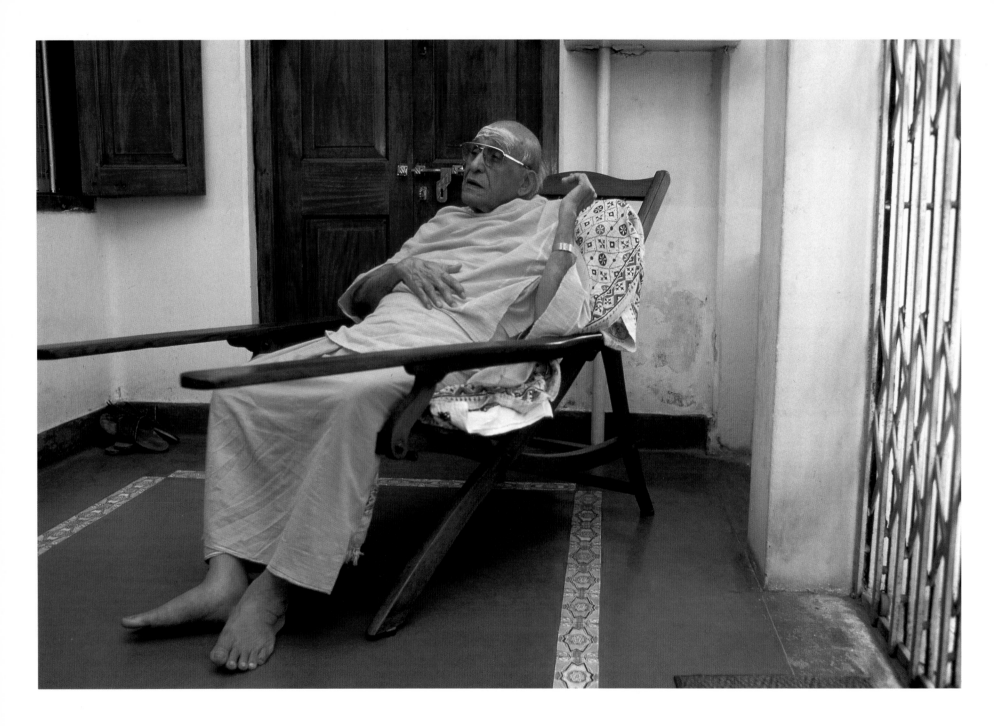

Semmangudi Srinivas Iyer, Carnatic music maestro, Madras

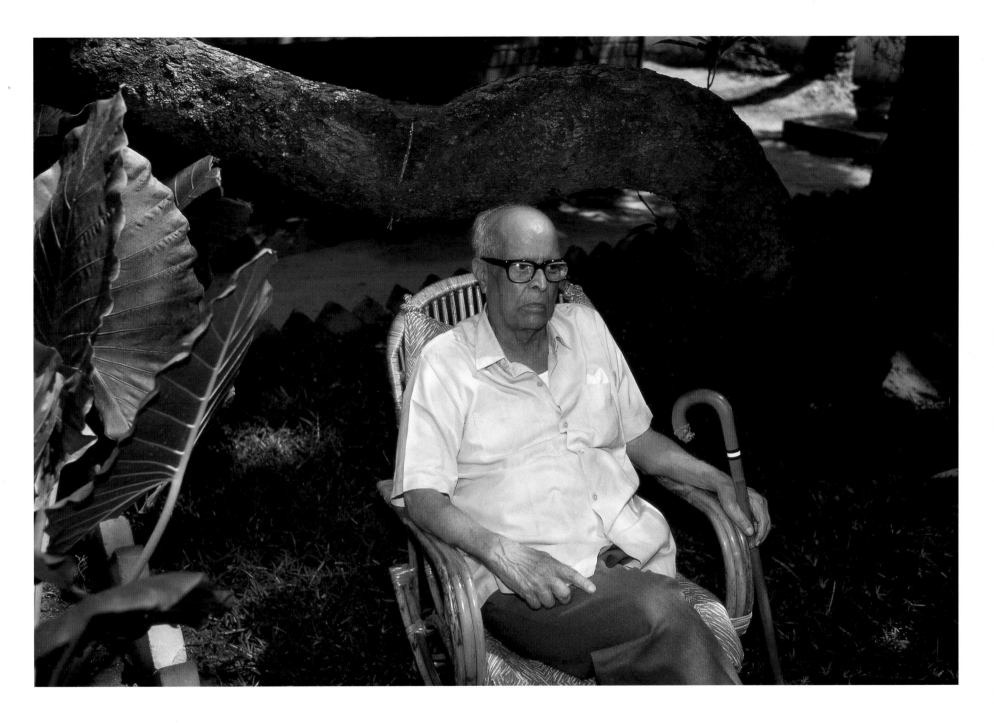

Novelist R.K.Narayan, Madras

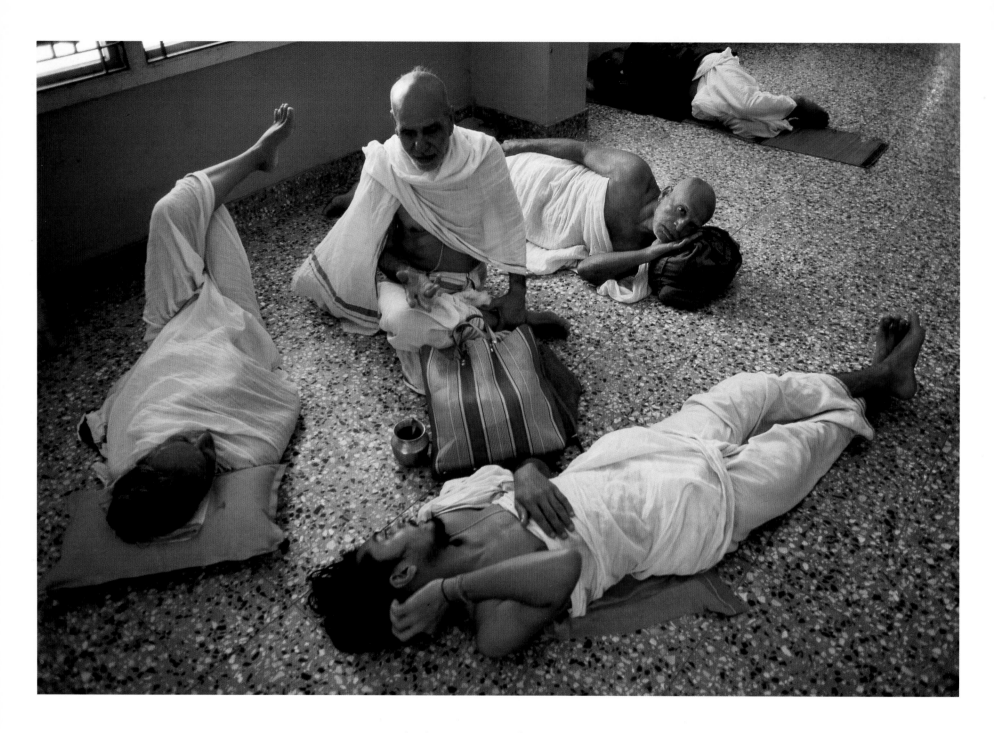

Brahmins at yoga conference, Madras

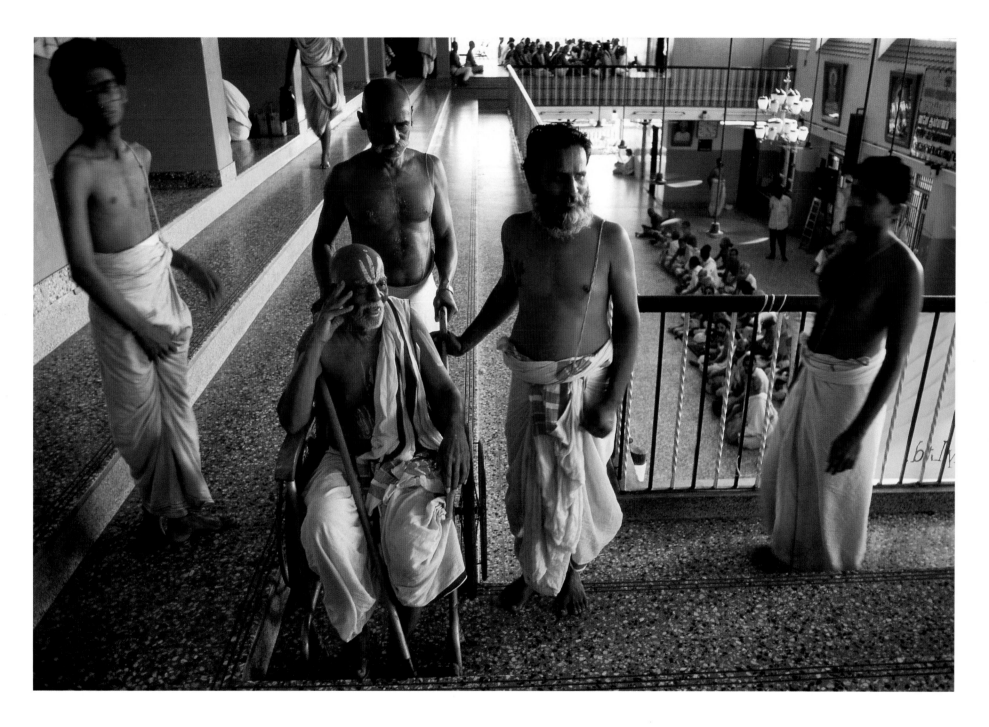

Agnihotram Ramanuja Tatachari, Vedic scholar, Madras

Vedic school principal and teacher, Thiruvaiyaru

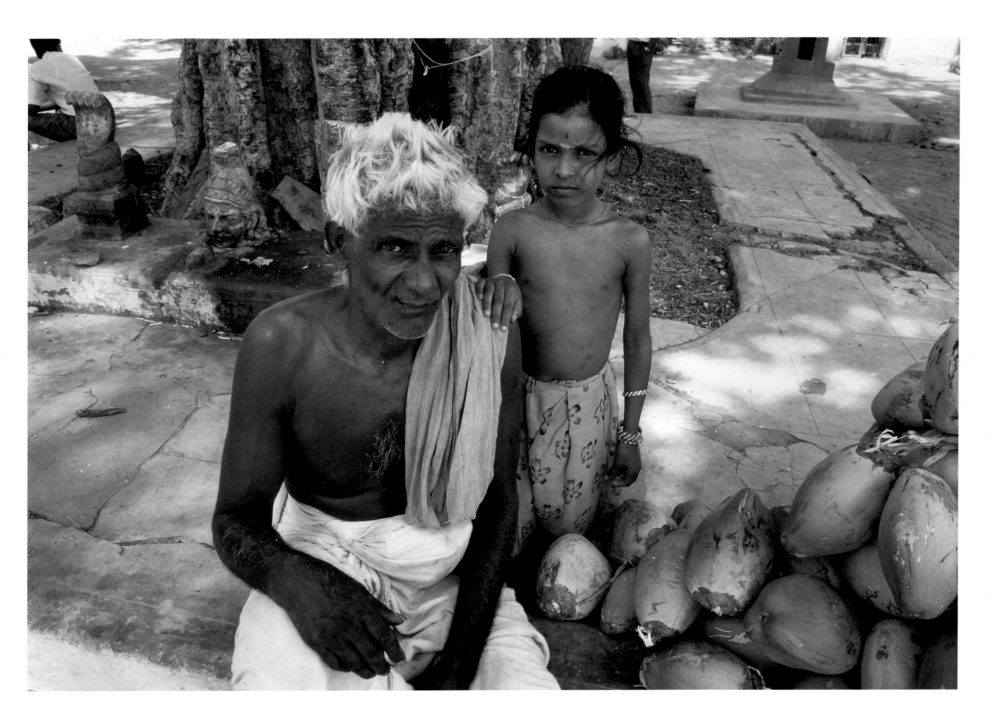

Coconut vendors, Thiruvaiyaru

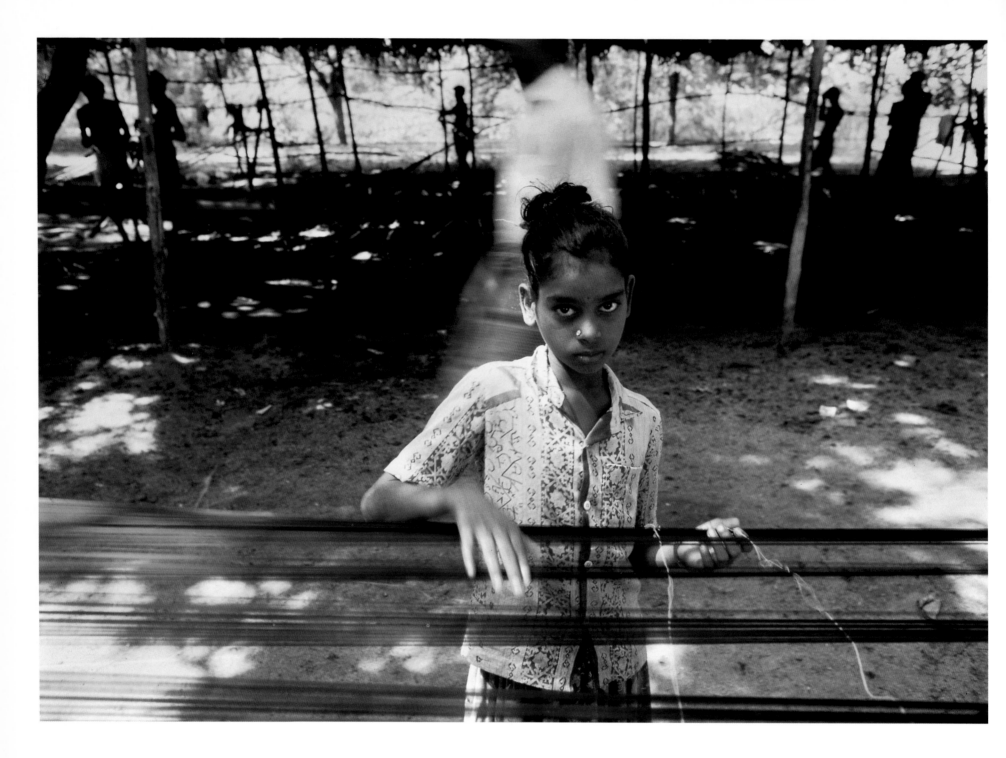

A girl with weaving thread, Kanchipuram

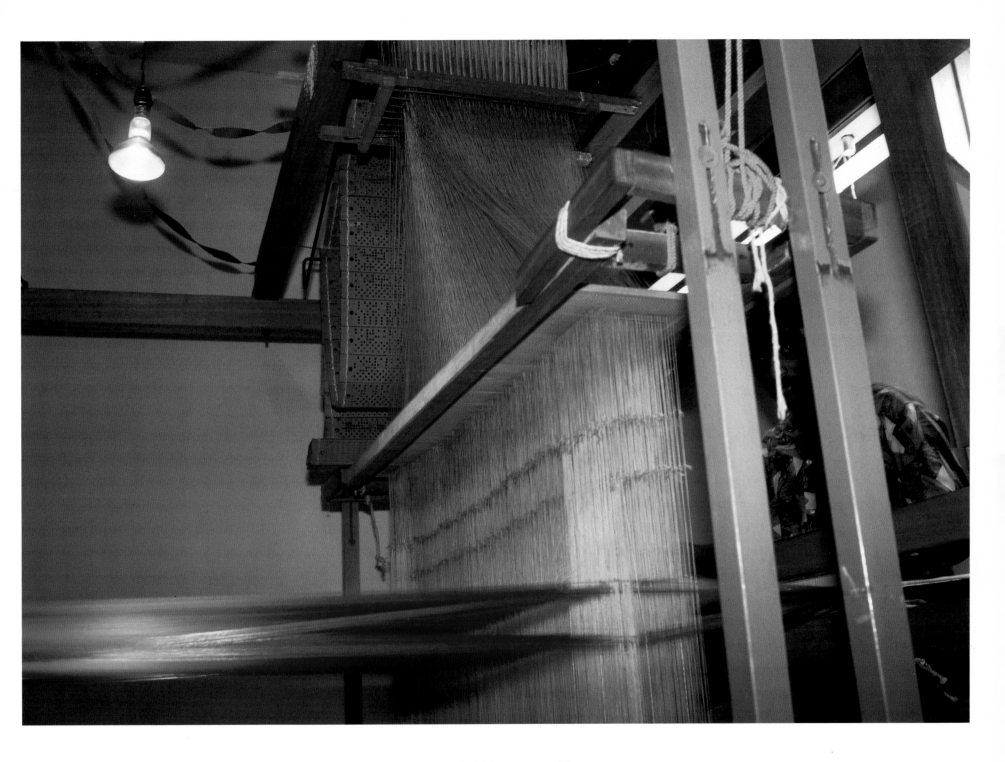

A weaver and silk loom, Kanchipuram

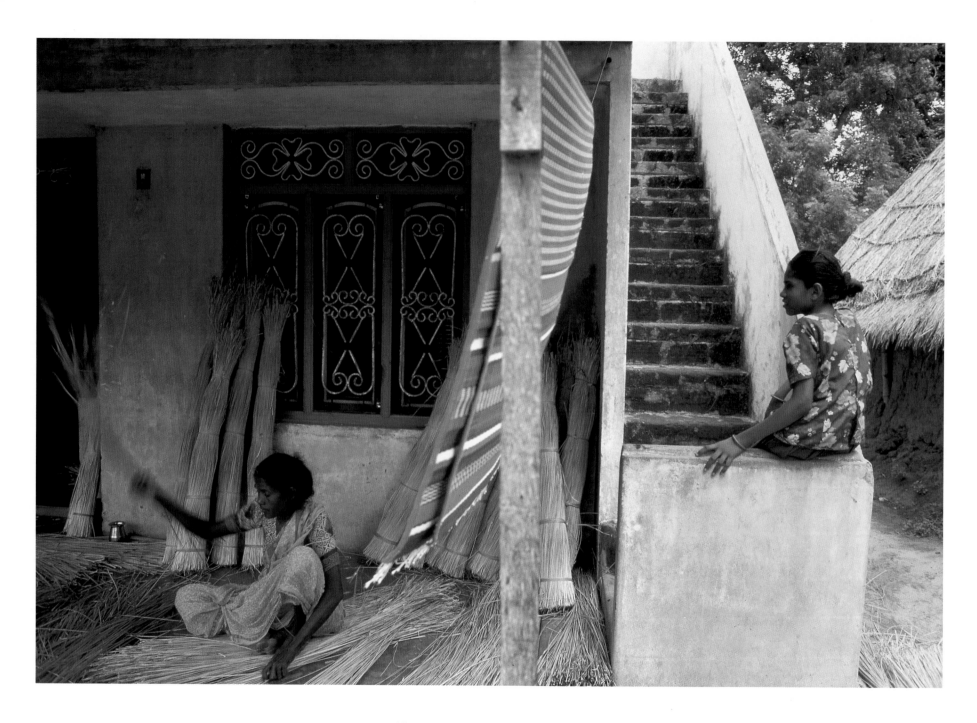

Village mat weavers, Swamimalai

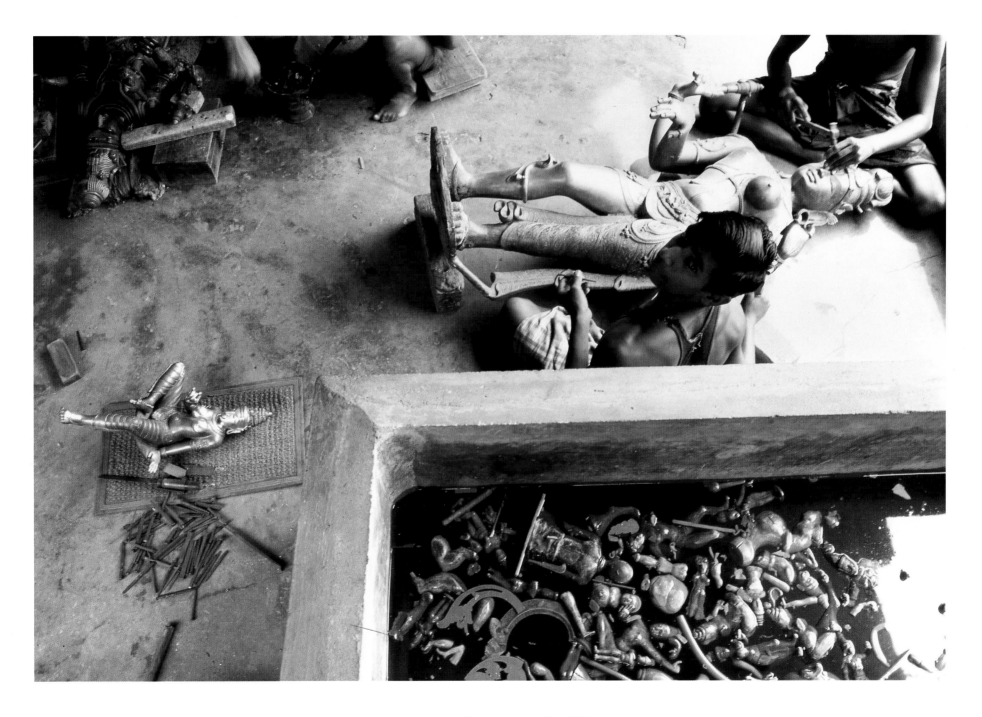

Bronze craftsmen, Swamimalai

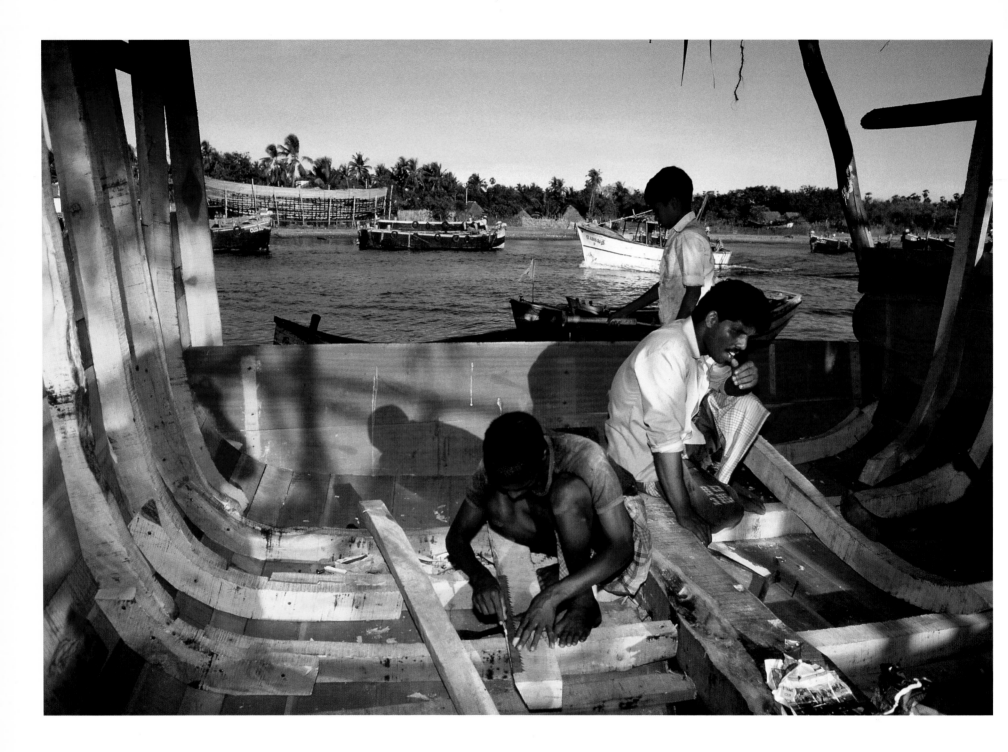

Boatbuilders, Cuddalore

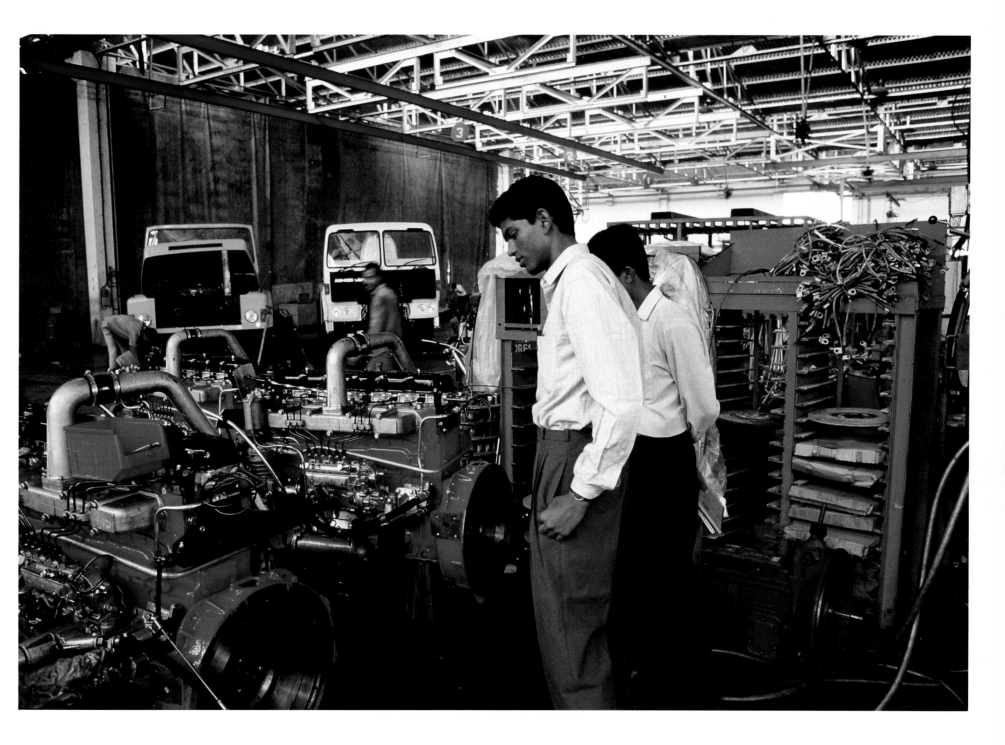

Ashok Leyland truck factory, Hosur

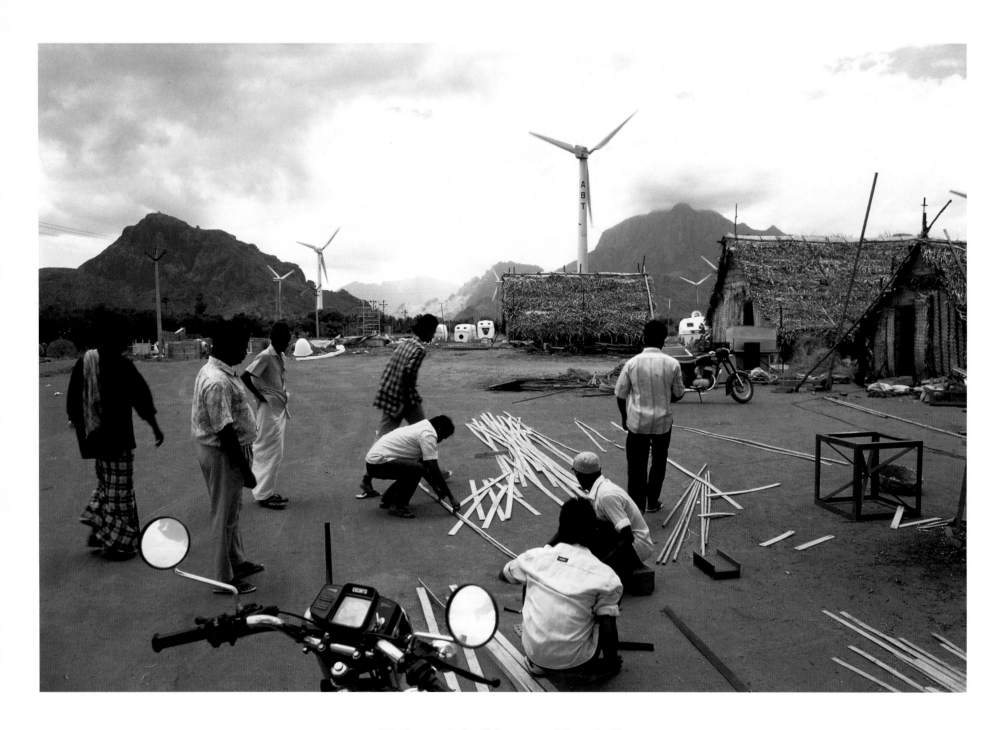

Workers, windmill farm, near Tirunelveli

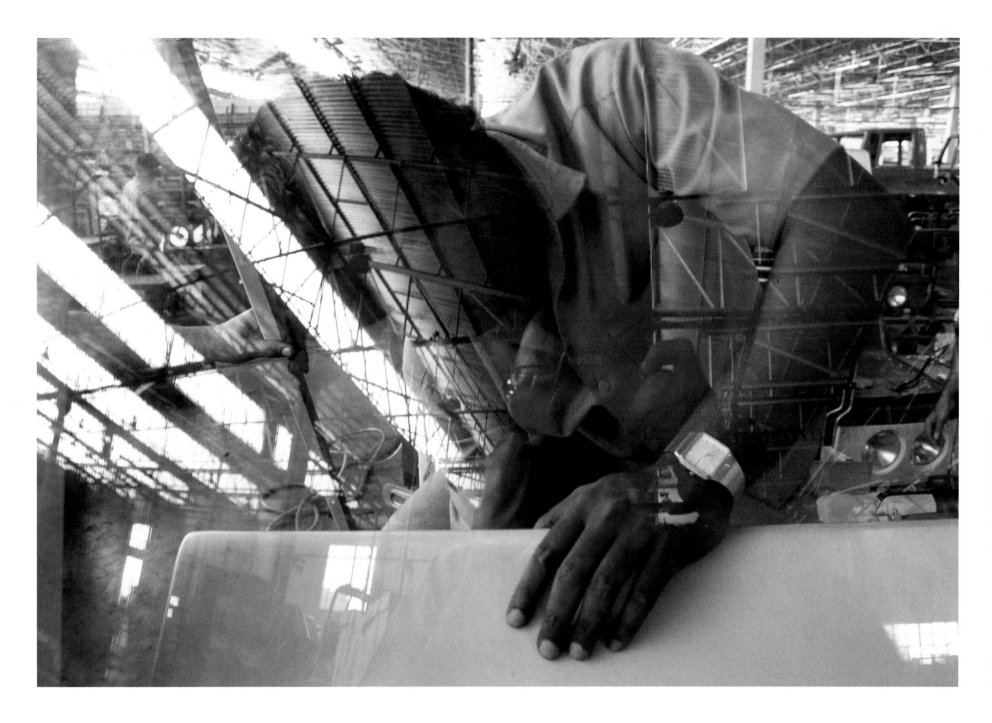

Ashok Lelyland factory, Hosur

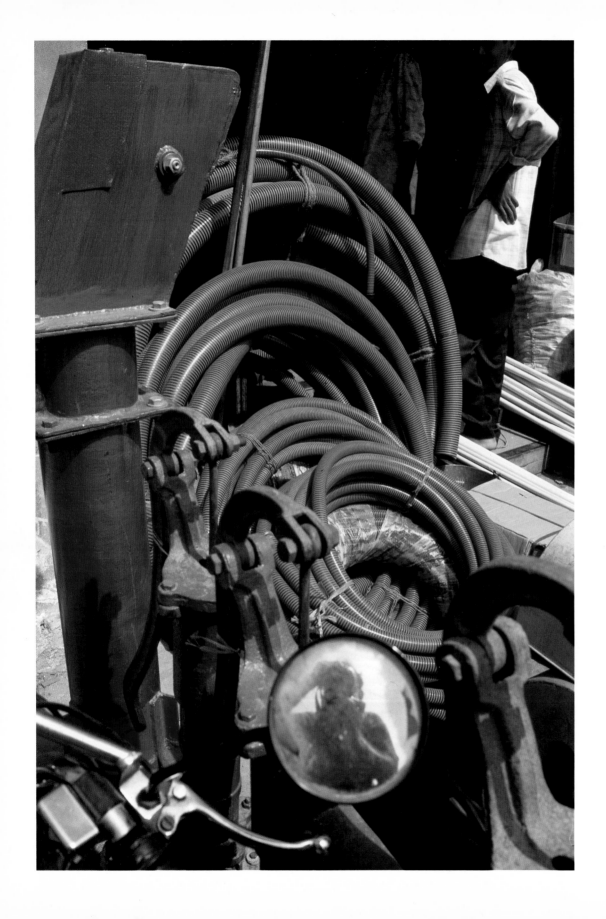

Shop for agricultural implements, Tiruppur

86

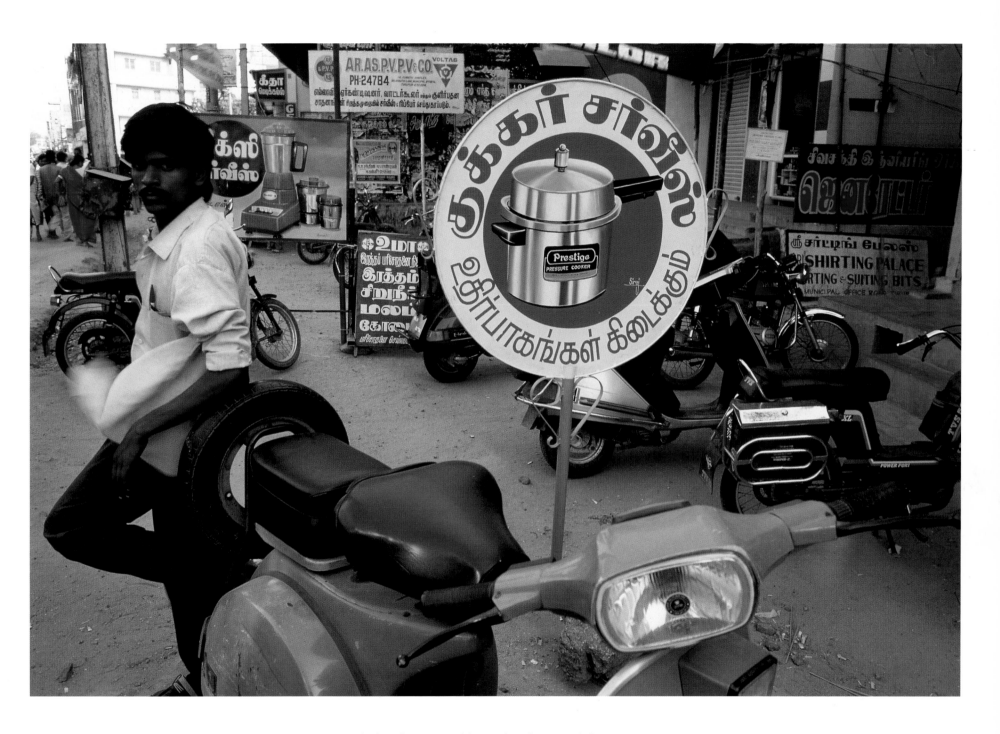

A shopkeeper and home implements, Tiruppur

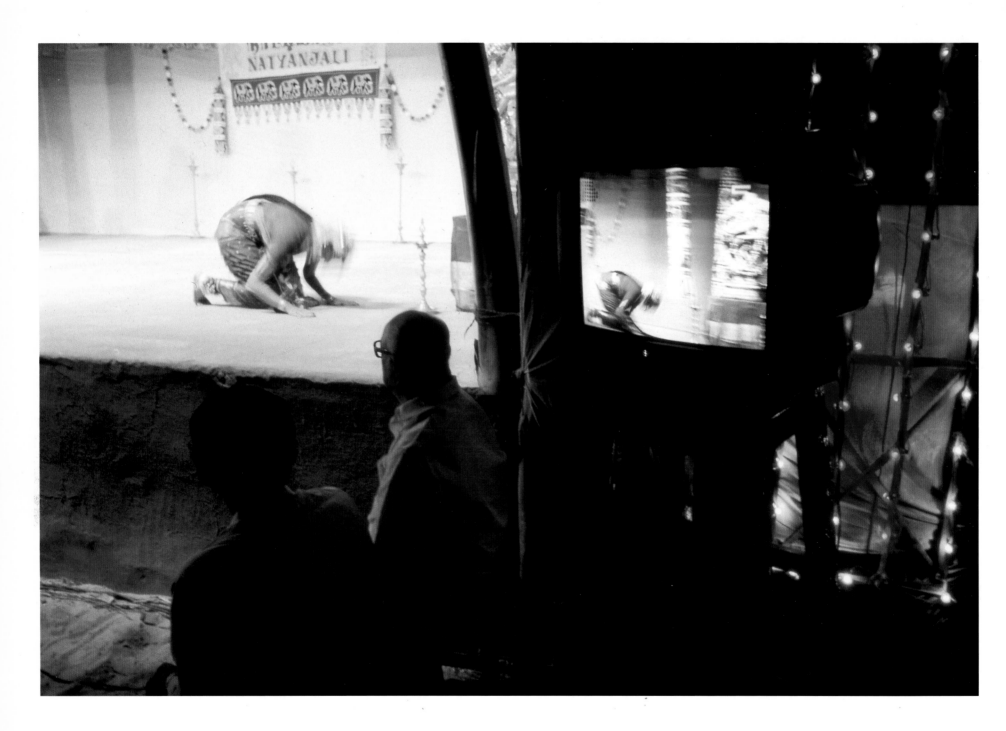

Natyanjali dance festival, Chidambaram

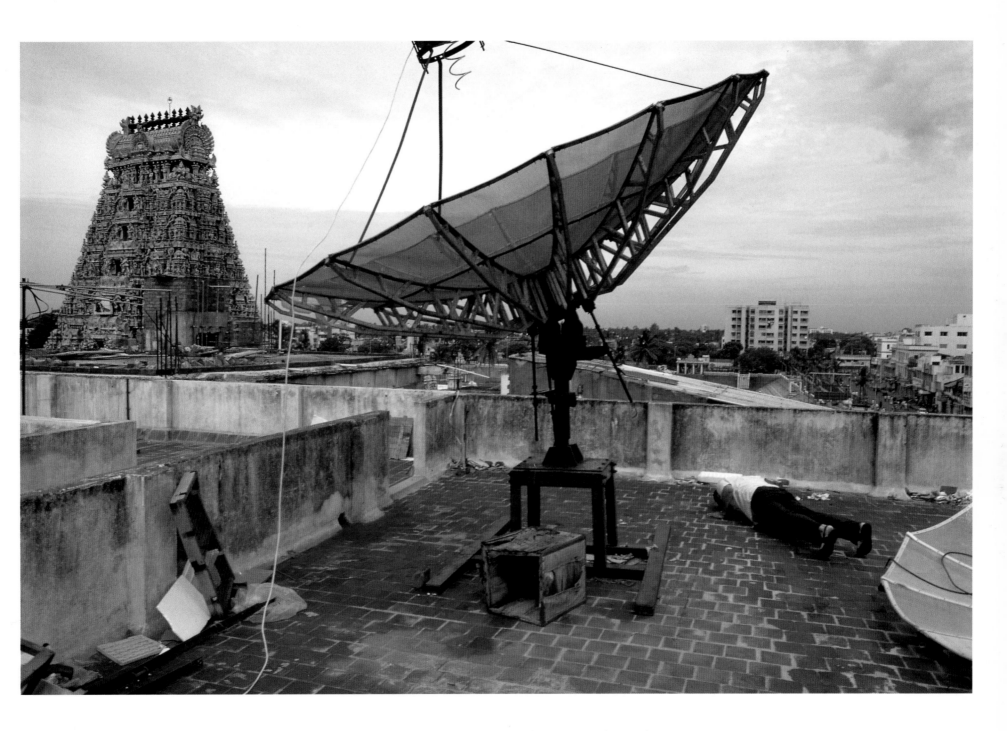

A businessman prostrates to Kapalisvara Temple, Madras

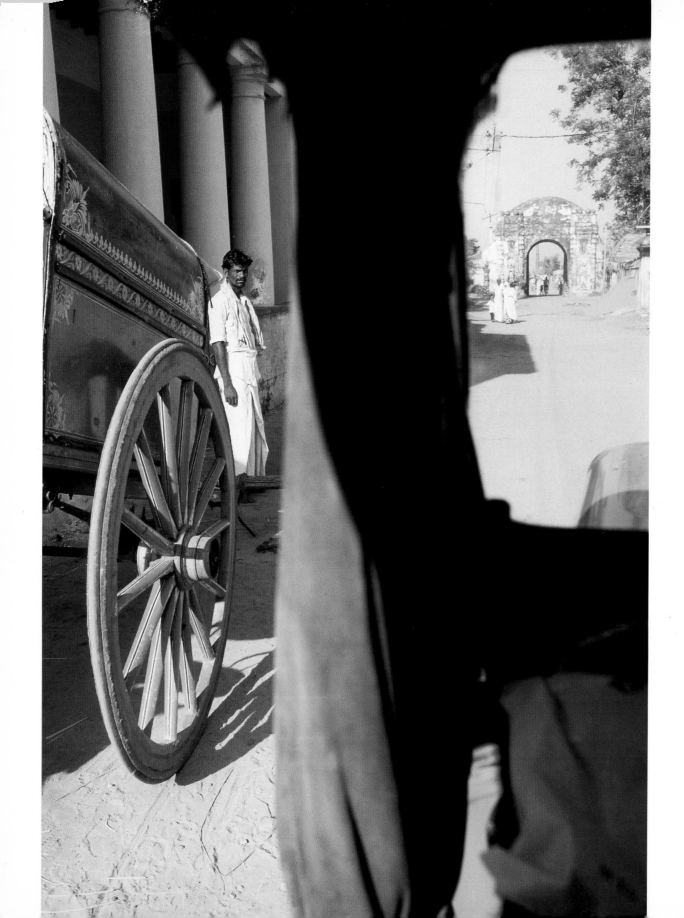

Visitor to Tranquebar Fort

90

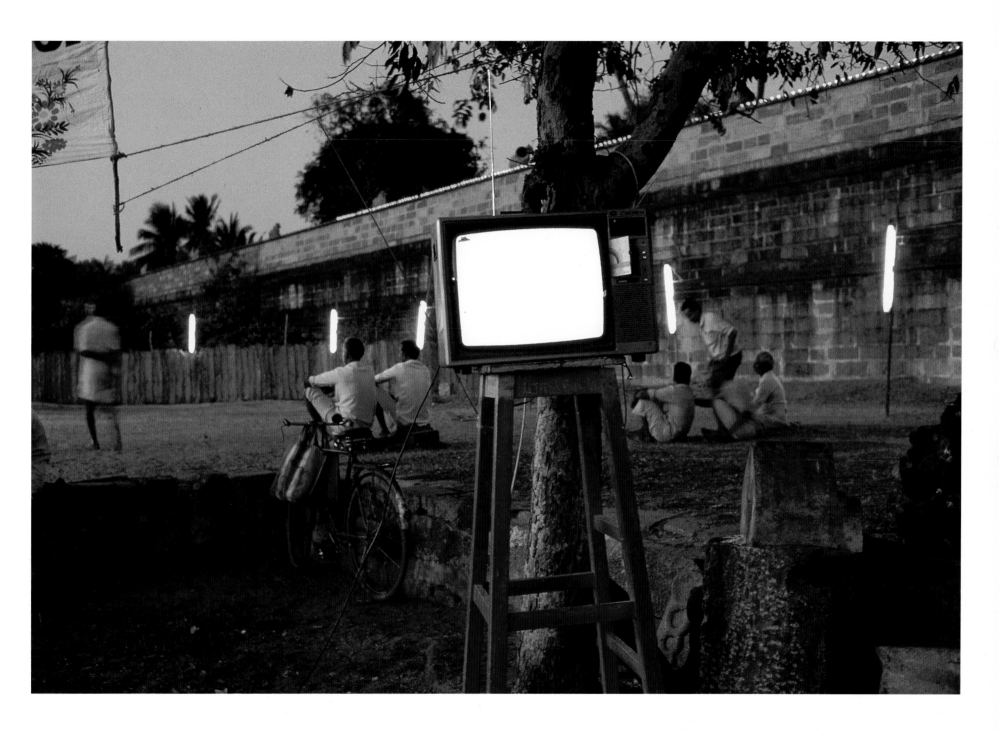

Television set at dance festival, Chidambaram

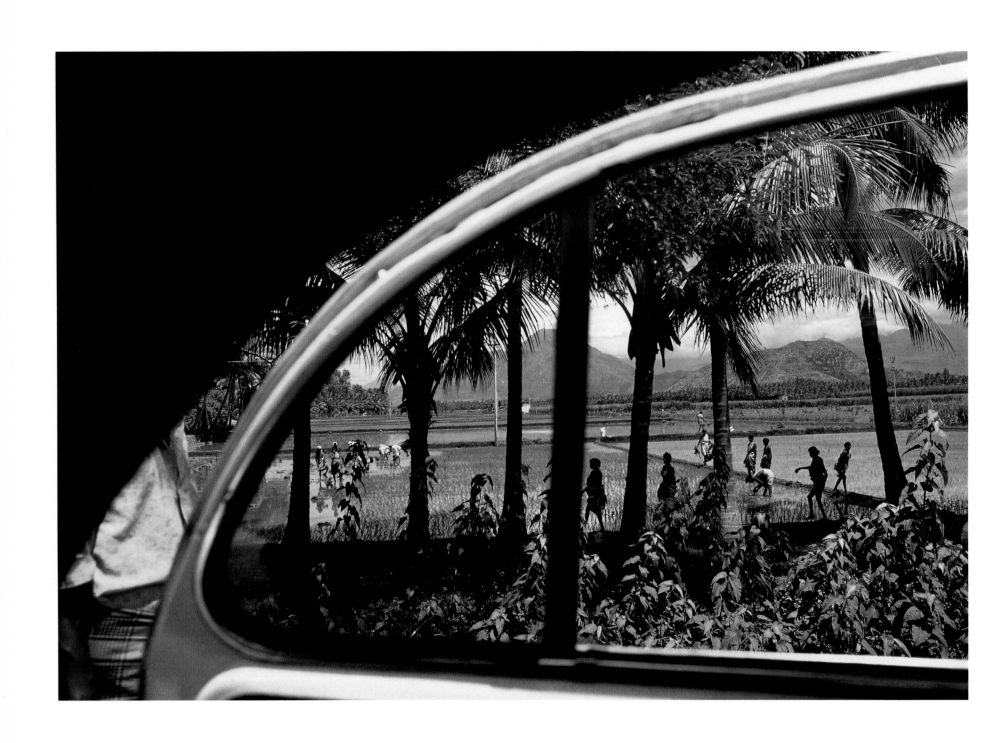

Workers in paddyfield, near Palani

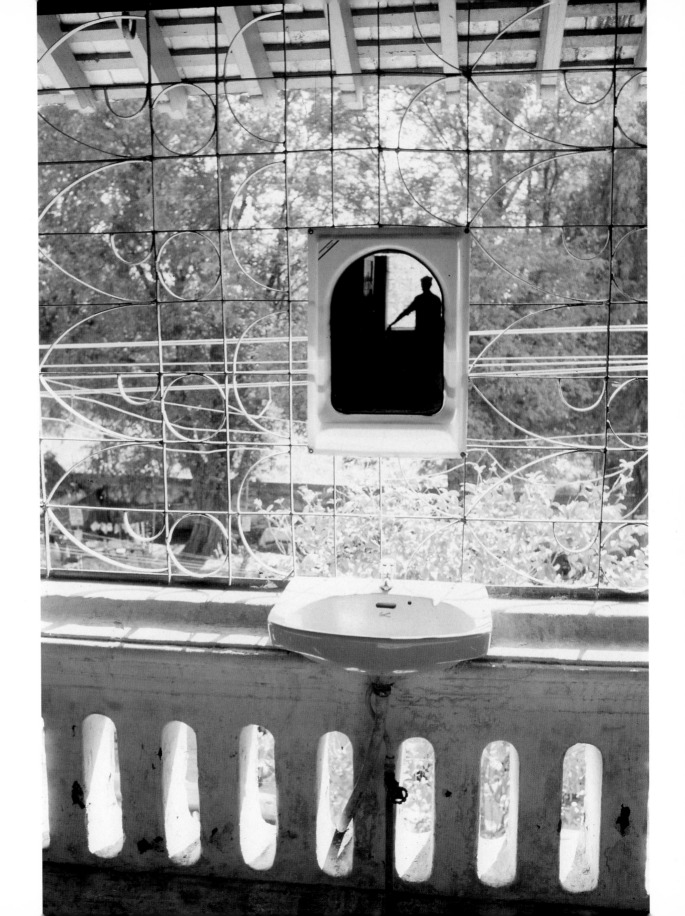

Washbasin, traveller's bungalow, Bhawani

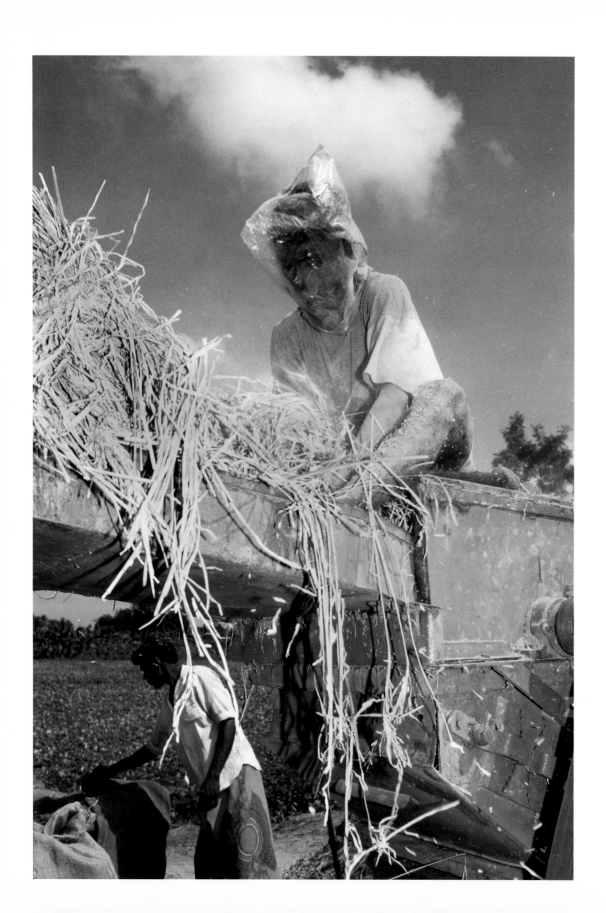

A worker threshing paddy, near Trichy

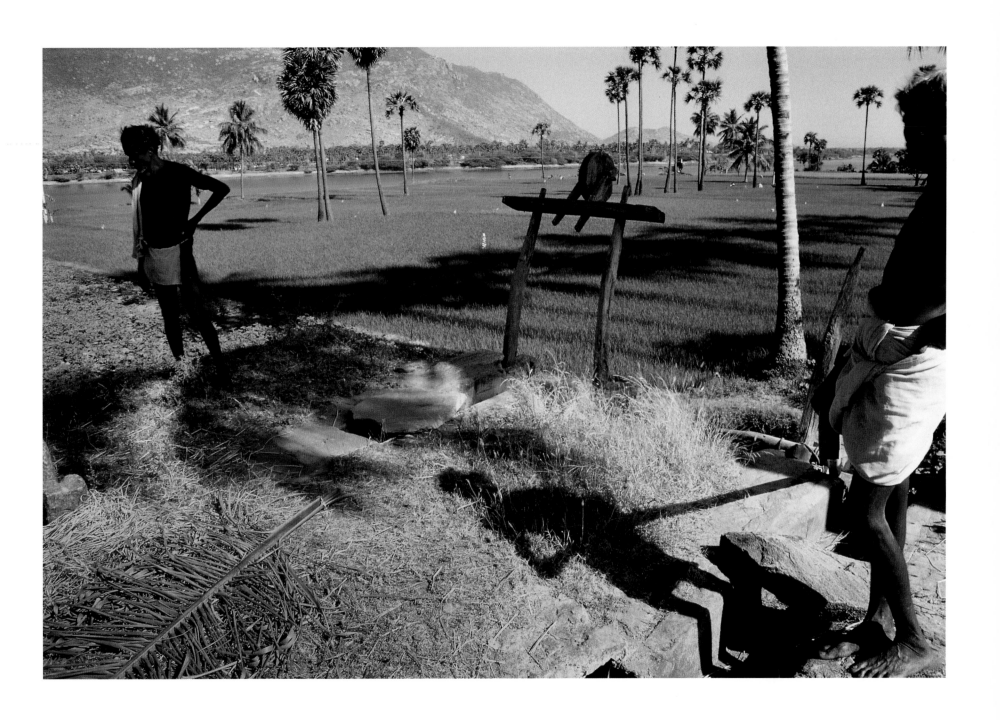

Farmers and paddyfields, Mettur

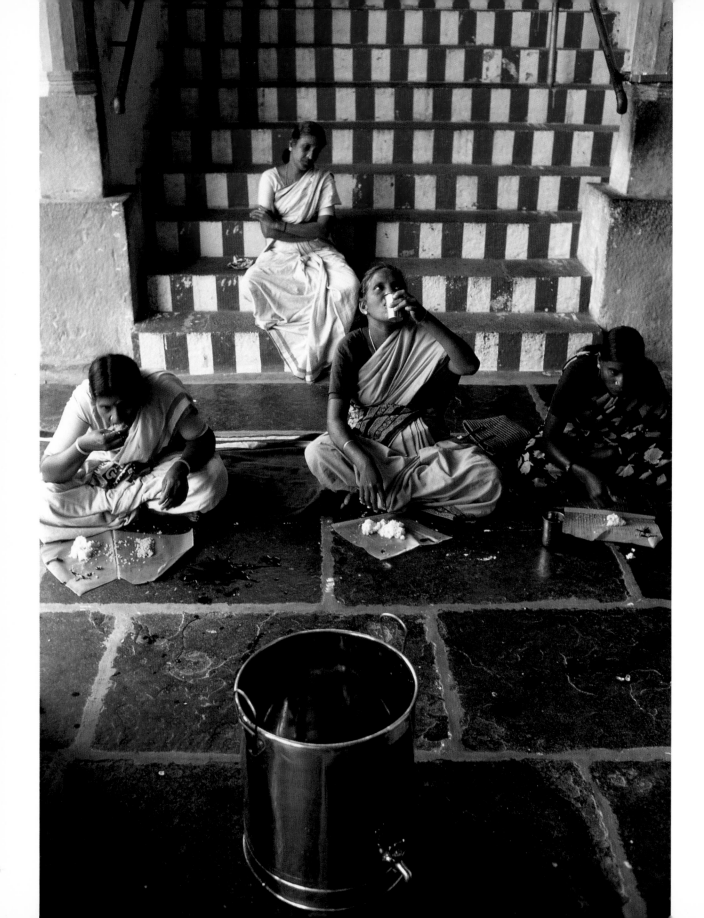

Women at lunch, Kumbakonam

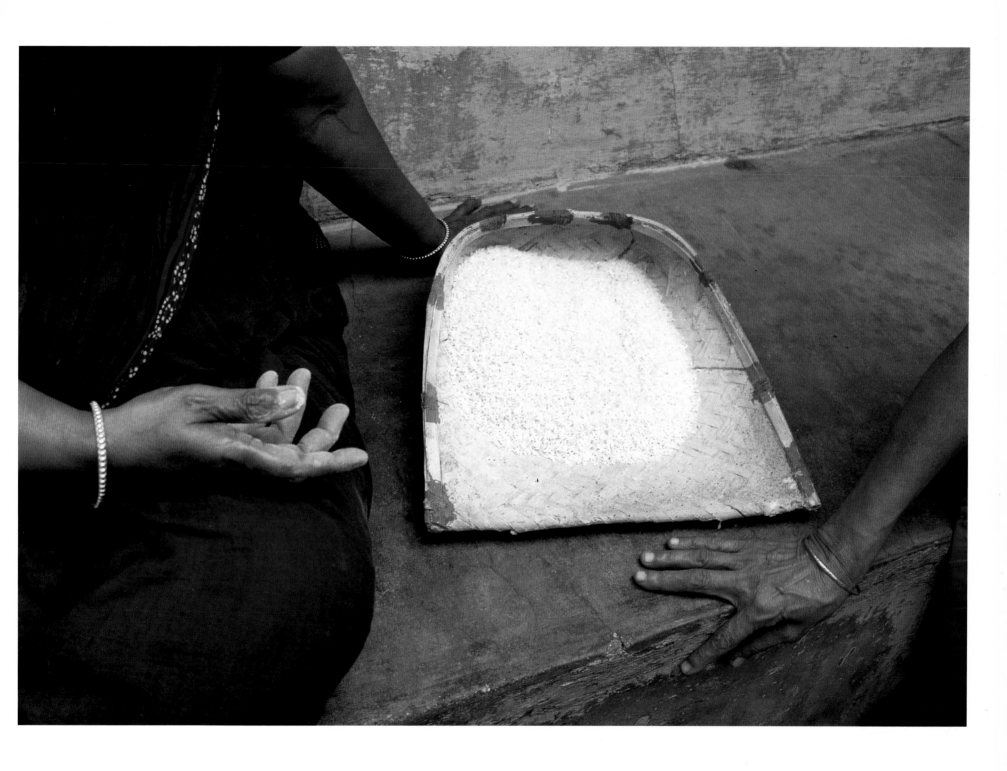

Housewives hands, Purasawalkam, Madras

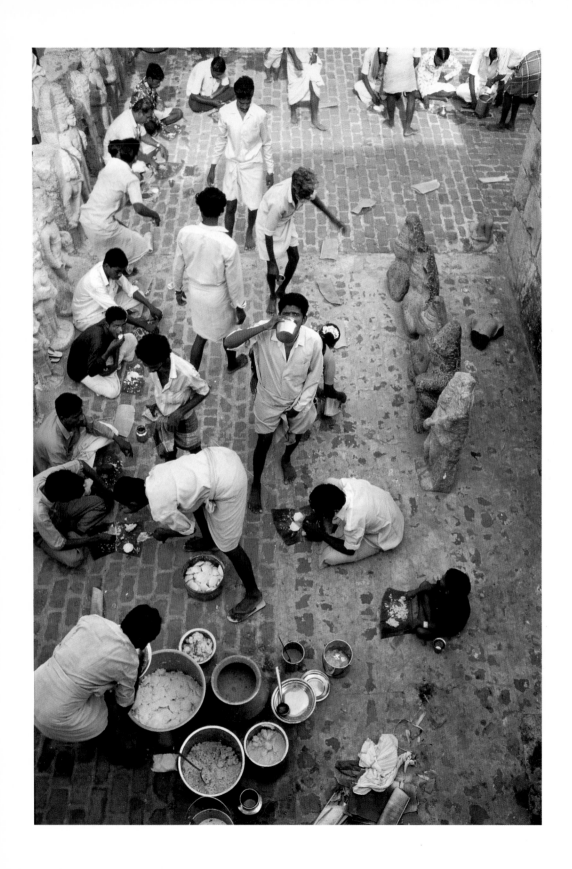

A wedding lunch, Gangaikondacholapuram

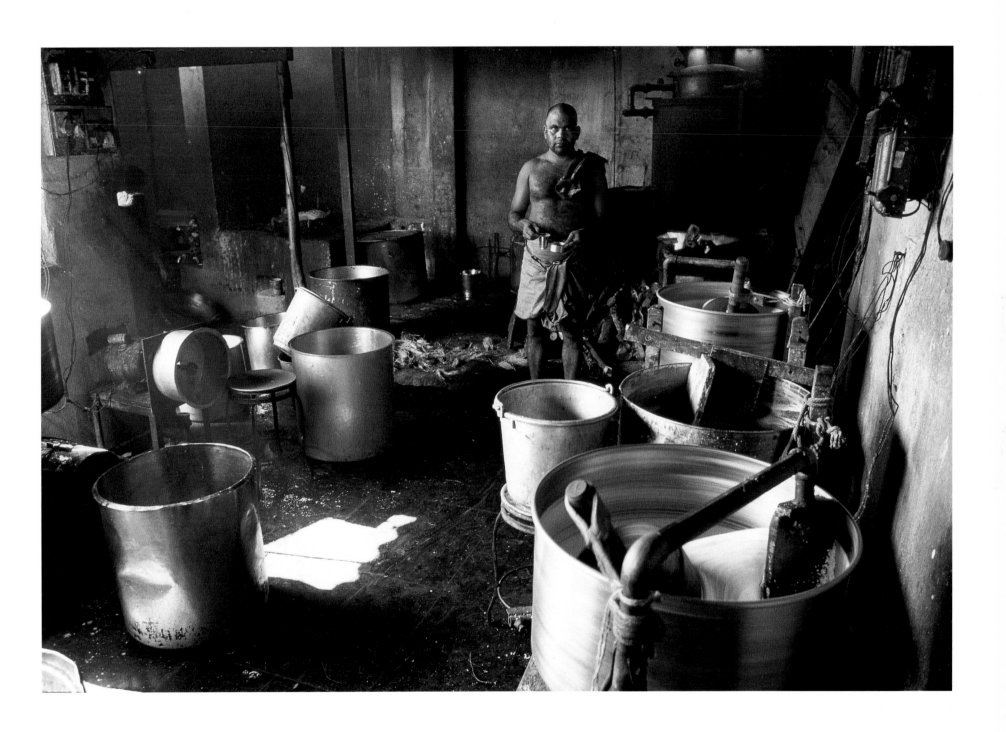

A chef in his kitchen, Srirangam

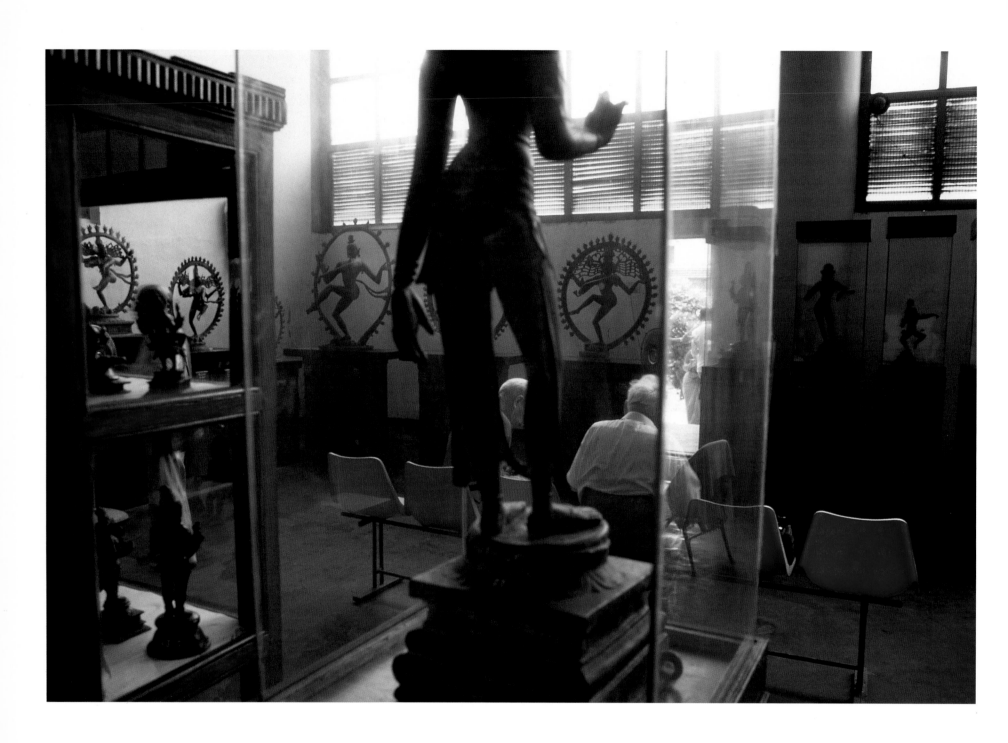

Bronze sculptures, Thanjavur Art Gallery

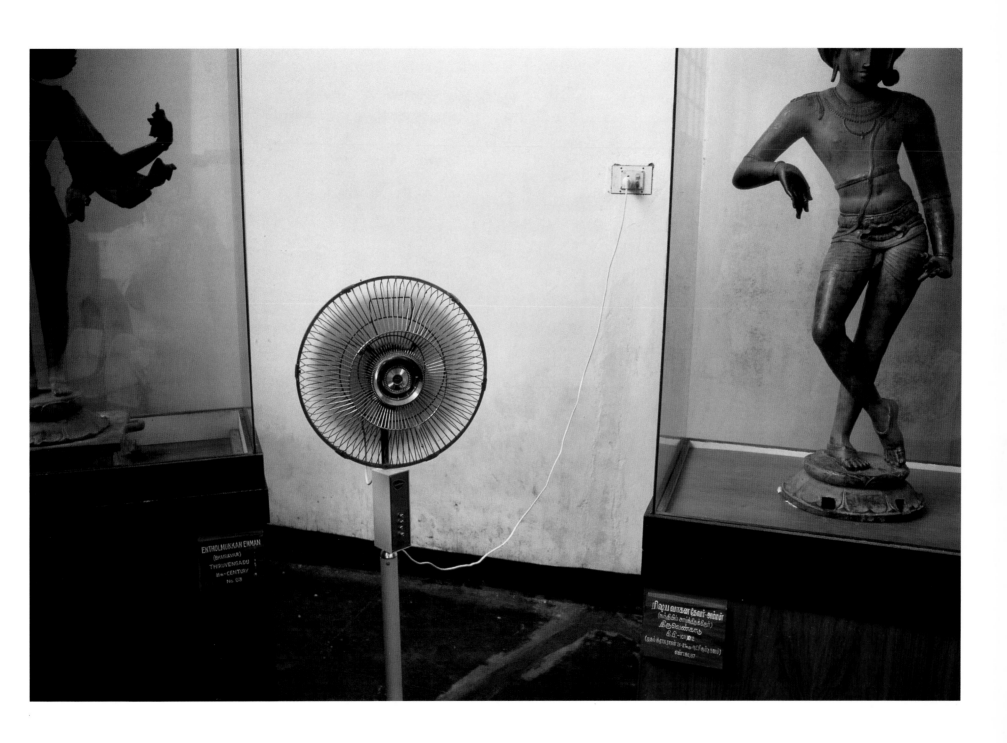

Siva as Vrishabhavahana or Rider of the Bull, Thanjavur Art Gallery

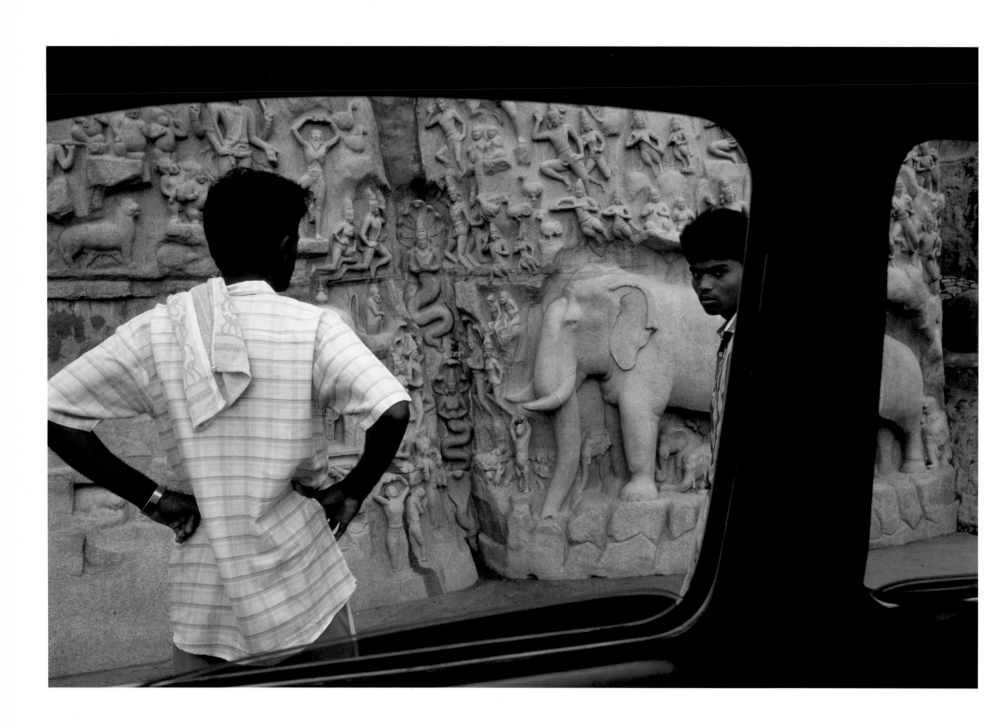

Arjuna's Penance, Mamallapuram

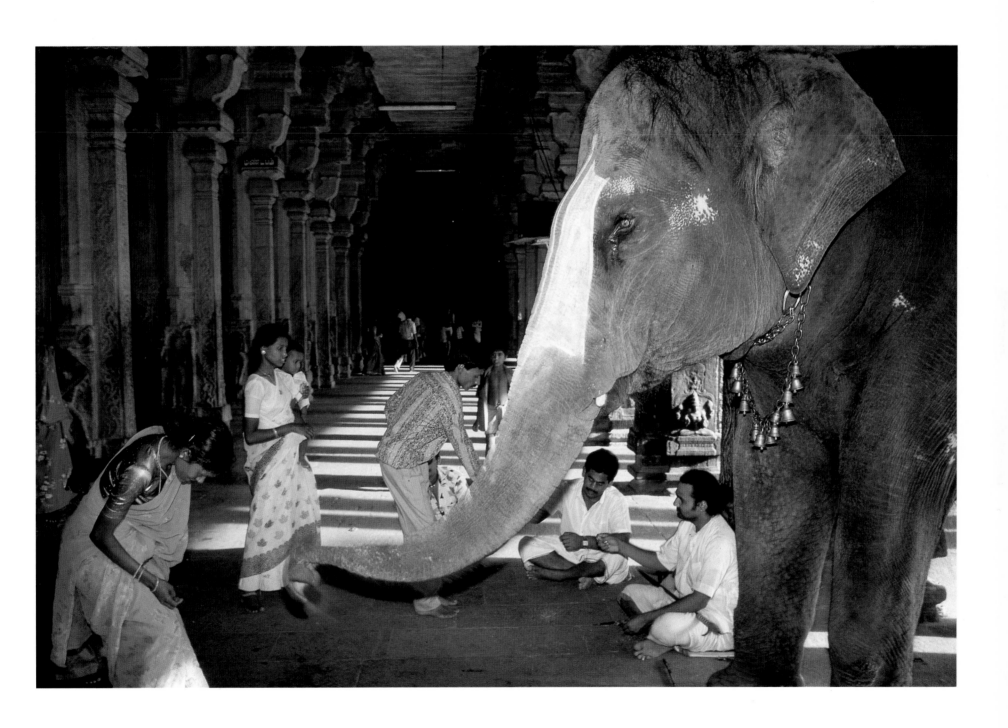

Worshippers and temple elephant, Srirangam

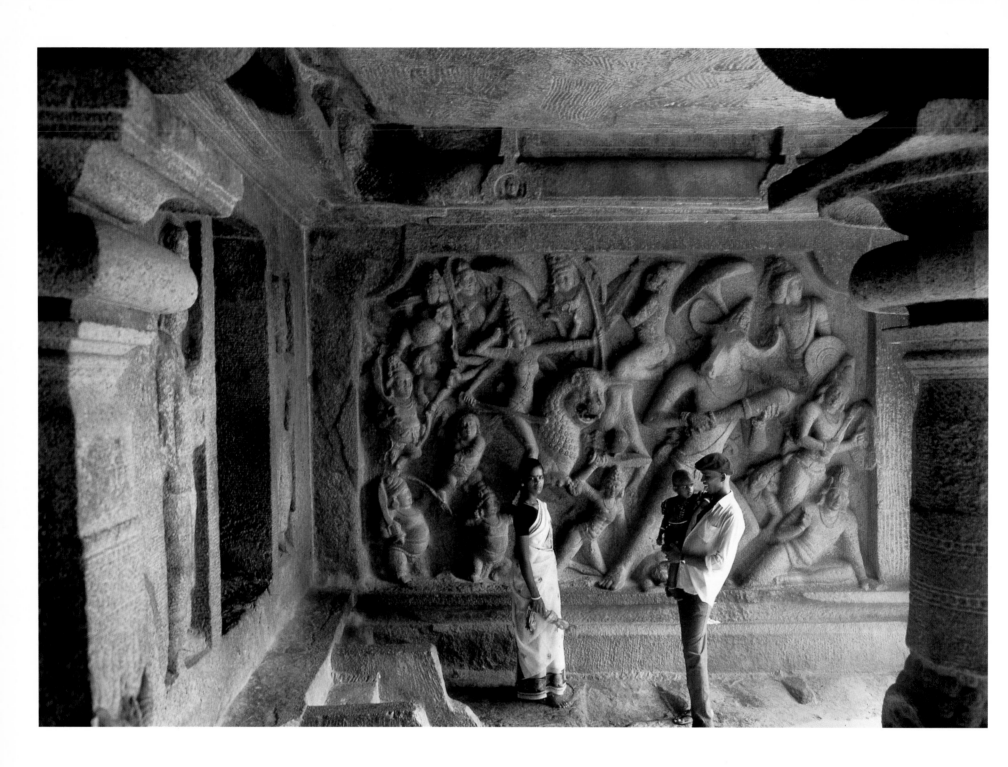

Visitors to Goddess Durga and Mahisasura frieze, Mamalllapuram

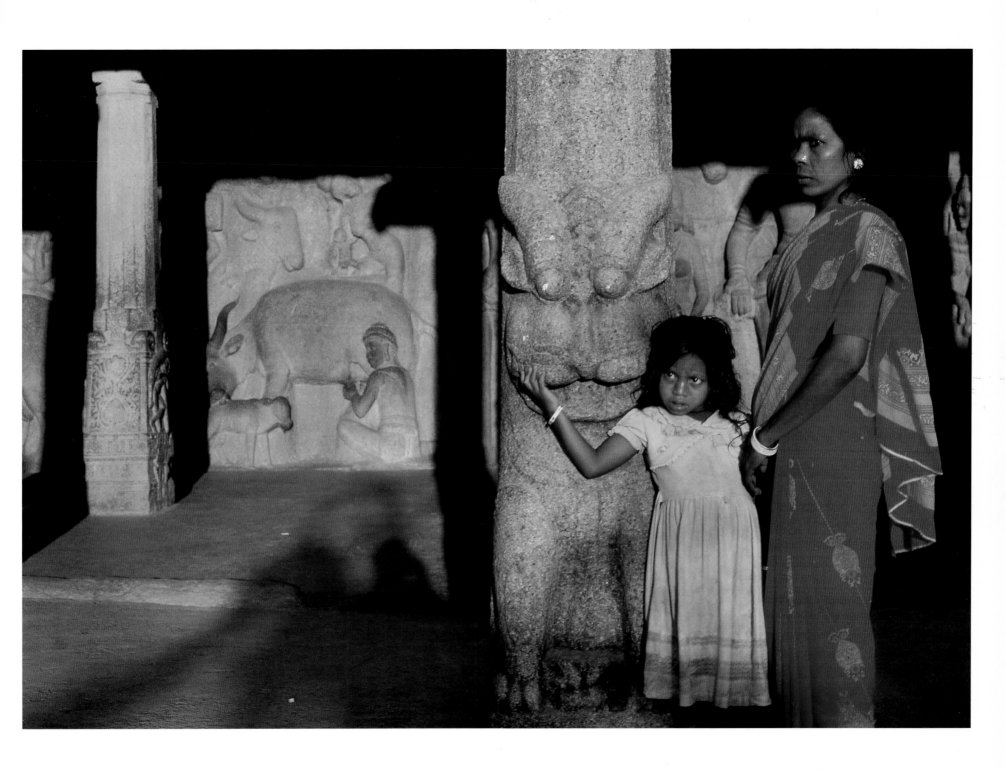

Pilgrims by Krishna and cow and calf frieze, Mamallapuram

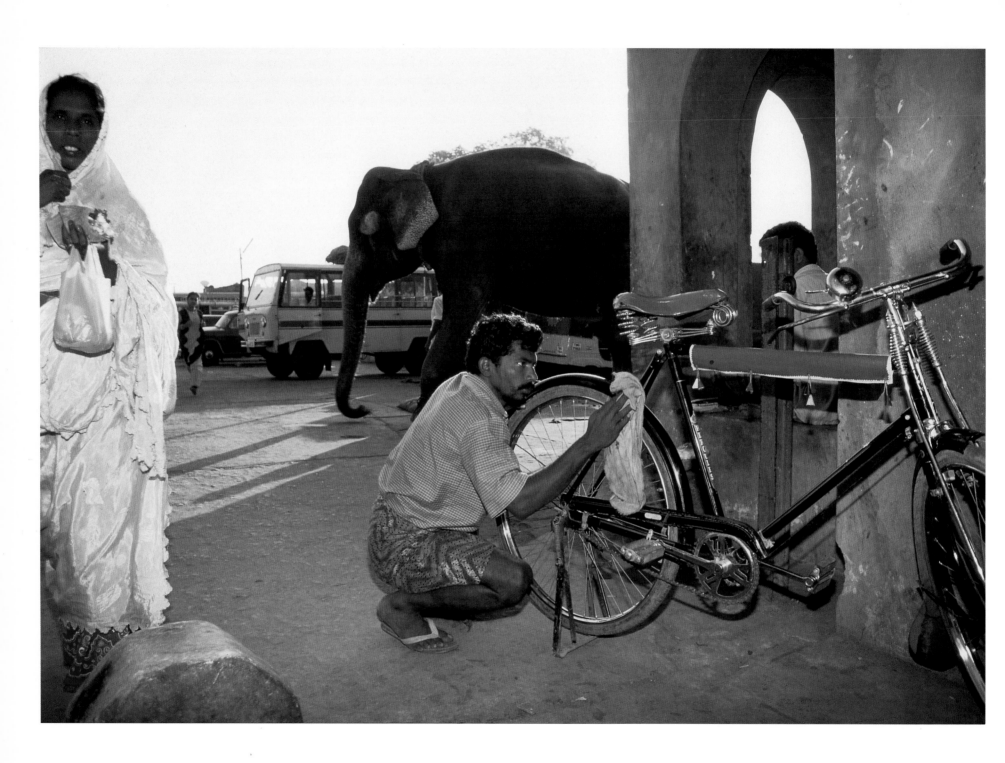

Cleaning a bicycle, Brihadisvara Temple, Thanjavur

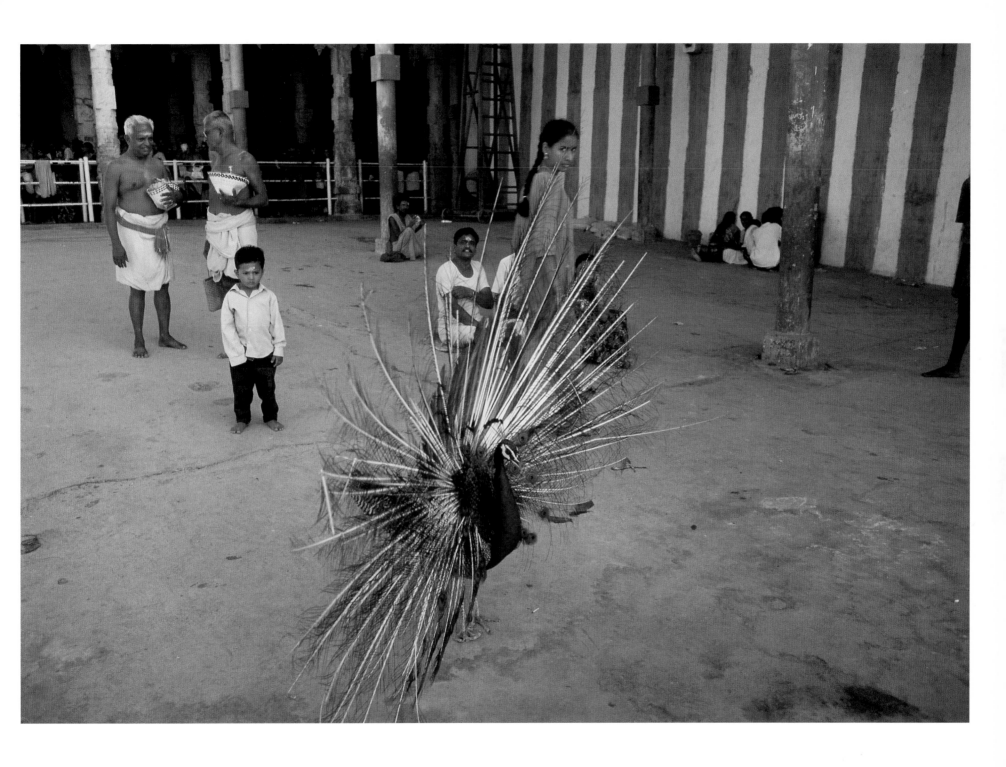

Pilgrims, priests and peacock, Tiruchendur Temple

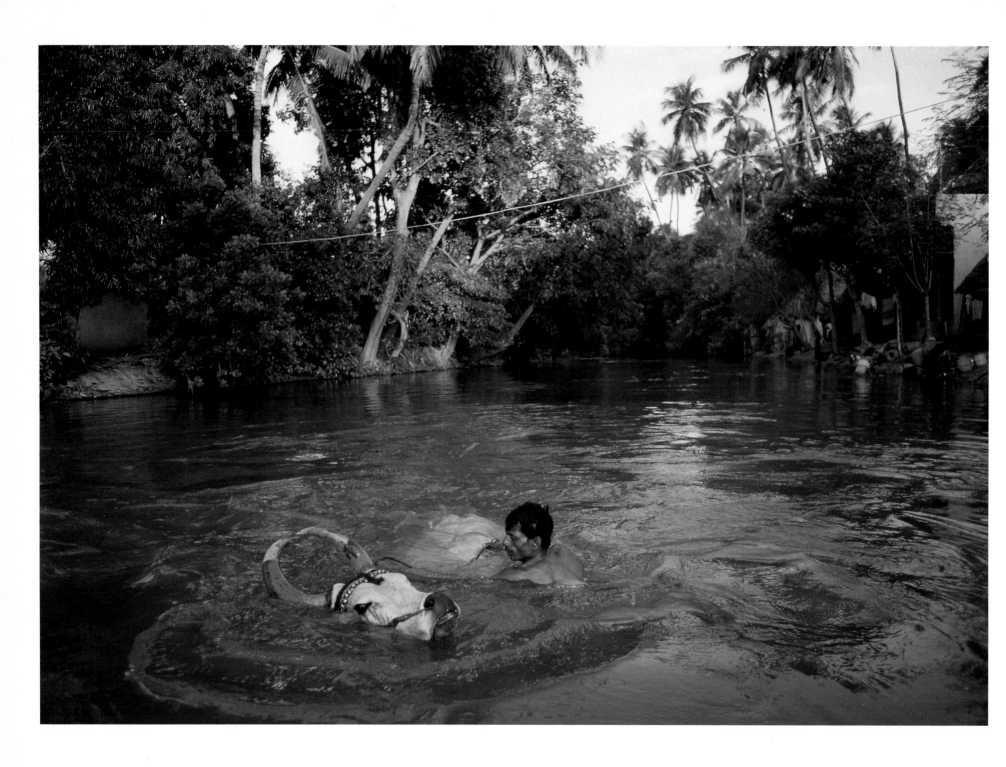

A man and bullock, Cauvery canal, Srirangam

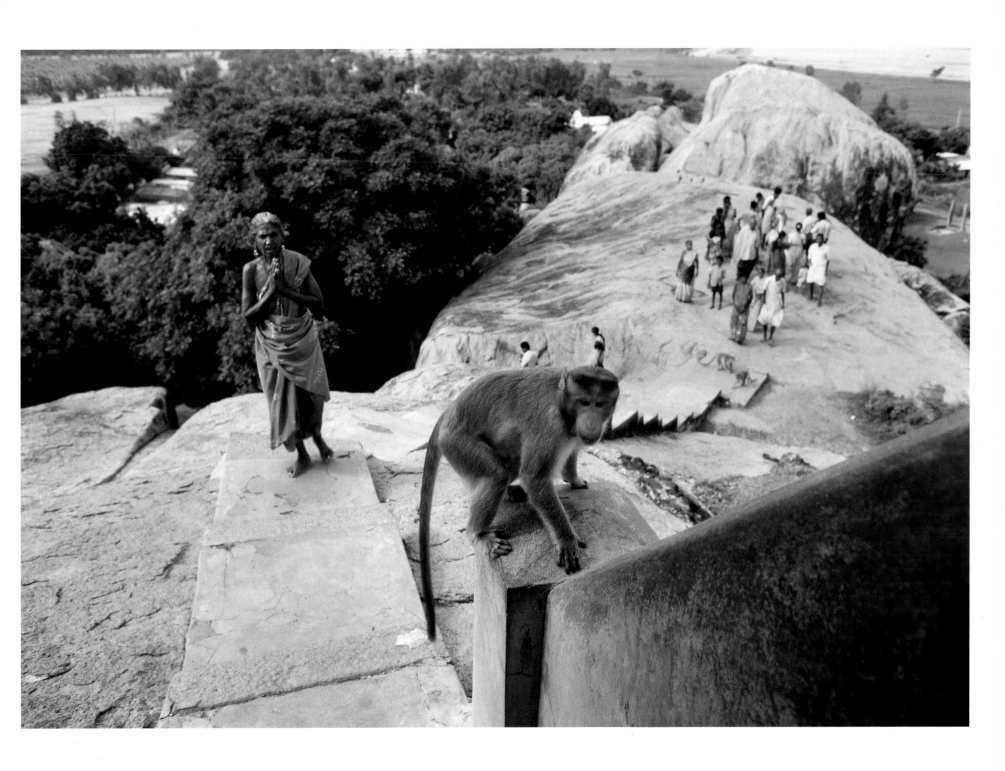

Worshipper and monkey, Mamallapuram

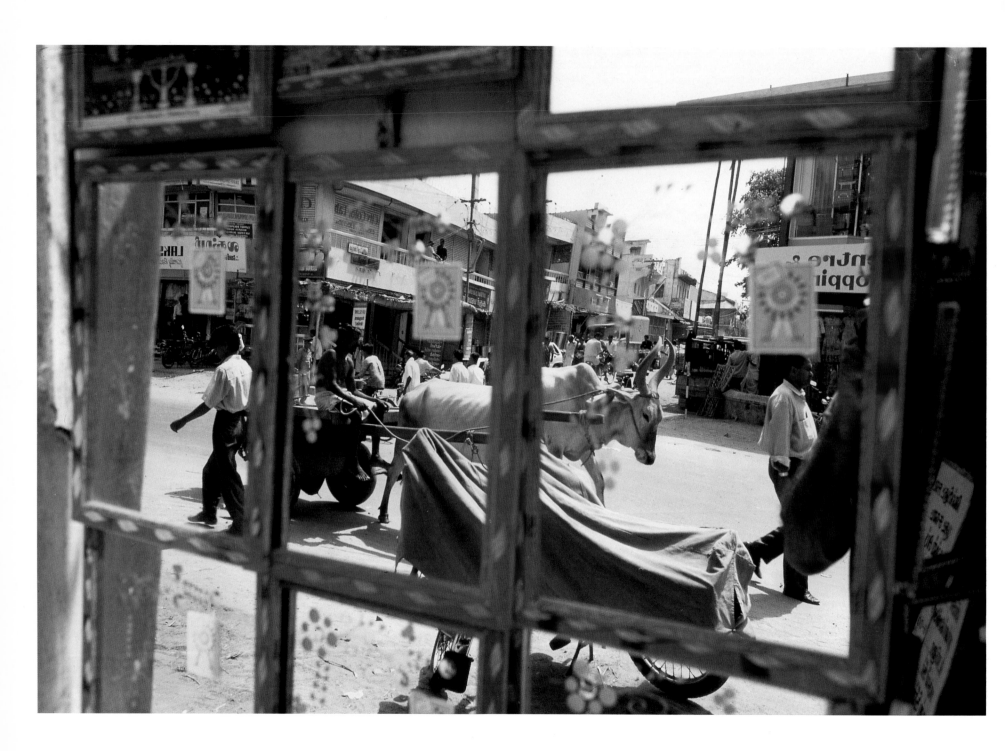

Bullock cart and mirrors for sale, Tiruppur

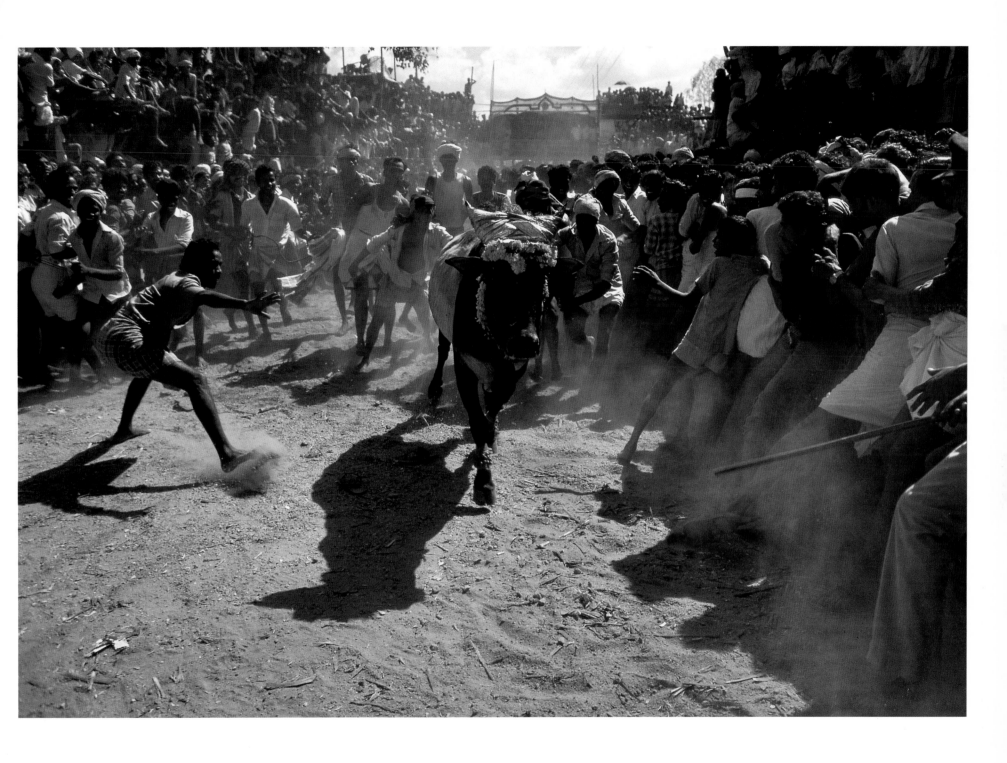

Jallikattu, bull running, Madurai District

III

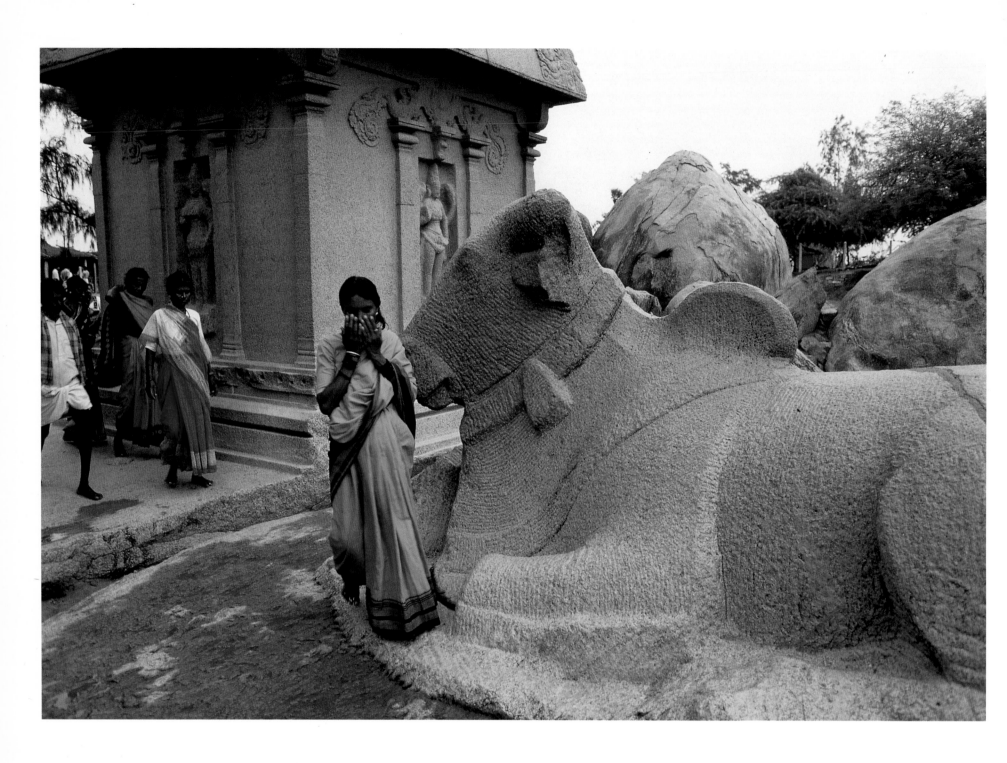

Worshipper and Nandi (Siva's bull), Mamallapuram

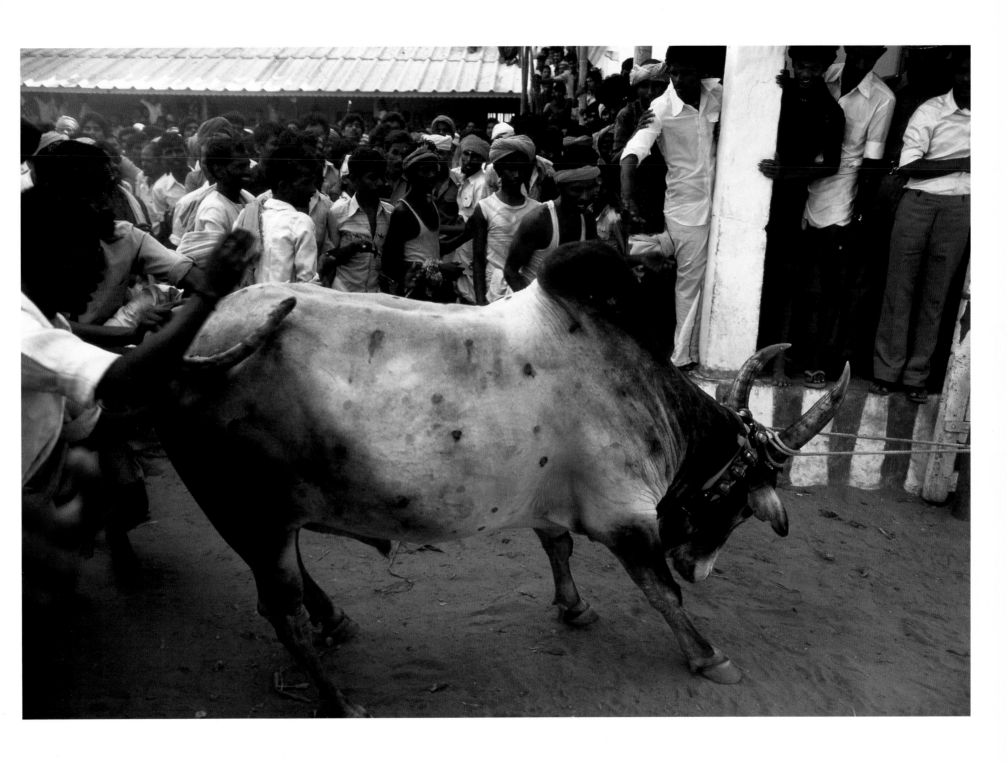

A Jallikattu bull, Pongal festival, Madurai district

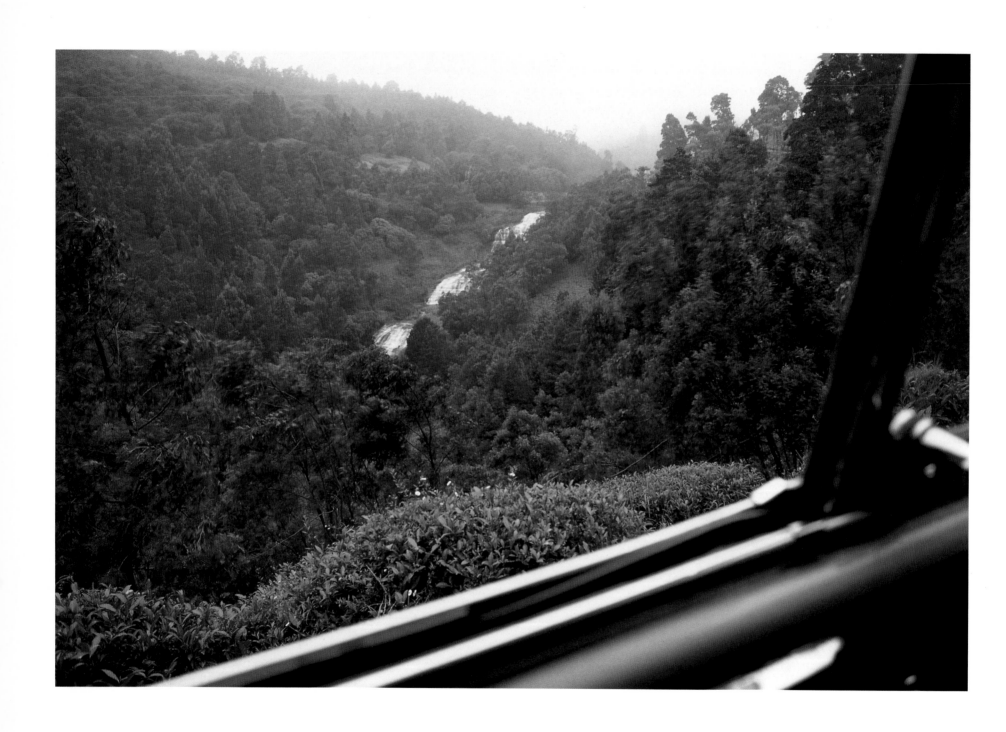

A mountain stream, Ooty Hills

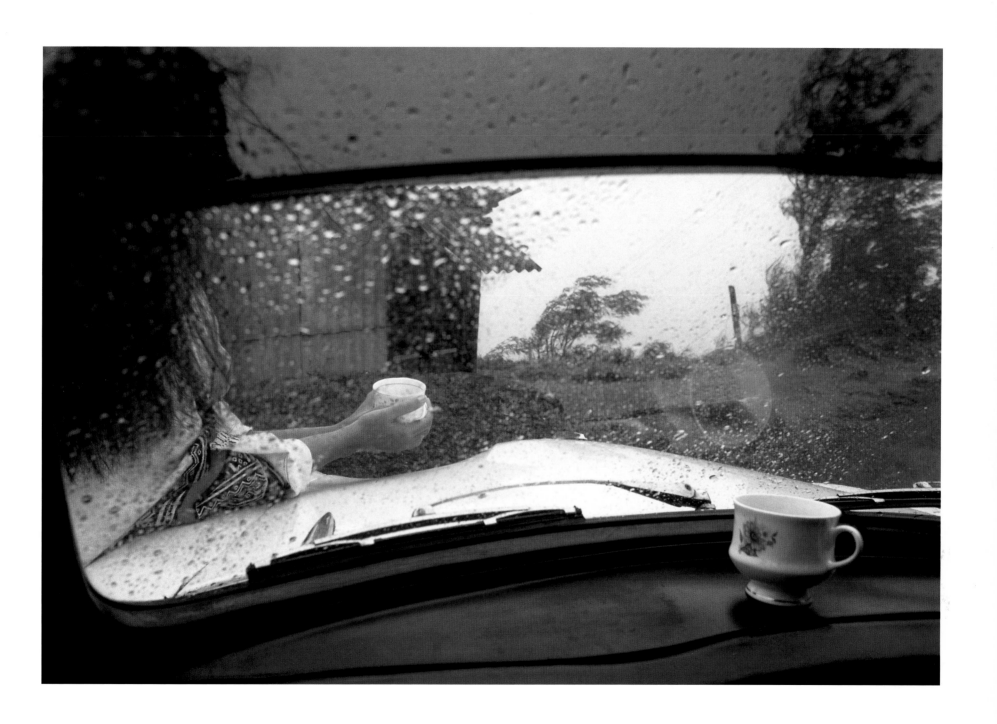

Monsoon and teatime, Ooty

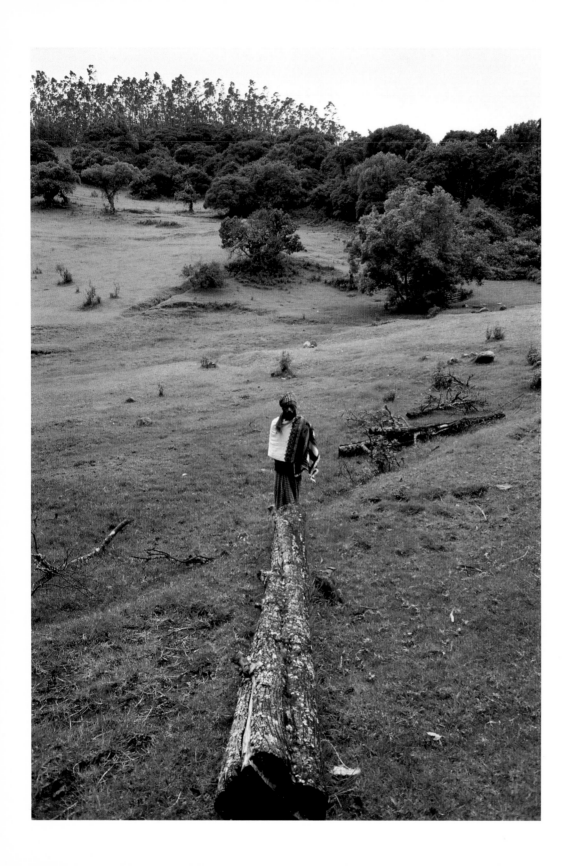

A Toda tribesman, Ooty

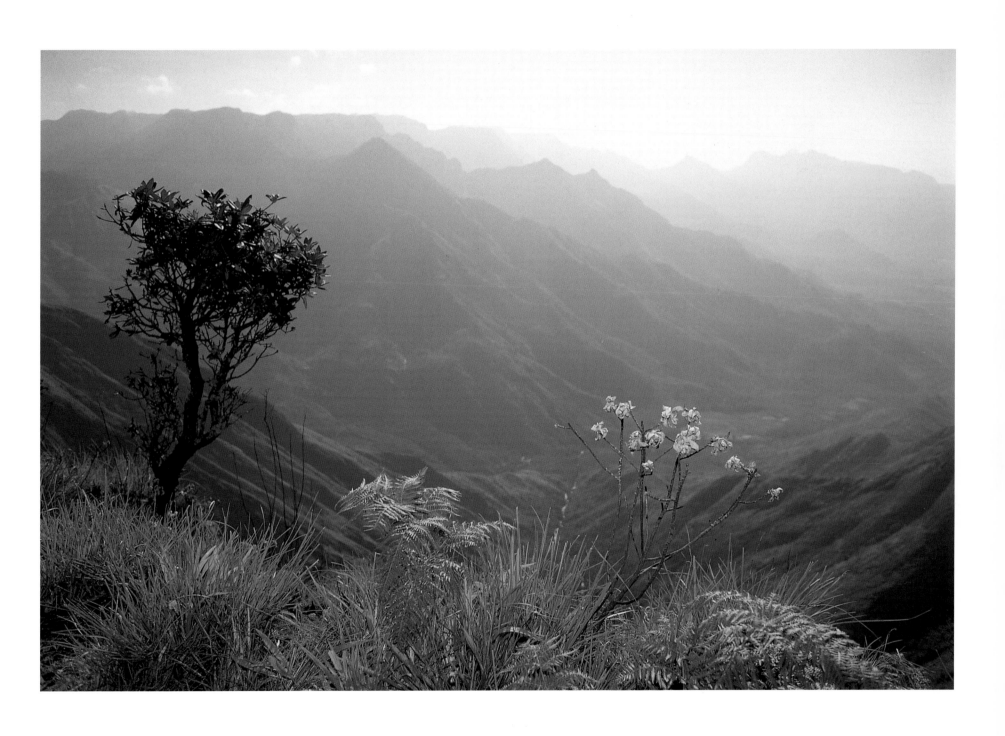

Western Ghats, Tamil Nadu—Kerala border

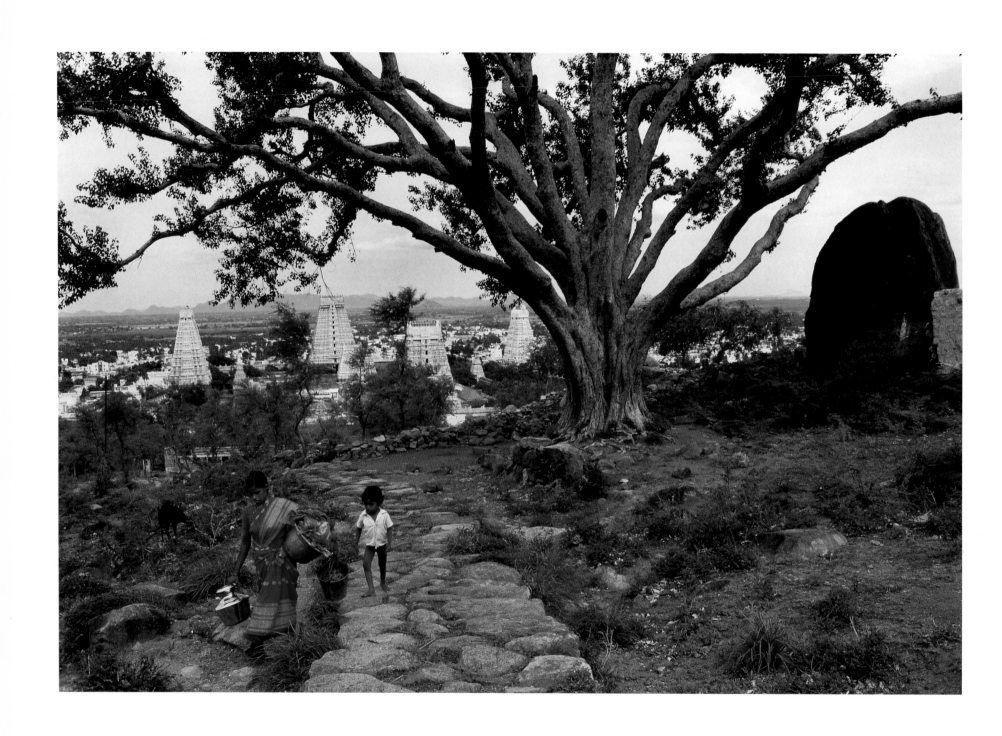

Village people, Arunachala Hill and Tiruvannamalai Temple

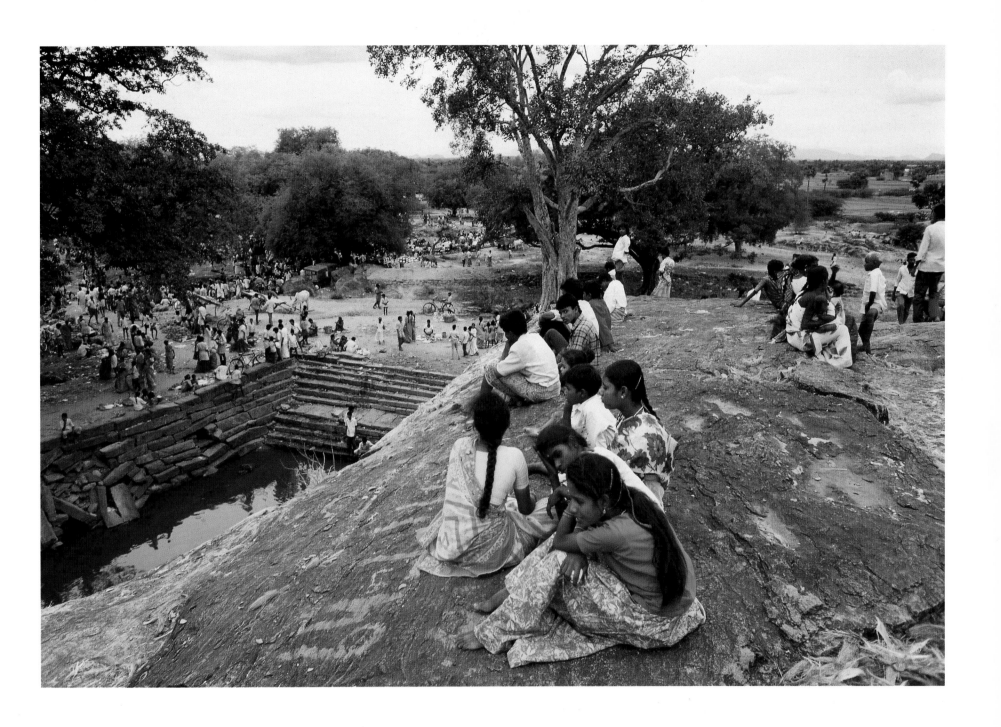

Village festivity around a water tank, near Gingee

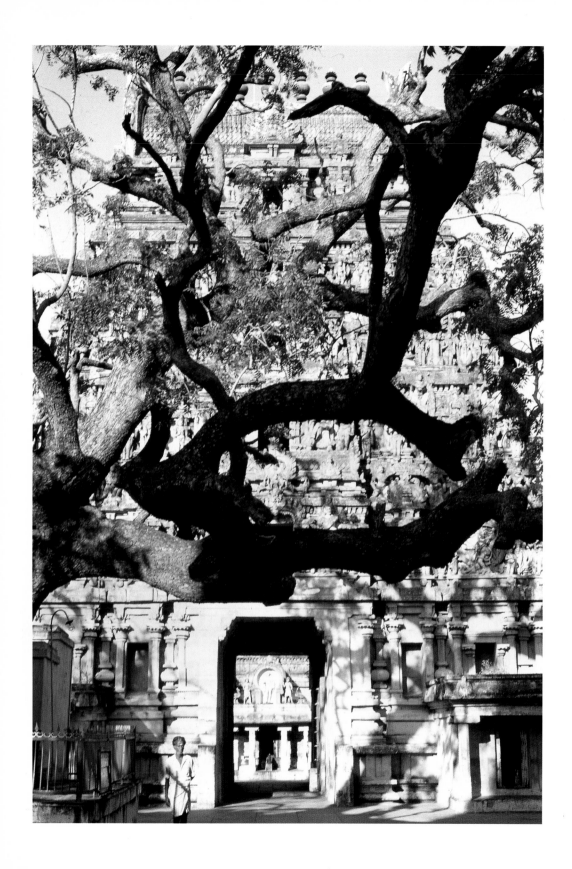

The neem tree at Vaitisvarankovil

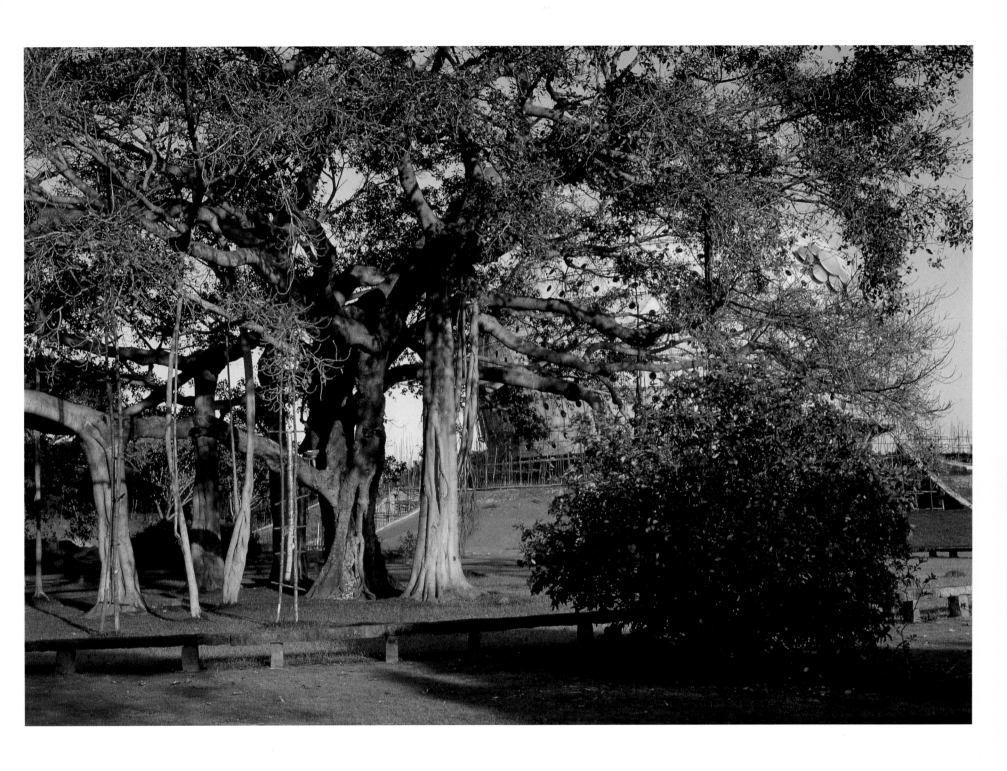

Matri Mandir, Mother's Temple, Auroville

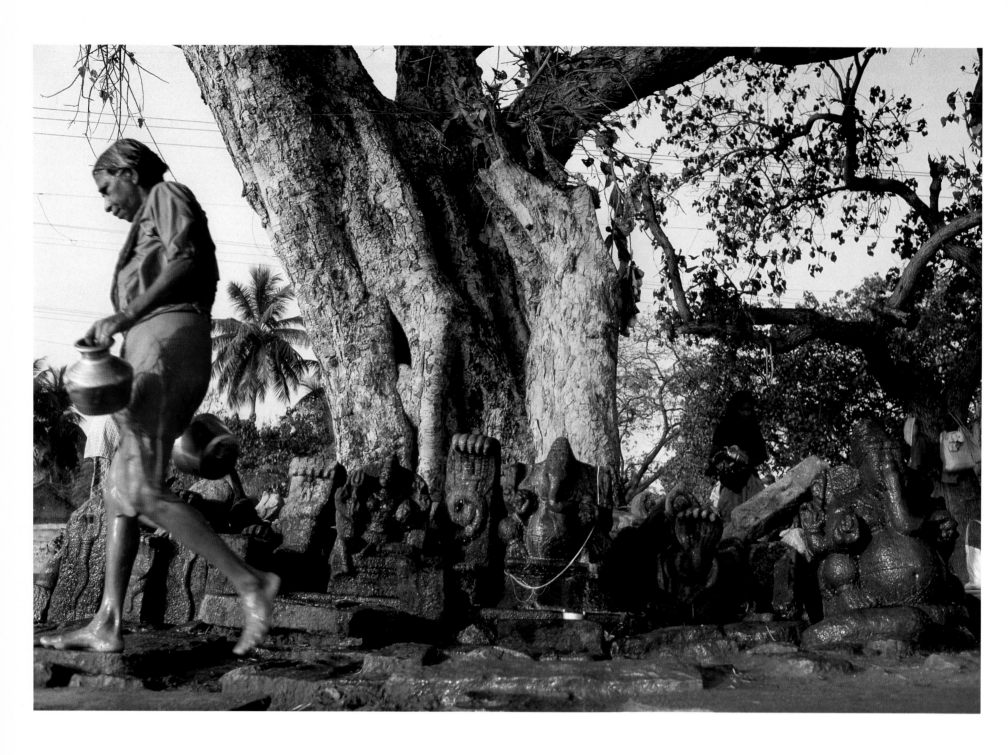

Worshippers at tree shrine, Malayampalaiyam

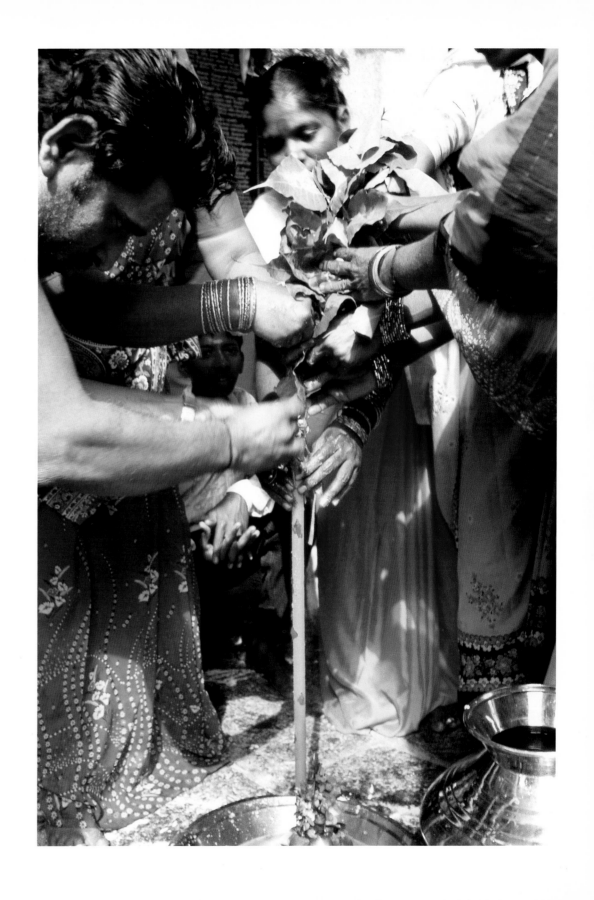

A wedding ritual, Purasawalkam, Madras

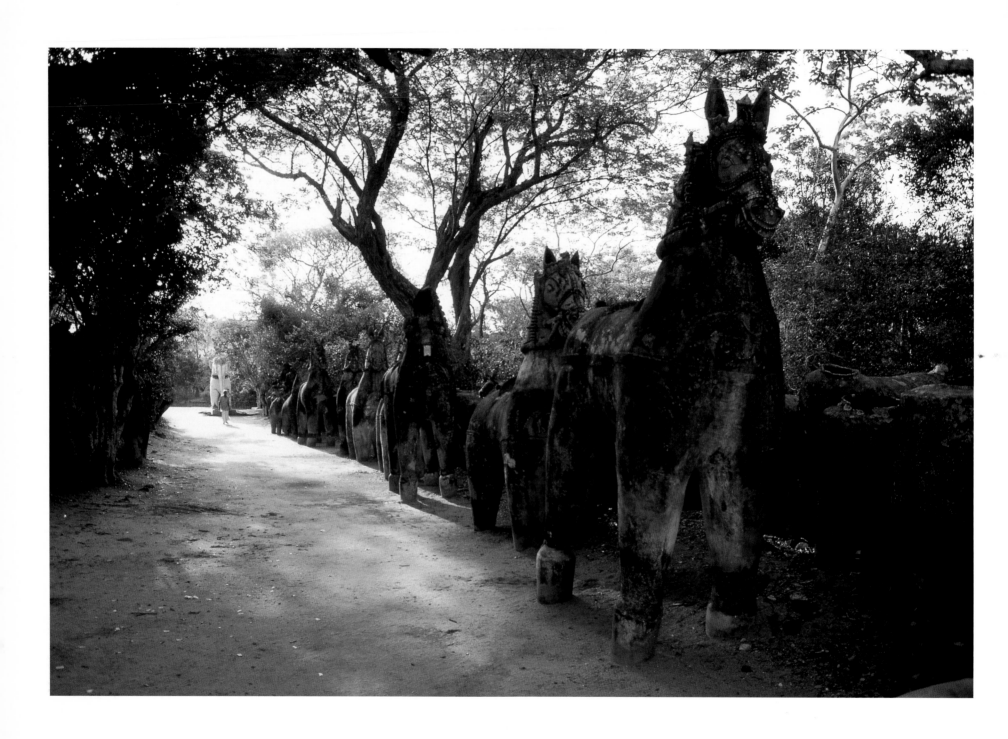

Folk dieties, Pudukkotai district

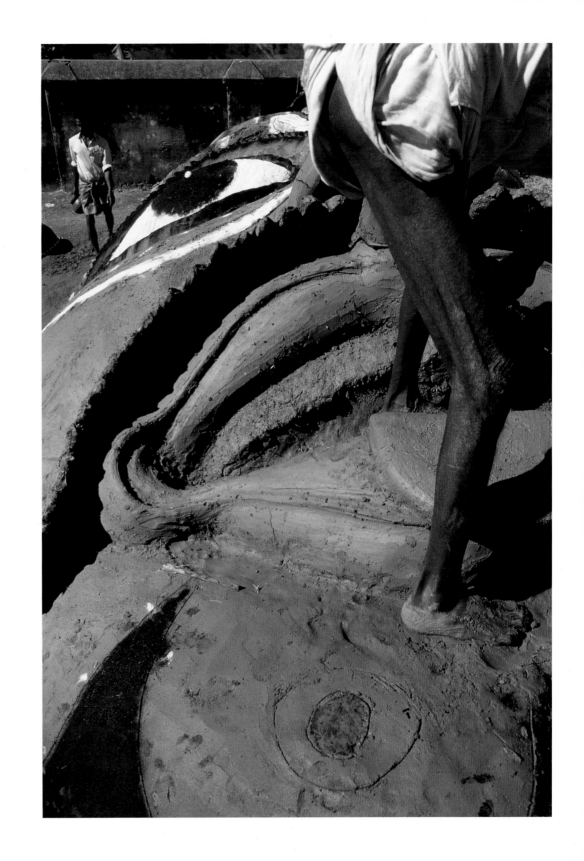

Duryodhana being sculpted for Mahabharata-kuthu, Uttiramerur

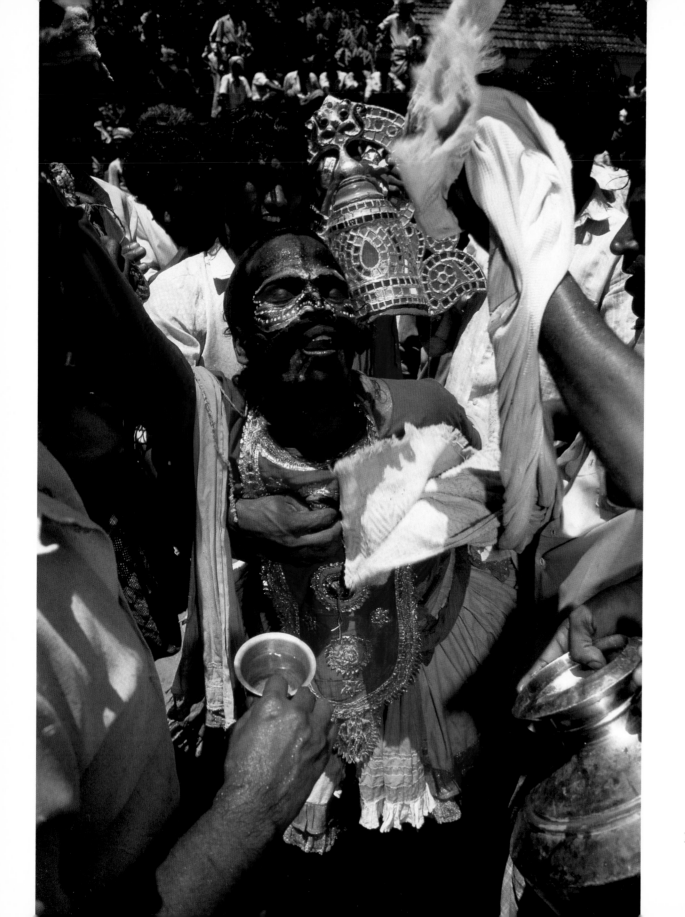

Bhima takes a break, Mahabharata-kuthu, Uttiramerur

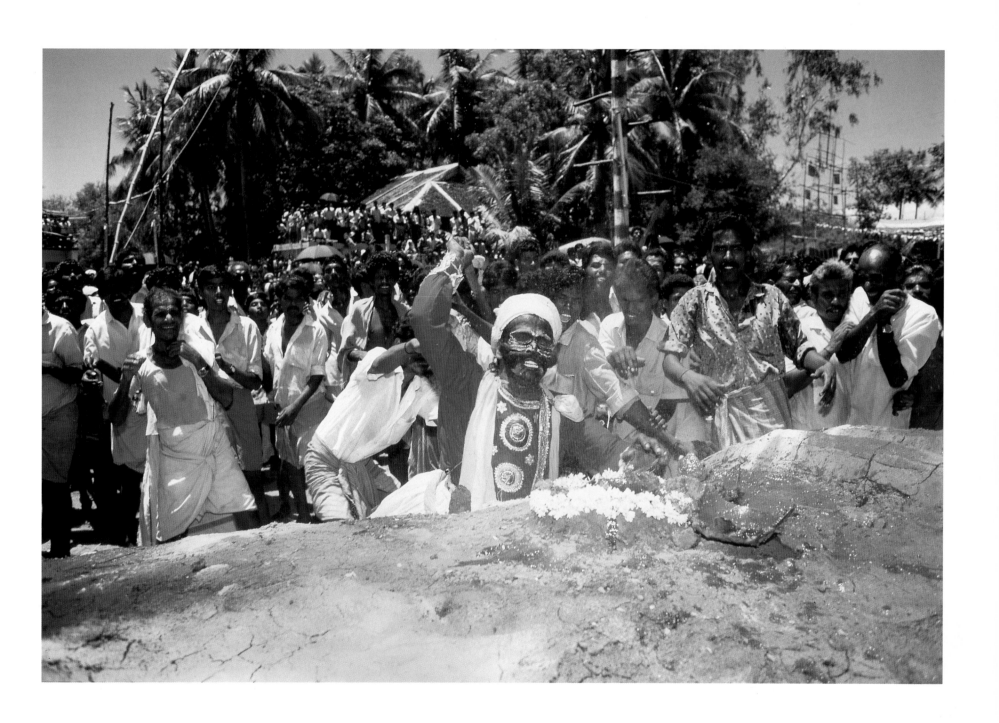

Bhima kills Duryodhana, Uttiramerur

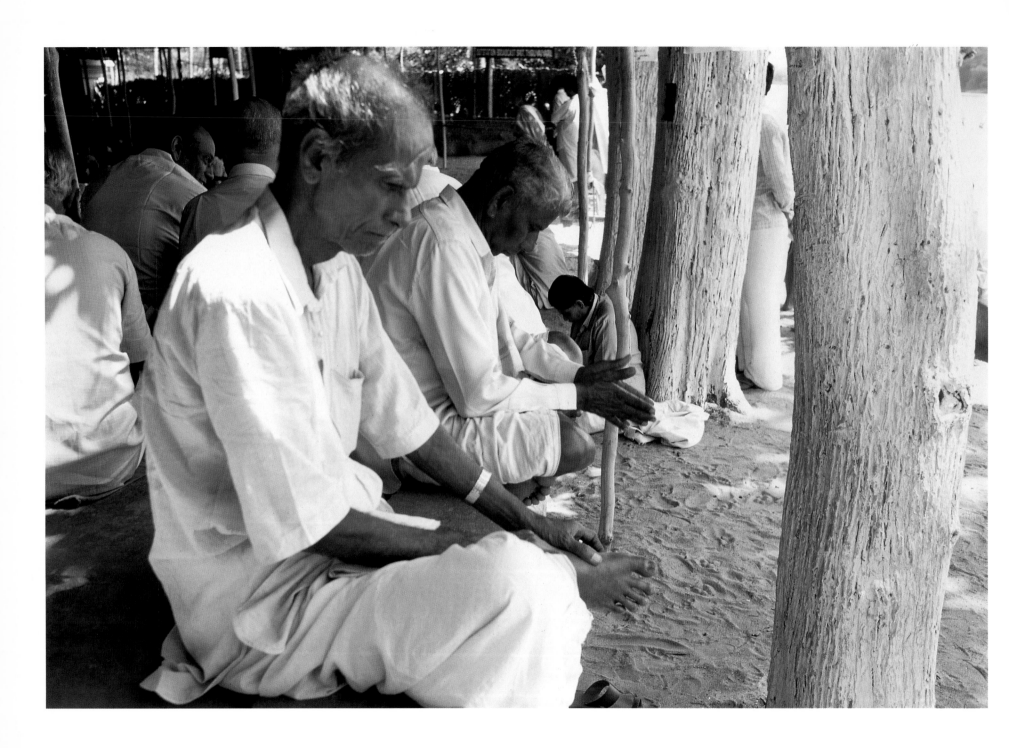

Music lovers, Thayagaraj Music Festival, Thiruvaiyaru

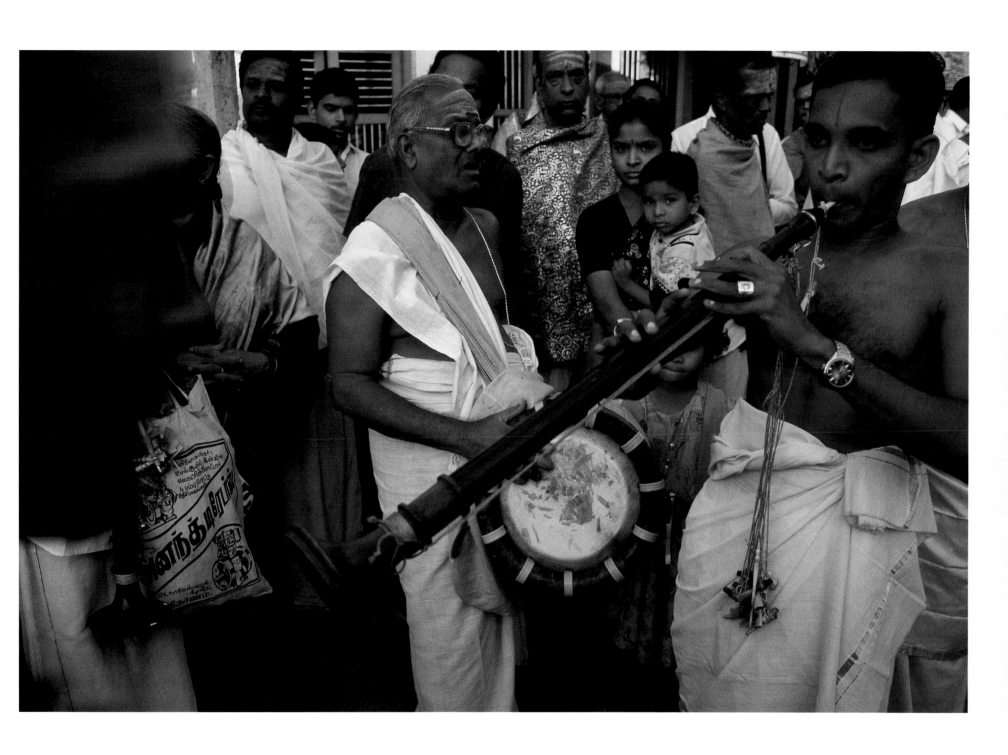

Nadasvaram (pipe) and Tavil (drum) players, Thiruvaiyaru

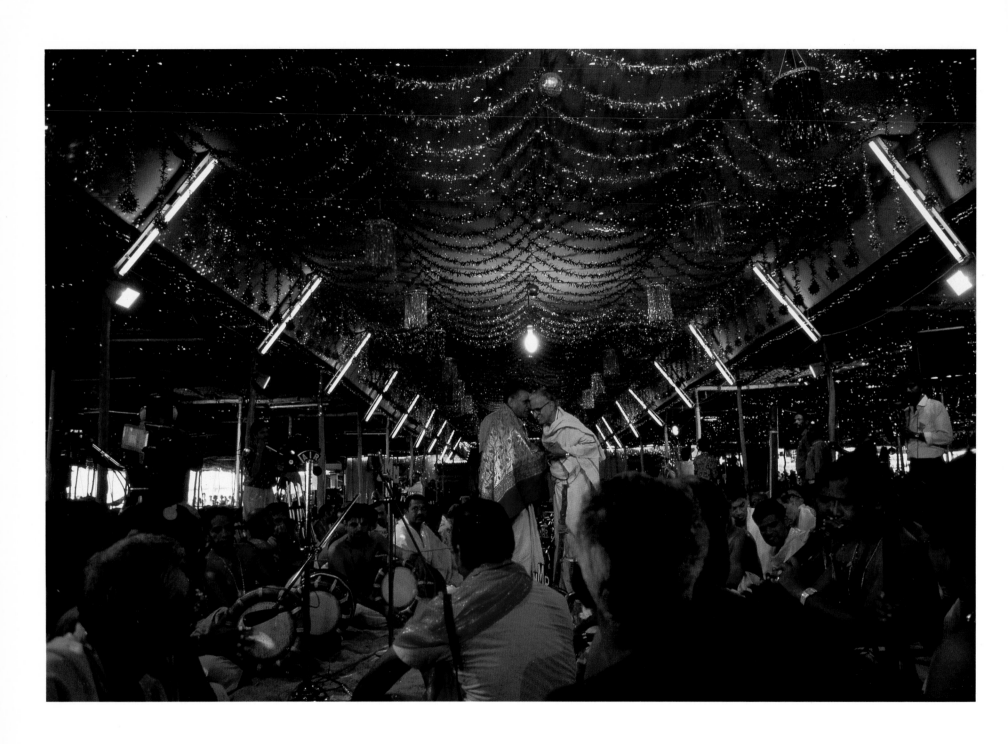

Panchavadayam, communal singing, Thyagaraj Festival, Thiruvaiyaru

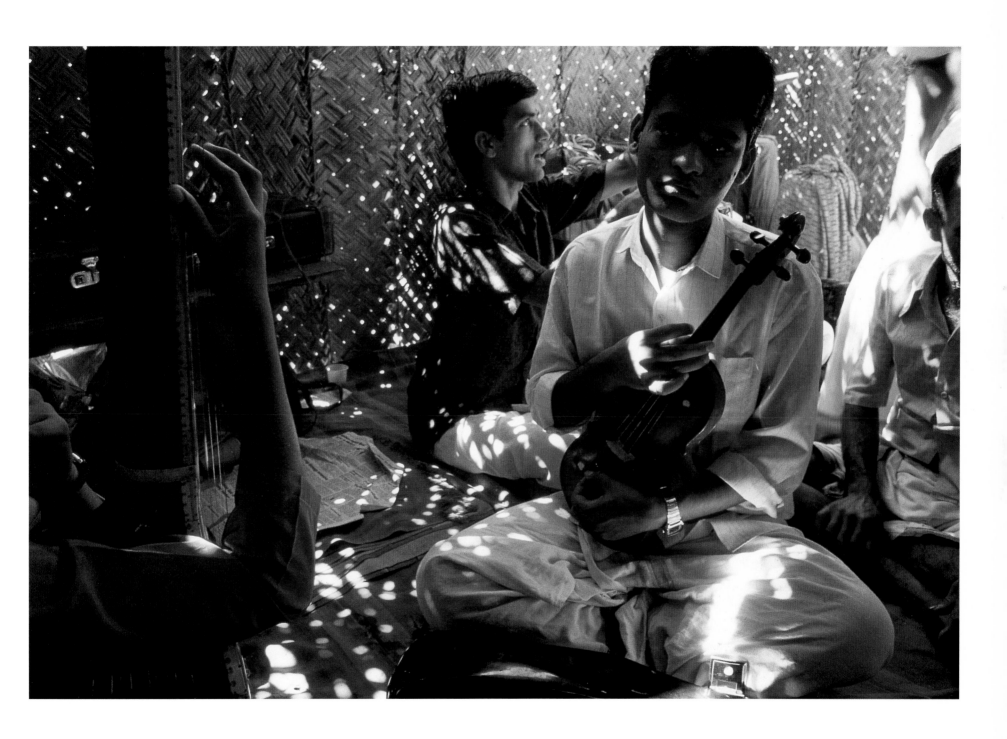

A violinist, Thyagaraj Festival, Thiruvaiyaru

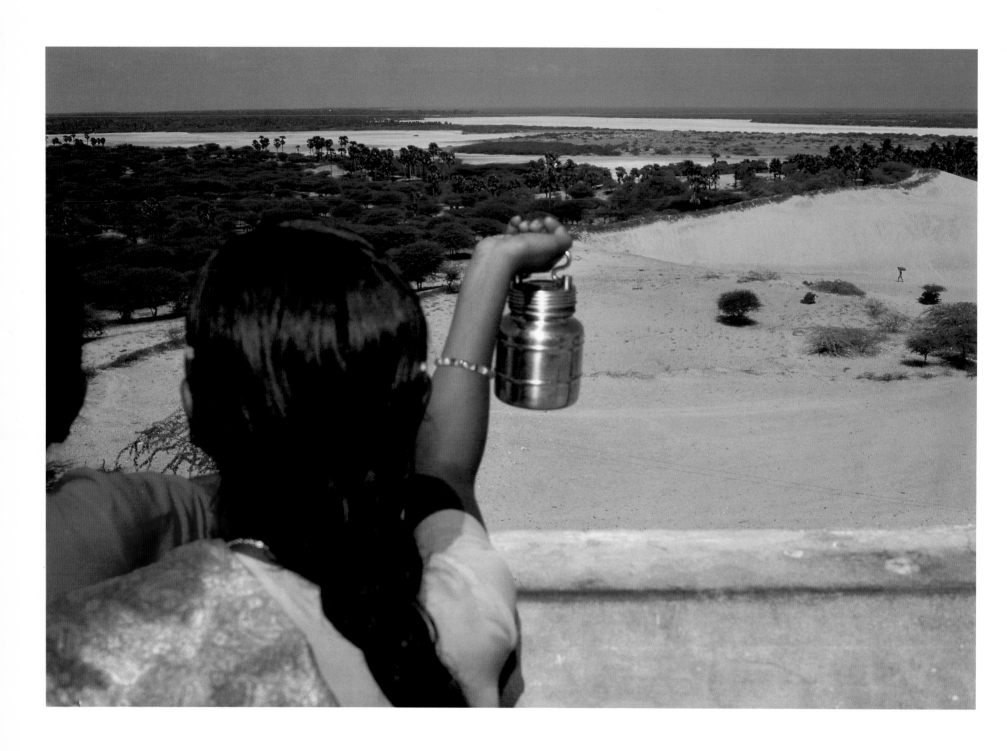

A pilgrim with a vessel of sacred water, Rameswaram

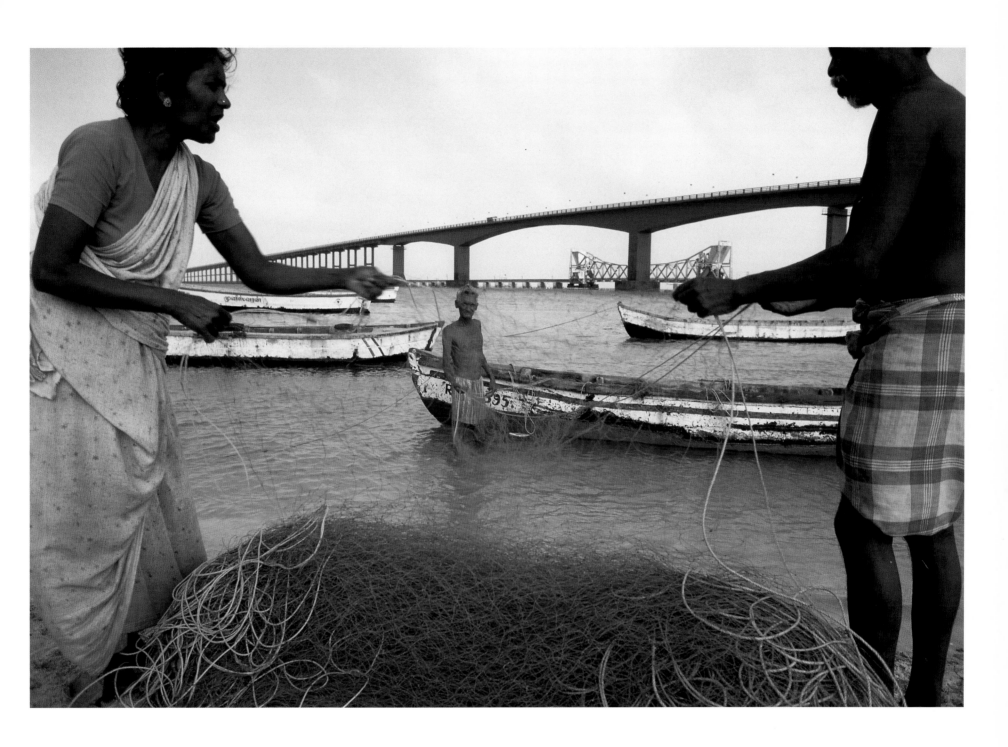

Fisherfolk, Pambam Bridge to Rameswaram

Old and new bridges, Vaigai River, Madurai

The Rameswaram Sands

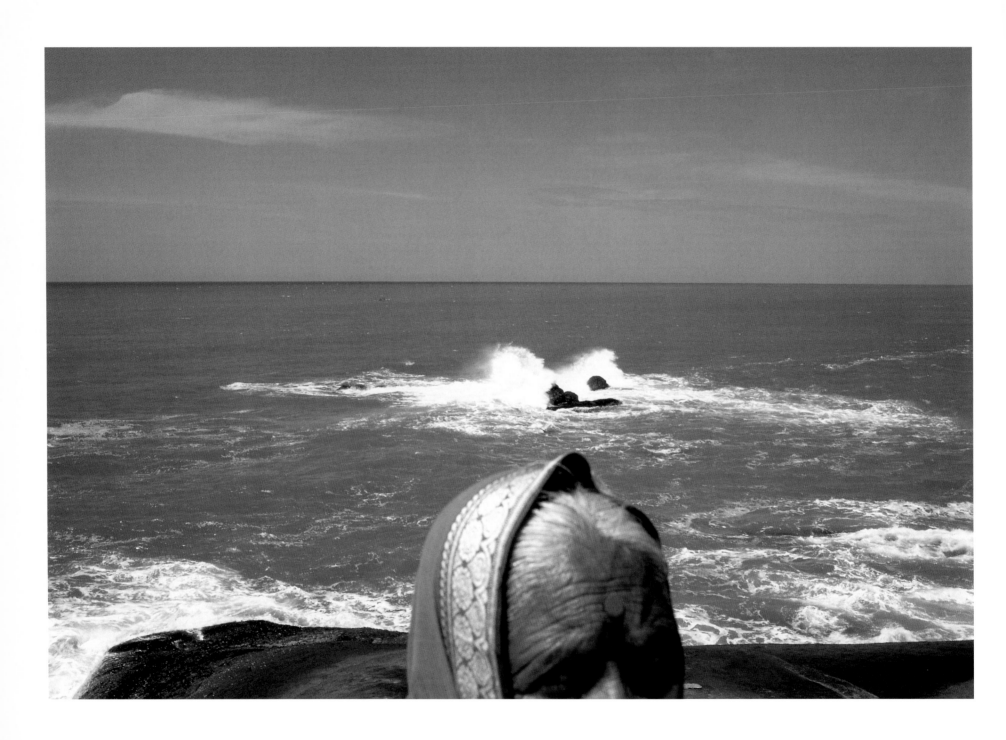

A woman pilgrim, Vivekananda Rock, Kanniyakumari

ACKNOWLEDGEMENTS

I would like to acknowledge the considerable support given to me by the Government of Tamil Nadu, in bringing out this book, however, no conditions were imposed on me. I had complete artistic freedom. The civil servants I would like to thank are T.V. Venkatraman, Hari Bhaskar, Mrs C.K. Gharyali, P. Parthasarthy, S. Ramakrishnan, N. Athimoolam, D. Sunderesan and V. Gunalan.

I would like to profusely thank N. Ram and Susan Ram for their support and encouragement. And without the enthusiasm, the regular participation and intervention of G. Venkatramani this work could not have been realised. Ashok Joshi, as always, remained a friend. John and Sunaina Mandeen came up with valuable introductions which made the production possible. I would also like to acknowledge the support of N. Kumar, Ram Sahani, Vijay Kumar, Jyoti Subbiah, John Parkar, Shankar Menon, Meera Mishra Harris, Gowri Vishwanathan, and Dr Vidya Dehejia, the scholar of Chola bronzes and other Indian arts—who hails from Tamil Nadu—for looking over my manuscript and making valuable suggestions.

Additionally, there was friendly support from Rustom Bharucha, Jean Deloche, Francois l'Hernault, Vilas Humbre, R.K. Hariprasad, D. Krishnan, Dr R. Nagaswamy, N. Muthuswamy, Mrs Murlidharan, Ray and Deborah Meeker, K. Narayan, N.S. Palaniyappa, Geetha Rajasekhar, Gowri Ramnarayan, V.K. Ramachandran, Dr S. Rajaram, Shanti Rayapillai, Prema Srinivasan, Shashi Sekhar, T.S. Shankar and Alarmel Valli.

In New York, whenever I needed a detached opinion Thomas Roma and Joe Lawton were always willing to be generous with their time. At D.A.P., New York, I would like to thank Sharon Helgason Gallagher, Avery Lozada and Heather DeRonck for their friendly expertise and patience—much patience in tying the loose ends between Madras and Manhattan.

Finally, a salute to R.K. Narayan for treating me as if I was the star photographer of Malgudi.

WOR. 28/05/04 BK-69041

First Edition published by D.A.P./Distributed Art Publishers, Inc.
155 Avenue of the Americas, 2nd Floor, New York, New York 10013

ISBN 1-881616-66-5

Book typography and jacket design by Wynne Patterson
Sequencing and editing of photographs by Raghubir Singh
Printed and bound in Italy by Arti Grafiche Amilcare Pizzi